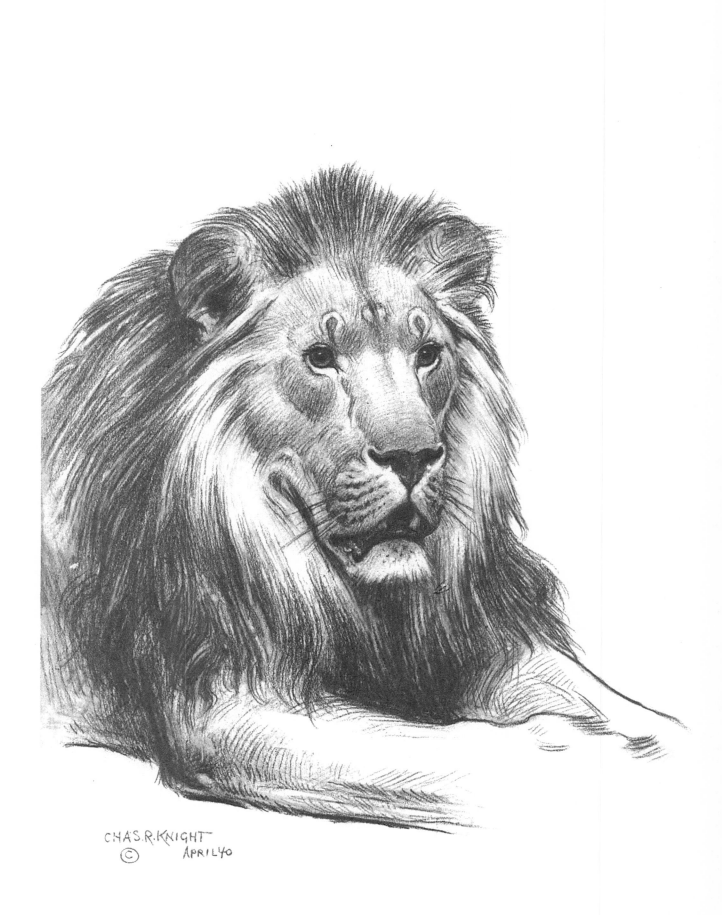

CHAS.R.KNIGHT
© APRIL40

ANIMAL DRAWING

Anatomy and Action for Artists

(Animal Anatomy and Psychology for Artists and Laymen)

By Charles R. Knight

with illustrations by the author

Dover Publications, Inc. New York

This Dover edition, first published in 1959, is an
unabridged and unaltered republication of the work
originally published by Whittlesy House, a division
of McGraw-Hill Book Co., in 1947, under the title
*Animal Anatomy and Psychology for Artists and
Laymen.*

Library of Congress Catalog Card Number: 59-10441

International Standard Book Number

ISBN-13: 978-0-486-20426-0
ISBN-10: 0-486-20426-X

Manufactured in the United States by LSC Communications
20426X28 2017
www.doverpublications.com

Preface

What is a satisfactory procedure for the artistic rendering of an animal form? This has always been a difficult and perplexing problem. Numerous books have been written on the subject, some of them beautifully illustrated insofar as they portrayed the muscular and bony anatomy of the creature represented. For many of us these volumes have proved of great value. Yet the author has always felt that the story as set forth was only half told, because no attention was paid to the psychological aspects and attitudes assumed by the various types under the emotions which control their existence.

These emotions are, after all, the wellsprings of the animal's character, guiding and governing all muscle and bone movements according to the particular needs of the individual or species.

Evidently, therefore, it is a matter of prime necessity for the artist to examine not only the anatomy but also the mental traits of an animal before he can properly represent a lifelike attitude, in either action or relaxation. The artist must also study the actual appearance of a three-dimensional object with all its diversified planes, light and shade effects, color pattern, and skin embellishments—hair, feathers, scales, etc., as the case may be.

To the artist whose particular business it is to see and set down in various mediums an impression of these manifold attributes, every sort of assistance may be regarded as necessary. In the following pages an attempt has been made to assemble in logical sequence a series of anatomical studies combined with many finished and unfinished drawings from living individuals, these latter calculated to best set forth the special peculiarities of various types of animal life.

Associated with the illustrations will be found descriptions of the environment of all the creatures represented and a résumé of their psychology and mode of existence in a state of nature. In the author's opinion, this method of approach should be of real value to the artist, as it presents conceptions of widely different types with suggestions as to their pictorial or sculptural possibilities. In this way the artist will, it is hoped, be better able to grasp the outstanding characteristics of his models, their beauty, virility, and charm, and the splendid opportunities which they offer for every sort of artistic expression.

The author wishes to acknowledge with thanks the valuable suggestions on muscle identification by John Eric Hill, Department of Comparative Anatomy, American Museum of Natural History, New York.

<div align="right">CHARLES R. KNIGHT.</div>

NEW YORK, N. Y.,
February, 1947.

Dedicated to the Memory of

CHARLES R. KNIGHT
(1874 - 1953)

for his Contribution to
Art and Natural History

Contents

Preface . v

Introduction . 1

MAMMALS . 7

GREAT APES AND OTHER MONKEYS 8

THE FELINE GROUP 13

TIGER HEADS: AT REST AND IN ACTION 25

DOGS . 28

BEARS . 32

HORSES . 36

CATTLE . 42

DEER . 46

ANTELOPES 50

SHEEP AND GOATS 52

ELEPHANTS 54

CAMELS . 59

SWINE . 63

SEALS, WALRUSES, SEA LIONS 65

RODENTS . 67

YOUNG ANIMALS 69

EXOTIC TYPES 72

ANIMAL EXPRESSION 77

HOW ANIMALS LIE DOWN 80

SKELETON OF MAN COMPARED WITH GREYHOUND . 84

HAIR TRACTS 87

HOW ONE PAINTS AND MODELS AN ANIMAL . . . 90

BIRDS—GENERAL OBSERVATIONS 96

WINGS . 100

BEAKS, TAILS, AND FEET AND LEGS 105

EXPRESSION IN BIRDS' EYES 107

REPTILES: CROCODILES, LIZARDS, SNAKES, TURTLES 109

FISHES . 111

INVERTEBRATES 113

PROTECTIVE COLORING 117

Summary . 119

Introduction

The portrayal of the human form, either in sculpture or in painting, seems to have been the goal of man's artistic endeavors for many thousands of years. Indeed, even our prehistoric ancestors made crude but clever drawings and images of the men and women of their time, attesting an interest in such matters that has continued to the present day. However, not only human figures but animals as well are depicted in lifelike action on the rough stone walls of caverns and grottoes in Europe and Africa. France and Spain are particularly rich in these early examples of man's handiwork. One gazes with fascinated interest at long processions of mammoths, horses, reindeer and bison, and other striking and picturesque creatures, while mentally paying homage to the skill and knowledge that made these renderings possible. Early man was, perforce, a hunter—an expert in the capture and killing of wild animals for use as food or for skins that provided warm covering for his otherwise naked and sensitive body.

The assumed necessity for propitiating the animal hunted undoubtedly influenced primitive man in making some of the drawings found in these subterranean shelters, but others seem to express merely a desire to portray in black and white or color the creature that he was accustomed to see in his wanderings in search of food or other necessities of life. These drawings show no conscious realization of anatomy as such, but they indicate a close observation of animal character (as a glance at the reproductions of some of these pictures will reveal) and combine good vision with a clever hand in their ultimate effect.

These old-stone-age cave artists belonged to the Cro-Magnon race, a tall and sturdy people, who either killed off or absorbed the much more primitive Neanderthals, who preceded them in western Europe. For some not clearly understood reason, the races that followed the Cro-Magnons were not artistically inclined, as we find no evidence of such workmanship on or near their homesites. They did, however, eventually make crude pottery, polish their flint implements, and live in huts; but art was for them a thing of the past, and perhaps much more urgent matters occupied their attention, such as tribal wars or troubles at home. Food scarcity and generally unpropitious living conditions may also have diverted them from the things of the spirit. At any rate, it was not until the later bronze and iron ages that man emerged again as an artist, a being who could make not only useful but also beautiful objects with which to accomplish his daily tasks. Animals again figure in many of these designs; horses, deer, wild boars, and birds of various species all appear in the decoration of household utensils and war and hunting weapons.

In Egypt at an early date and later in Assyria many types of animals were used as decorations for walls, arms and armor, and domestic utensils, while clothing and sundry objects of religious worship were fashioned to include animal forms. Even some of the gods themselves assumed animal attributes and were so represented in carvings and paintings in the great temples and palaces built by these wonderful peoples.

The Assyrians particularly displayed great skill and knowledge in their alabaster and colored-tile reliefs and in the great winged granite bulls that guarded the palace gates. The king and his henchmen figure in numberless designs depicting battle and hunting scenes, all done with a consummate grasp of the action and psychology of both animals and men under exciting and dramatic conditions. Indeed, the Assyrian artists seem to have been almost the first to comprehend the need of a thorough understanding of the actual musculature and bony anatomy so evident in their models, as well as the emotional element involved in their proper presentation. We have only to glance at the well-known example of a wounded lioness to see just what is meant in this connection. An arrow buried in her flank has paralyzed the hindquarters, which she drags along the ground, at the same time roaring defiance at her enemies. The action and the psychology are superb: the great brute mortally wounded still strives to put up a fighting front. Only a close observer could have caught the salient points of this dramatic pose.

At a later date the Greek sculptors infused great refinement and technique into the fashioning of some of the most splendid statues the world has ever seen. The human form, of course, was their great artistic ideal, but they also made magnificent models of horses in interesting and convincing action. Other animals they did not do so well; for some unexplained reason their lions, bulls, and infrequent dogs do not compare with the work of the Assyrian masters.

The Romans did not attain much distinction in their animal studies, though they must have known the appearance and action of many species of wild beasts which they captured and brought to Rome for use in the arena and to impress an ever restless and turbulent populace.

With the decline of the empire, all art suffered a collapse, to recover no semblance of its former glory until the so-called Dark Ages had come and gone. No very important works of art were produced in Europe that we can definitely ascribe to those troublous times. Gradually, however, as economic and political condiions improved and the Church asserted its influence to a greater and greater degree, we see beautiful, naïve work being

done, most of it under ecclesiastical inspiration. These productions, though crude in workmanship, were so often imbued with a deep religious feeling that one cannot help admiring their spiritual qualities, as well as their charmingly artistic conception.

While many forms of animal life figured in these designs, the artists were so unacquainted with the actual appearance in life of these creatures that a modern observer often requires considerable ingenuity to make out just what sort of beast the artist intended to represent. Strange, clumsy little animals wander about on complicated Romanesque capitals or grace some lovely and intricate bit of gold or silver jewelry. Lions, birds, frogs, turtles, fish—in fact, a motley array of rather absurd and grotesque creatures—simply executed and often symbolical in meaning, give zest and interest to wood, stone, and metal objects of this era.

Later, the Gothic period of architecture permitted even greater opportunity for the use of animals as decorative adjuncts in numberless ways, but again as purely conventional additions to the general composition. Indeed, the artists of this time loved to invent all sorts of combinations in animal anatomy. Griffins, dour and sinister brutes—often eagle-headed and lion-bodied, with either lion's feet or eagle's claws and with small wings sprouting from their shoulders—were great favorites, while even more dreadful dragons—lizard-formed monsters often spouting flames from their distended jaws—ramped and roared in the midst of terrorized human beings, too weak to resist their attacks. Gargoyles, part man and part beast, still leer and stare from the high towers of Notre Dame, the great Gothic cathedral in Paris. It was not until the Italian artists of the Renaissance had turned their highly trained faculties upon this somewhat neglected branch of art that we begin to discern a more or less scientific interest displayed in the accurate reproduction of animal forms. After the lapse of centuries these wonderful creatures were again to be portrayed realistically and their anatomy and proportions considered of prime importance even by such masters of the human form as Leonardo da Vinci, Michelangelo, and many others. Horses in particular received much attention from great sculptors, who received commissions for huge equestrian statues of prominent men mounted on vigorous, high-stepping steeds. Leonardo, with his usual keen delight in all manner of things both living and inanimate, naturally enjoyed these new developments, while other painters and sculptors soon discovered the fascination of making close and accurate studies of dead wild animals in order to understand the living creatures better.

In Belgium, Holland, Germany, and France the art of animal painting was presently to become the fashion among the aristocracy and higher gentry, and as a result scores of animal painters appeared in those countries. Men of high technical skill devoted their time to the making of beautifully painted pictures of both live and dead game, canvases whereon swans, ducks, pheasants, deer, wild boars, and hares are represented in meticulous fashion. Even today their superb textures and color effects are a joy to look upon.

Paul Potter, one of this group, specialized in domestic animals. His celebrated "Bull," an almost life-sized reproduction of a young animal, is beautifully and realistically done, finished to the very last hair and crease of the shining coat, so that the total effect is one of extreme but pleasant realism.

The renowned Flemish master Peter Paul Rubens disclosed a decided flair for portraying animals in violent action and covered huge canvases with scenes of wild but impossible carnage, wherein bears and hounds, wolves, dogs, and foxes, lions, horses, and men all battled furiously for mastery. As might be expected, these pictures were executed in brilliant fashion, but the total effect is neither true nor pleasant. For Rubens with all his skill in figure painting emphatically did not understand animal anatomy or psychology, so that his creatures are awkward, lacking in true character, and badly out of drawing and construction, bringing the master very little credit in any way, even though he apparently loved to do them.

Far to the east, in India, Persia, and China, where animal painting, modeling, and weaving had flourished for ages as a branch of art, they usually assumed a certain decorative quality, even though the Chinese and Japanese masters produced many seemingly realistic pieces. The Persian and Indian rulers were great devotees of sport and often directed their artists to immortalize their feats in stone or wood, in fabrics and rugs, in jewelry, armor, and pottery, or in lovely water-color miniatures. Many of their gods and lesser religious deities also possessed animal attributes, so that we have today endless objects of Eastern art wherein animal forms are employed as symbolical features in the general scheme.

Nevertheless, as we have already indicated, it was in western Europe that the attainment of true realism in animal portraiture became not only an art movement but also the prevailing fashion. So great a number of more or less gifted men became enthralled by this fascinating study that the European market became almost swamped by the output of sporting pictures, many of dubious merit but holding their own today as historical documents of a bygone time. In England and especially in France there was a tremendous vogue for animal painting. In the latter country, court painters of merit worked assiduously on canvases of hunting scenes and portraits of hunting dogs, coursers, pointers, and retrieving breeds, while in England fox-hunting scenes and portraits of celebrated horses became the rage. It was the heyday for animal painters generally, and they took advantage of their opportunities.

It must be admitted, however, that with the exception of paintings by a few talented men the total effect of all these pictures is somewhat disappointing. They are apt to be incorrect in drawing and though carefully finished (indeed, usually over-

finished) are lacking in true color. It seems strange that even as recently as a hundred years ago the world of art had not quite grasped the full significance or the true appearance of a living animal. There is often a rather *human* quality about most of the creatures represented, as if the artist knew more about human construction and expression than about the lower animal types.

However, a slowly growing realization of this fact is evident in the work of men who began their studies about the middle of the last century. Among these, Edwin (later Sir Edwin) Landseer in England was the animal painter par excellence of his time. A man of exceptional insight and extraordinary technical ability, he portrayed the wild and domestic animals of England and Scotland in a way never seen before. Landseer did many fine pictures of the great Scotch red stags in striking and dramatic action, as well as remarkable studies of dogs of various kinds. He thoroughly understood the anatomy, expression, and psychology of dogs; and while he has been criticized for humanizing them, I myself see nothing in their expression that is in any way out of character. For dogs *do* look (and act) strangely human at times, and we human beings understand dogs as we understand no other animal and thus can read into their looks and actions many of our own psychological peculiarities. Anatomically Landseer's drawings are superb; almost for the first time in recent art we see the bones and muscles of a living creature indicated by a master hand. In color his work was not so good; yet so clever was his technique and so great his knowledge of hair tracts (especially in dogs) that we must marvel at his almost unique ability in portraying these splendid creatures.

Strangely enough, considering his masterful handling of other subjects, Landseer neither drew nor modeled the cat family with any degree of certainty. His well-known lions at the base of the Nelson Monument in Trafalgar Square, London, are not well modeled. They are strangely suggestive of the dog family in their contours, resembling a cross between these two great types. The back line is distinctly doggy, not feline, in its curve; and the faces show, not the hard, scornful features of a cat, but the rather benign and open countenance of a dog. I cite these great bronzes as a shining example of what might be called human limitations in the execution of a work of art. The explanation of their failure is simple: Landseer knew and understood more about dogs than he did about cats. The truth of what I say will become more and more evident to any student of the subject, especially as his growing knowledge of a certain species of animal becomes more firmly fixed in his mind.

In the author's opinion, the French sculptors are the finest portrayers of the feline character. Witness, for example, the work of Bartholdi, whose magnificent lion in the Place St. Jacques in Paris (a replica of the one at Belfort on the German border) is a work of art particularly successful in this respect.

A photograph of this statue discloses the splendid mien and beautifully rendered planes of the semirecumbent creature—an effect made possible only by a deep knowledge of its general character and a trained eye for mass and the effects of light and shade in the open air. Bartholdi also executed our splendid "Statue of Liberty" in New York harbor. Another Frenchman, Antoine Louis Barye, was a true genius in this line. His models of various animal types in more or less violent action have never been surpassed. Working under poor conditions in the old Jardin des Plantes in Paris, he produced a wealth of little bronzes of tigers, lions, bears, elephants, deer, dogs, and horses, to say nothing of more pretentious groups that in many cases included human figures. Except in the case of horses, which he did not understand very thoroughly, no one has excelled him in a grasp of the finer points of animal anatomy and psychology. His "Statue of the Lion and Serpent" (of which there is a replica in Rittenhouse Square in Philadelphia) is a fine example of what is meant in this connection. The massive, ferocious cat, head turned to one side and jaws distended in a terrific growl, is glaring at a snake on which he has just placed his great clawed foot. How well the sculptor understood the psychology as well as the anatomy of this action! For cats do when angry (but perhaps a little afraid) assume just that pose, and Barye was quick to grasp its peculiar emotional qualities. Notice too the small mane, which grows so evidently forward and upward from the focal point on the shoulder, and the equally well understood hair, on the face and body. All in all, it is an expertly conceived and executed work of art, well constructed, distinctly feline in every way, and modeled in the best manner with due deference to all the planes and contours.

Frémiet, another very able animal sculptor, made splendid groups of animals and men. His "Prehistoric Man and Bear" group is full of life and ferocious energy. The great, upright brute clasping the man in a death grip is prepared to destroy him by a terrible bite across the head and neck. From the bent-back body of the man hangs a dead bear cub, its hind feet dangling awkwardly on the ground. Not only does the small animal give a reason for the struggle, but it connects the man's form with the ground in a very clever manner. Besides many large groups, Frémiet also made equestrian statues and designed elaborate dinner services for the Sèvres porcelain factories. His smaller works in bronze, stone, and other mediums are too numerous to mention. Our impression of this quiet, unobtrusive man is that he was a tremendous worker carefully trained in his art. His boundless energy and brilliant execution delight the eye of the serious art student.

Richard Friese, a German painter of the last century, was also a master in his way. He was a real student of animal anatomy and possessed a great knowledge of it. His work combined both action and detail to an extraordinary degree. From a critical standpoint, it is overdetailed in many cases, and the color in

his pictures is not charming. However, we are indebted to Friese for his exposition of the finer qualities of animal portraiture and may forget his slight leaning toward almost photographic delineation.

Liljefors, a Swedish painter of the last century, must be mentioned here. His productions at times have much the same meticulous finish as is found in the work of the German painter; but we may also enjoy the wonderful charm and accuracy in his renderings of bird life—great white-tailed sea eagles pouncing upon sea-ducks, hawks at nesting time, or the big European grouse booming out his challenge from the vantage point of some lofty pine branch. All are superb studies of splendid wild creatures, beautifully finished and painted and displaying excellent coloring and texture. Truly he was a great bird painter, one who combined picture-making ability with deep insight into the actual forms, psychology, and actions of his models. Artistically the style is lovely in every way. It is regrettable that his work is so seldom seen in this country.

In England after Landseer's time there arose several men of note who specialized in animal painting, among them John Millais (son of Sir John Millais), an expert hunter, naturalist, and bird lover, who devoted most of his life to the study and delineation of wild things. He wrote extensively and illustrated books on British birds and the game animals of England and Africa.

John Swan created many pictures, usually in fanciful vein, of men and animals in more or less sylvan surroundings. A lovely example shows Orpheus with his lyre, charming the wild beasts of the forest. In Swan we see an artist whose approach to animal painting is at variance with that of practically all the men whose work has been mentioned. True, a certain amount of realism is apparent in many of his pictures, but primarily Swan employed animal forms and colors as interesting details in a general scheme and was therefore concerned not so much with the anatomical features of the subject as with the texture, patterns, colors, and artistic ensembles of his models. In other words, animals as individuals were not especially interesting to him, nor was their inner character of any particular moment. The effect of this viewpoint is very apparent in his work. His animals have a sort of disembodied quality, with a surface finish of great beauty, but as animals they hardly seem to exist, except in a superficial way. Swan's artistic efforts are of a very high order, and he stands as a brilliant example of an unusual phase of animal painting.

Let us retrace our steps as far as our own country is concerned in order to consider here a very remarkable man, John James Audubon. This talented artist, about whom we have heard much in recent years, was a most unusual personality and a man of extraordinary physical strength, zeal, and persistence. His work, often done under extremely difficult conditions, exhibits a skill and faithfulness of execution seemingly impossible at the time of its conception. When one considers the primitive facilities for travel in this country during his lifetime, the wonder continues to grow. The fact that no photographs were available with which to fix the image of a bird or mammal in the artist's mind renders his accomplishments astonishing in the extreme. He was primarily a lover of birds, though all animal life stirred his imagination to a high degree of enthusiasm. Most of his studies, usually done in water color, are preserved in the collection of the New York Historical Society; a visit to that institution will be of great interest to art students.

Audubon was a pioneer in his work, a zealot in his attempts to put down on paper or canvas his impressions of all types of living things, particularly the forms, patterns, and colors of the bird life of this country. However, there are from a purely critical standpoint many artistic and scientific lapses in his work. We as a nation are prone to overglorify our great men, but this attitude should not prevent a true appraisal of a man's work when viewed from a strictly professional standpoint. Audubon's art instruction was no doubt of the most meager description. He was not a person who accepted criticism easily but rather an individualist of the first water. Perhaps all in all it was better so; otherwise, he might have been persuaded to change his methods, and we should have lost something of even greater value artistically. One of the fairest criticisms that can be made of his work is to say that he often missed completely the true and always characteristic profiles of many of his larger birds and thus lost at once the most essential part of any bird portrait. His great blue heron is a good example of this fault: the bird is simply not in the pose taken by that species in life. His flamingo is another of these failures, partly no doubt because of Audubon's desire to fit a very large object into a small space. Whatever the reason, the results are not satisfactory, either from an artistic or a scientific viewpoint. Often though not always his composition is poor. He was not an expert in values, with the result that many of his pictures are extremely flat in effect. A black bird such as a raven could not be the same strength of black all over owing to the effect of light and shade on the body mass; yet Audubon's raven panel certainly has this defect, and thus much relief and roundness are lost while at the same time the true life character of his model is destroyed. Had Audubon been better informed on these important art principles, his work would without question have been of vastly better quality. And we may attribute to the same cause the curious lapse already referred to, viz., missing the true profile outline. We know (because he tells us in his diaries) that after a bird was shot he propped it up as best he could with wires or other supports and that from this dead model he made his sketches. This, of course, was a dangerous method unless he had first made many studies from the living creature in order to catch its true life poses. No one, not even Audubon himself, could overcome such a lack of insight into the very first principle of

any representation of a living creature.

It might be inferred from this somewhat detailed criticism of Audubon's work that the author is not an admirer of this extraordinary man. On the contrary, he is tremendously intrigued by the force and variety of the paintings, which also exhibit a certain exquisite delicacy. Added to this is the all-important fact that Audubon was the first man to the author's knowledge who saw the necessity of working directly from the wild models. By this means he saw and set down the skin and eye colors and the perfectly formed feet, legs, and bills of the bird life that he loved so well. His contribution to art therefore, while deficient in many ways, has done more than perhaps the work of any other man to stimulate a keen and intelligent interest in the variety and beauty of the unfettered creatures to be found in a state of nature. For this inspiration, as well as for the splendid example he set of hard work, personal sacrifice, and immense enthusiasm, animal lovers will always be indebted to him.

To resume our brief survey of men who have contributed much to the art and science of animal painting, we may mention Wolf, a German by birth but long a resident of England. He is favorably known for his many studies of birds, but he painted mammals as well. Much of his work was done for large monographs on bird life, notably the pheasants, birds of prey, birds of paradise, and many other types, all executed with great knowledge of feather tracts and general construction. His pictures are well composed and very interesting in conception.

There were in Europe during the later nineteenth century many fine animal painters, for example, Troyon, Rosa Bonheur, Van Marcke, Mauve, and many lesser artists in France, Germany, Switzerland, and other countries. Troyon painted cattle by preference. Rosa Bonheur, one of the few good woman painters of her time, essayed some very large and brilliantly painted canvases. The best known of these is the "Horsefair," a huge picture some twenty-five feet in length showing a group of powerful Percheron stallions. The drawing of the great creatures is very fine and the composition excellent. Rosa Bonheur did many other types of domestic animals, dogs, sheep, cattle, and occasional lion pictures. In this latter type she was not at all successful, seeming not to understand the anatomy and construction of the big cat, though she was at one time the owner of several lions and must have studied them carefully. In order to save herself embarrassment in a day when women were supposed to be homebodies, she often assumed the trousers and jerkin of a man. As she had strong features and wore her hair short, she probably easily passed for a man in her numerous visits to stables and farm buildings, where many of her studies were made.

Van Marcke, a Dutchman by birth, has given us beautifully painted pictures of cattle in his own home fields. The placid brutes are always finely drawn, and the color of his panels is very lovely.

Anton Mauve, another excellent painter, did many rather small sheep pictures, usually of flocks with a man and a dog to keep guard over them. Mauve was a most accomplished painter; his values, color, and general drawing are of the highest order, so that his paintings, though simple in subject, are little gems of art work.

It should be remembered that the men just mentioned were well-known artists, highly skilled technically and able if they wished to paint and draw anything in a most beautiful and satisfactory way. The animals in their pictures were never too prominent or overdetailed in technique. Rather were they considered as part of a carefully thought out composition, a point of interest in the general landscape.

The art of animal painting was at a low ebb in this country during the closing years of the last century, but there were a few young enthusiasts, especially Louis Agassiz Fuertes, who was later to go far. Primarily, Fuertes was intensely interested in birds as objects of beauty and grace, but he had the true naturalist's flair for the close study of all their physical and mental characteristics. He was a fortunate man in the time and circumstances of his art career. Since Audubon, there had been no really good painter of birds in America, and both scientists and bird lovers in general welcomed this ambitious young man as the logical successor of Audubon. Fuertes was almost literally groomed for this exacting role. As later events proved, he was an excellent choice, surpassing in his attainments the hopes of even his most enthusiastic advocates. Backed by the sincere admiration of his scientific friends, all men of great influence, he embarked upon a career of bird painting that promised to equal if not to surpass that of the great Audubon himself. He was greatly aided on the artistic side by his acquaintance with Abbott H. Thayer, the noted portrait painter, a man of most delicate perception and highly trained observation. Under his guidance, Fuertes's work improved immensely; the subtle values were much enhanced, and the complicated problems involved in protective coloring were explored in painstaking detail. It is not a matter for wonder, then, that Fuertes, blessed as he was with great natural talent, stimulated by the very finest sort of criticism, should have produced some remarkably good studies of bird life during a period of twenty-five or thirty years.

In composition, however, Fuertes was certainly not inspired, though at times he attained some remarkably effective groupings. His grasp of the construction and bulk of the larger mammals especially was often distinctly at fault. A lack of general training in drawing and painting, as with Audubon, was evidently the trouble here, and his eyes though remarkably keen in most cases did not seem able to observe the rhythm and power of a big mammal. He was not then, one might safely say, a picture painter in the accepted sense of the word because of the peculiar and difficult lines of work that he seemed impelled to follow. His knowledge, however, of what a bird actually looks like was comprehensive; the details of eyes, beaks, feet,

legs, and general lifelike appearance in respect to feather patterns, color, and accurately drawn feather tracts are of exceptional perfection. Both he and Audubon are outstanding examples of ability combined with intense enthusiasm and a desire to portray in detail the extremely complicated and difficult models in the world of bird life.

It is well to note the important fact that Audubon and Fuertes were specialists in their line, a position taken by many devotees of animal painting, probably because the subject is so vast, requiring an immense amount of knowledge and study. Any detailed rendering, for example, of the birds of North America, is in itself a lifework, and the same applies to those of all the other continents. For most of us (a fraternity of persons interested in the subject as a whole), no such specialization may be necessary. There will always be men who do follow certain restricted lines of work in every form of art because they are drawn into such paths by various influences, either internal or external. Subtle leanings and preferences guide most of us unconsciously in our daily lives; it is not surprising, therefore, to see the artist displaying a preference for special phases of his art, whatever they may be. I believe, however, that every artist, no matter what his individual proclivities, should study and learn as much as possible of the general as well as the particular phases of his profession in order to do his best in any special line. In other words, sound academic drawing of all objects, be they plaster casts, human figures, animals, or landscapes, is a prime necessity for all of us. Painting, its color qualities, light and shade, atmosphere, values, and all the other things that go with this section of art work, should of course be studied constantly. Composition, an enormously important part of art work, necessarily should occupy much of our attention, and the various mediums best suited for certain types of impression should be understood and experimented with.

In my own work, a specialty if you will, I have come across many men who are so woefully lacking in general artistic knowledge that their specialties never advanced beyond the limits of the commonplace. Who among us does not realize sooner or later that had he studied art in general more extensively it would have helped him vastly in his chosen line? Nevertheless, we must not lose sight of the fact that, while a general knowledge of art is admittedly a prime factor in one's work, yet so great is the subject that those of us who do narrow down our production to a given branch will again be called upon to give much attention to the acquiring of information in this special field. No painter, sculptor, designer, or decorator who employs animal forms as the principal phase of his art expression can afford to be without a knowledge of the construction (both bone and muscular) of his various models. The difficulties of wing form and make-up, the hairy covering of animals and the complicated feather tracts of birds, as well as the strange forms of fishes and invertebrates—all these are the problems of everyone who essays the delineation of animal life.

In the pages of this volume, the author has tried to present in the simplest form possible at least some of the answers to an always difficult proposition and at the same time to instill into the reader the enthusiasm for his work without which all art must eventually deteriorate into flat and uninteresting mediocrity. We must remember that we are faced with a very difficult but fascinating problem when attempting the study of animal life and that in order to attain even a modicum of perfection we must realize that a tough job lies before us. Without hard work, constant application and study, and a proper reverence for the beauty of created forms, we shall not be able to reach our objective. That the results of his long life of application may be of service to students of animal life in general is the hope of the author of this book.

Mammals

The word "mammal" is intended to convey the image of a warm-blooded, four-legged creature, usually covered with hair, and capable of most diversified size and proportions in the different species. Man himself belongs to this group, or order, of living things; but he and occasionally the higher apes walk not on all fours but erect on the hind pair of limbs, the arms being comparable to the forelegs of the rest of the mammalian order. As a consequence of this change of posture, certain anatomical features of man's make-up have altered slightly from the usual plan. Chief among these is the position and shape of the *shoulder blades*. In four-footed animals these bones stand almost upright or lean slightly inward in a normal pose—and are of great importance in the silhouette of the body, from either the front or the side view. In man, however, they lie across the back, being barely visible on the side profile, and are completely hidden when regarded from the frontal position. Apparently because of this (to us) unusual skeletal variation there is apt to be a certain vagueness in the mind of the student as to just how he should indicate the shoulder blades when he attempts to draw an animal. It is well to keep in mind as a guide to one's memory that most mammals walk on the toes of both their front and hind feet, in contrast to man, whose heels are planted firmly on the ground in walking or standing. Bears too exhibit a phase of this unique structural feature and are therefore able to stand and walk, on occasion, much after the fashion of a man, though it is of course not their usual mode of progression. A realization of the foregoing facts will be of great assistance in future study and will help to clarify many otherwise puzzling problems in animal anatomy. As we are now to observe the particular forms and peculiarities of various species and groups of mammals, it will be as well to emphasize the advantage of a certain method in our approach to the subject.

For the purpose of the artist, a profound knowledge of the deeper muscular anatomy is not absolutely necessary, though some of us may find pleasure and profit in such a line of research. What we should all like to know, however, is the general structure and proportions of the bony skeleton and the principal overlying sets of muscles that cover it at almost every point and control the actions of the bones themselves. The proposition before us really resolves into four or five divisions in the case of most of the animals under discussion, of which the following are typical examples.

1. The bony structure—its proportions and characteristic attitudes in the different species of animals.

2. The principal muscles and tendons covering this skeleton —their shapes, sizes, and general functions.

3. The actual appearance of a given animal in life—its color, hair disposition, and character—and the effect of the underlying structure on the exterior as a whole.

4. The psychology of the animal—a very important feature, for without accurate knowledge on this point we are unable to visualize properly the creature as a living emotional entity. Each species will naturally exhibit its own peculiar attributes in this respect.

5. The artistic possibilities of certain animals, some species being wonderful in color, others in form, still others in mere picturesqueness or grotesque qualities.

Animals are all solid, three-dimensional, animated beings and must be so regarded by the artist and treated accordingly in his paintings and models.

Great Apes and Other Monkeys

First and foremost among the mammals by reason of their close resemblance to man, both mentally and physically, are the great apes, who occupy a unique position in the animal world. Gorillas, chimpanzees, and orangutans are all most interesting creatures, highly developed on the mental plane and almost painfully like us in their skeletal and muscular anatomy. Outstanding among the group for size, bulk, and dramatic appearance is the great brute known as the gorilla. Found only in two or three highly restricted regions of Africa, this massive animal was long regarded as a more or less mythical being, and weird tales of its strength and ferocity were related by numerous travelers to the Dark Continent. They seem rather shy and retiring creatures in their heavily forested habitat in Africa, and the family usually consists of but a few individuals, an old male, a female or two, and perhaps several young. The males are truly enormous, weighing when adult as much as 500 pounds. As they mature, they become suspicious, morose, and at times aggressive.

At present there are several splendid male specimens in captivity, notably the great gorilla Bushman in the Lincoln Park Zoo, Chicago. A glance at my drawings of this beast will bear out my contention that for general devilish and sinister appearance he would be hard to surpass. Also, one sees how very manlike is his general anatomy, especially in the squatting position. The huge crest at the back of the head is characteristic of the adult male, and the thick, enormously powerful body and arms are well shown. The standing position, however, is not especially human; for he is resting on all four feet, the usual mammalian attitude, and furthermore he is supporting himself on the knuckles of his hands, the short thumb not touching the ground. The gorilla can and quite often does assume the erect position characteristic of man, but in this pose he is unable to remain upright for any length of time and is not fully able to step boldly forward from the hips but instead shuffles about in a very awkward and inefficient manner. Note also the widely splayed great toe on the hind foot, set off so boldly from the other four digits.

Incidentally, after several harrowing experiences with this dour individual I can assure the student that in drawing some of these savage and morose creatures one really becomes a martyr to the cause of art. Fortunately for the public, a thick glass screen serves as a protection from the shower of fruit, vegetables, and everything else movable that issues from Bushman's cage whenever he is annoyed or irritated. This deplorable condition is becoming chronic with him as he grows older. During my last visit, I was obliged to draw him from the front of his cage instead of at the back as formerly. He was indeed a most alert, cranky, suspicious beast, and really dangerous too, rushing at me when I approached the bars, beating his great breast with his powerful clenched hands, and hurling or rather pushing out at me with lightning speed everything he could find at the moment. It was a nerve-racking experience, and one I shouldn't care to repeat.

Chimpanzees from Africa and orangutans from Sumatra are also dour and dangerous creatures as they mature. Naturally, they haven't the potential power of the gorilla, though they are perfectly able to injure one very severely, even fatally, if so inclined. Chimpanzees, however, while young can be trained to do any number of wonderful and interesting tricks, and their actions and expressions are so delightfully manlike that nothing else on earth can quite compete with them as a public attraction. They laugh, cry, scream, make talking noises, and perform trapeze and other extraordinary exercises with speed and precision. Such monkeyshines are all accomplished with a very good grace and evident enjoyment on the part of the clever brutes, so that the spectators' feelings are in no way outraged.

Chimpanzees walk on their hind legs with greater facility than the gorilla, but the usual gait is still on all fours. The legs in all the species—gorilla, chimpanzee, and orangutan—are much shorter than those of a man, and the arms longer, as befits a tree-living animal; but in general construction they are all exceedingly manlike, and your knowledge of human anatomy will be of great help in drawing them. Orangutans in the wild state are almost completely arboreal, seldom or never coming to the ground. They make huge nests on platforms in the trees and pass their entire lives feeding on the fruits and leaves by which they are surrounded.

Quite different from the preceding species are the baboons—those sinister, bizarre, ferocious creatures which live on the rocks and in the forests of certain parts of Asia and Africa. In some forms the males are brilliantly colored on part of the face and body, a decoration that gives them a strange and terrifying appearance. The male mandrill, for example, has two intense blue pieces extending on either side of the long doglike nose, the tip of which is a magnificent scarlet shade. This supertinted mask is more than matched in glowing effect by the opposite end of the animal, where lovely hues of violet, carmine, turquoise blue, and yellow vie with each other to create the most fantastic posterior known in all the realm of animal life. This color is of course not hair color but the skin itself, which appears on close inspection to be covered with a pastel-like film. The pigment, however, is really beneath the first skin layer and is guaranteed not to fade. Still other species of this singular race

are equally strange in form and color, but they are all fierce, alert, sagacious brutes, habitually walking on all four legs and running in large groups, presided over by the powerful male animals.

Other species of the monkey family, while differing greatly in size, color, and length of hair and tail, are not specifically different anatomically from the preceding types.

Certain races, however, such as the spider monkeys of South America, possess long prehensile tails, which they use as a fifth arm and hand, swinging through the branches of trees with the utmost ease and speed.

Naturally, all the members of this highly developed family are of the greatest interest to us because of their near relationship to the human stock. In their diversified silhouettes, proportions, and manlike emotional attributes we see grotesque and caricatured presentations of our own personalities.

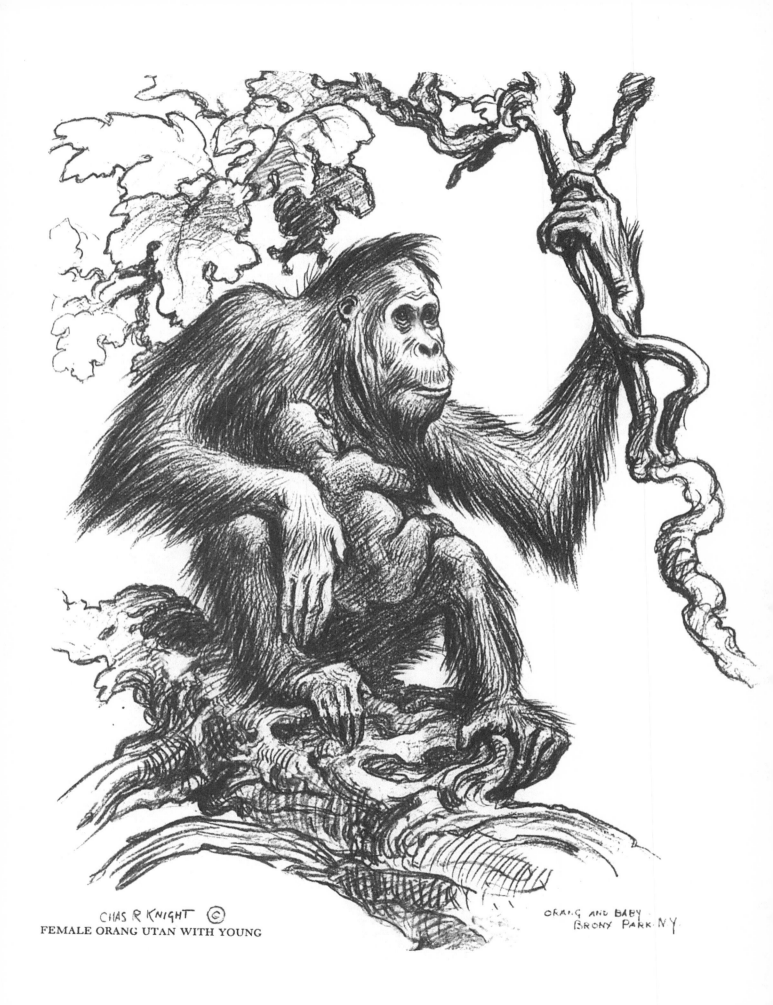

CHAS R KNIGHT ©
FEMALE ORANG UTAN WITH YOUNG

ORANG AND BABY
BRONX PARK. N.Y

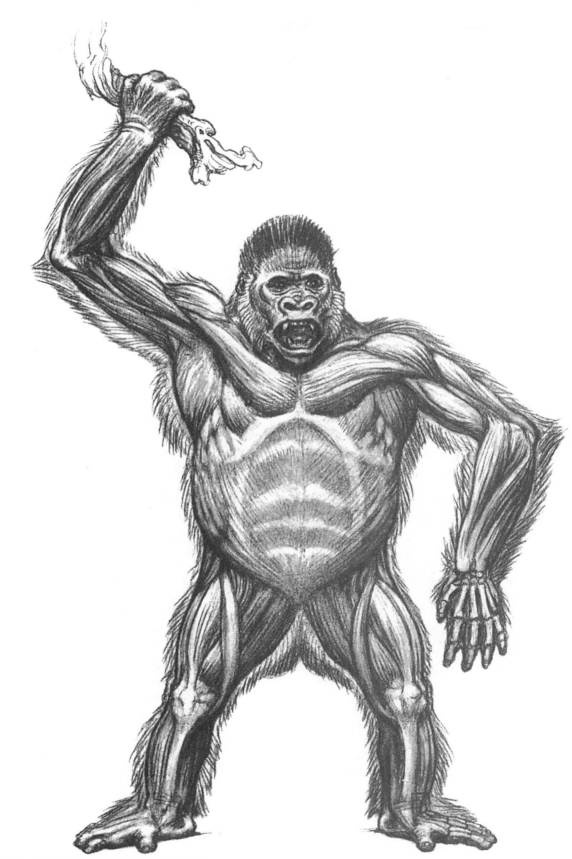

MUSCULAR ANATOMY OF MALE GORILLA

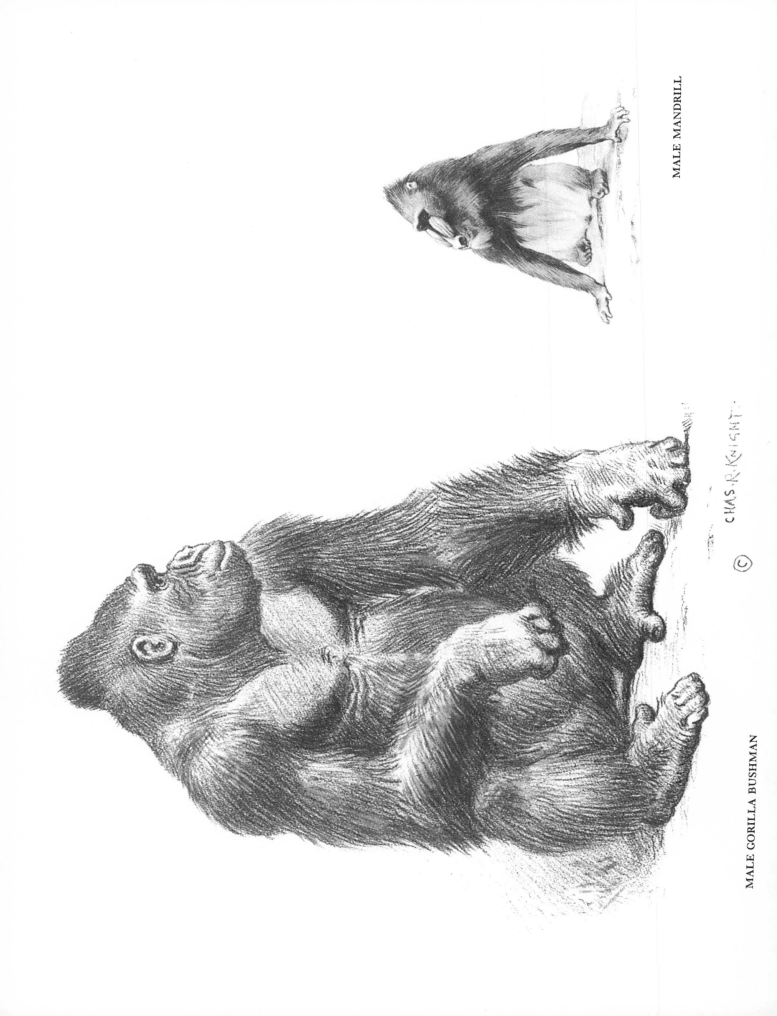

MALE MANDRILL

MALE GORILLA BUSHMAN

CHAS. R. KNIGHT

The Feline Group

The wonderful class of mammals known as the "Felidae" are represented throughout the world by numerous species differing greatly in size and color but all singularly alike in character. As a type, they have great interest for the artist because of their striking color patterns and the grace, power, and ease of their movements. They are without exception flesh eaters, or carnivores, securing their prey by stealth and killing it in one quick rush by means of their sharp claws and long canine teeth. The sense of smell is not particularly well developed in the cats, but their vision and hearing are very acute under certain conditions. As examples of power and grace combined with fierce and intractable dispositions they are almost unique in the animal world.

All the cats, with the possible exception of the lion, are very lithe, capable of twisting their bodies into all manner of strange and interesting positions under the stress of fear or anger or in the pursuit of prey. Their movements are always subtle and complicated, so that they make difficult models for one not accustomed to analyzing their actions. Fortunately, in our common house cat we have a perfect representative of the whole family, one who in every motion, action, and reaction is identical with all the other members of the group. This is a good point to remember when one is called upon to paint or model any individual of the class. We may be sure that each movement of our favorite tabby can and will be duplicated by the greater members of the family. If Puss licks her paws in a certain way, or hungrily crouches in rapt attention at the approach of a victim, then the lordly tiger himself will assume those same positions under the urge of similar emotions. Study your house cat therefore in all its varied positions, and you will be surprised to note how much these observations will assist you in your understanding of the group as a whole.

All the large cats pace when walking, *i.e.*, they advance both the fore- and the hind leg of one side at the same time. Their movements are then deliberate, graceful, and undulating because of the soft and flexible muscles which ripple and glide under the bright and shining fur. Angularity is distinctly not a characteristic of the family, and we should be careful never to impart this quality to our drawings of the beautiful creatures. There is power behind all their actions, however—power, and in the case of the lion and tiger a certain ponderous and assured something difficult to describe.

Owing to the protective coloring of most of the cats, both the general form and the muscular anatomy may be very much concealed by the maze of stripes, spots, and irregular markings that constitute a great number of their skin patterns. For this reason it is advisable for a novice to study the lion and the puma, whose almost monotone coloring discloses the muscular form to advantage.

If the family, as a whole, are deliberate in their more serene moods, they can on occasion move with tremendous speed and agility. In springing on its prey or fighting with an adversary, no other animal quite compares with the cat in ferocity and violence. Under these emotions the creature seems transformed into a veritable demon, as with claws unsheathed and jaws distended it hurls itself upon its adversary. Perhaps nothing in the whole realm of animal creation can vie with an angry tiger for sheer terrifying effect, as at such times the long, sharp fangs are bared, the ears are laid back, a greenish fire glows from the eyes, and snarls issue from the mighty throat.

To anyone who has not observed the cat in all its transient moods the changes in expression caused by different emotions are well-nigh incredible. For those of us who specialize in such things nothing is more thrilling than to witness one of these physical exhibitions. But, as artists, we must be prepared to analyze just what happens in the creature's anatomy so completely to transform a quietly beautiful and relaxed feline. A glance at the drawings that illustrate these points will help more than any verbal description to clarify the problems presented.

In contrast to the dog or canine family the cats grasp their prey with the sharply curved claws of the front feet, and this peculiarity gives a decided and unusual character to their feeding and fighting poses. This is one of the points to be looked for in a study of animal life—these differences in construction that alter so tremendously the attitudes and customs of one type as compared with another. The crouching and creeping motions of a cat are of outstanding interest to the animal painter since they seem to exemplify the very soul of the beast in its search for prey. At such times the body is pressed closely to the ground, and the animal advances by a series of stealthy movements of the limbs until the game is within reach, when, with one tremendous leap, the hunter pounces upon its victim, seizing it with both teeth and claws and killing it when possible to do so. However, should the spring be unsuccessful and the quarry free itself and dash for safety, the affair is finished, for the cats cannot and will not run after the prey unless it appears to be badly hurt or temporarily helpless. None of the feline family, with the single exception of the cheetah, seem fitted for pursuit in the sense that a dog or wolf tracks down a deer or other game. Indeed, they soon become breathless and are easily discouraged by a failure to accomplish their object at the first

rush, while their running speed is very inferior in comparison with that of most wild animals.

It may easily be gleaned from the foregoing how many things are to be looked for and appreciated if we are even roughly to understand the movements, form, and character of any given species of animals. This must not discourage us, however, in our search for the truth. On the contrary, it should make achievement in this field all the more interesting. Closer study of the splendid creatures of the plains and forest can only fill us with enthusiasm and zest for a still greater knowledge concerning all living things, with their application to art in its multiple phases.

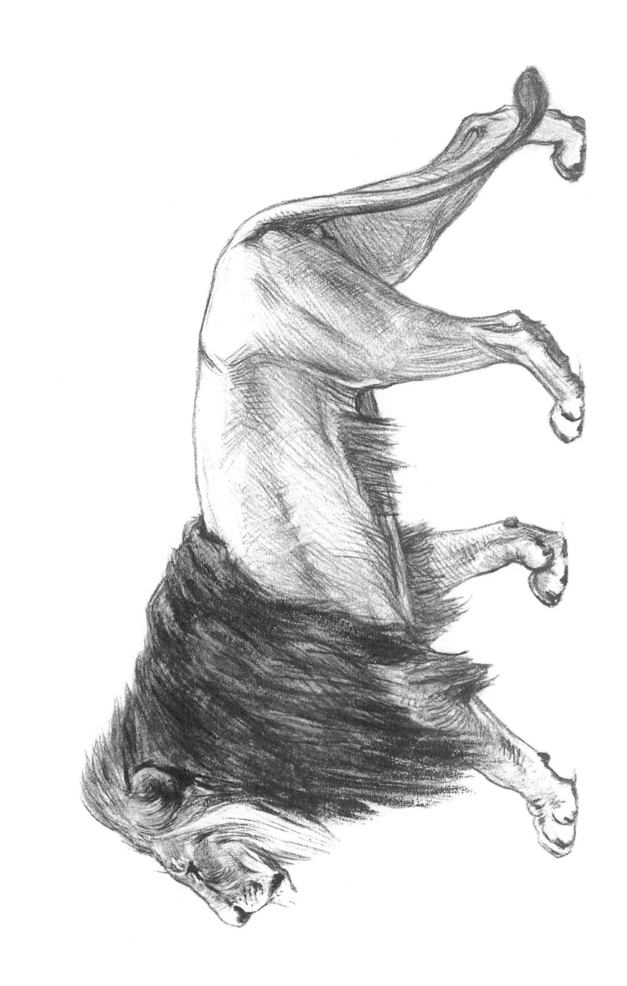

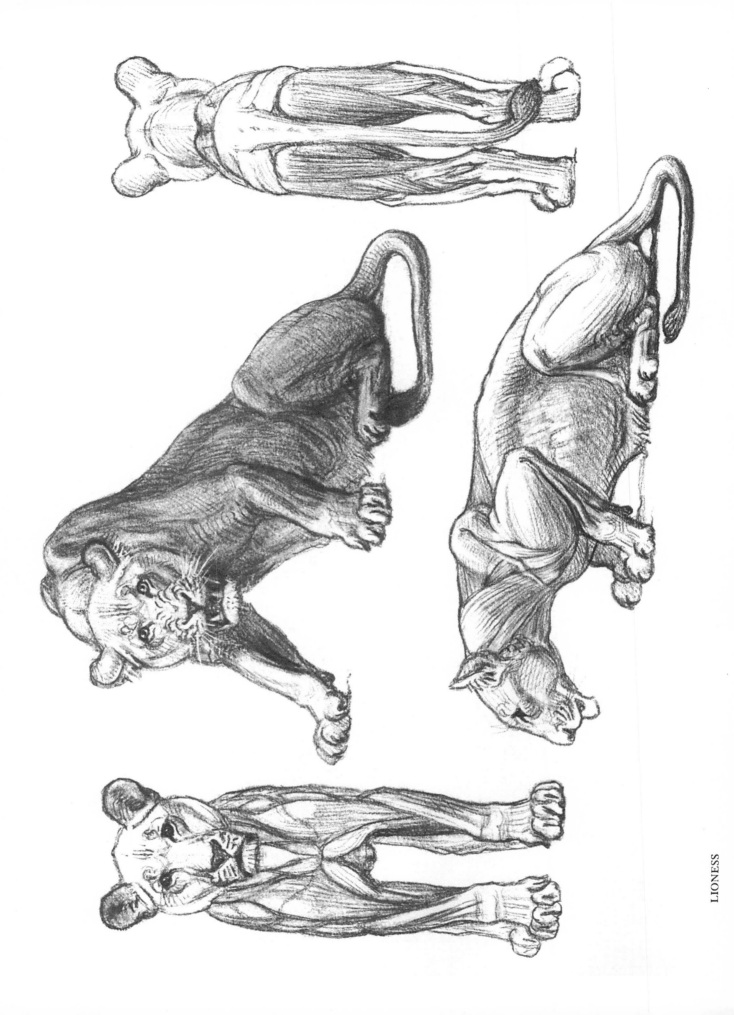

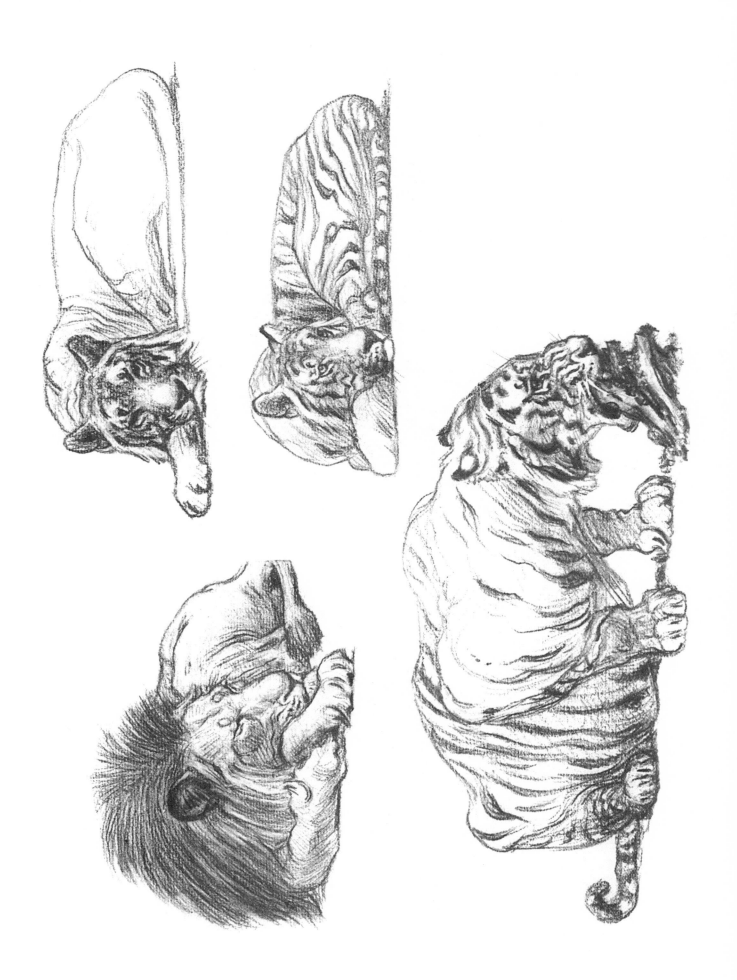

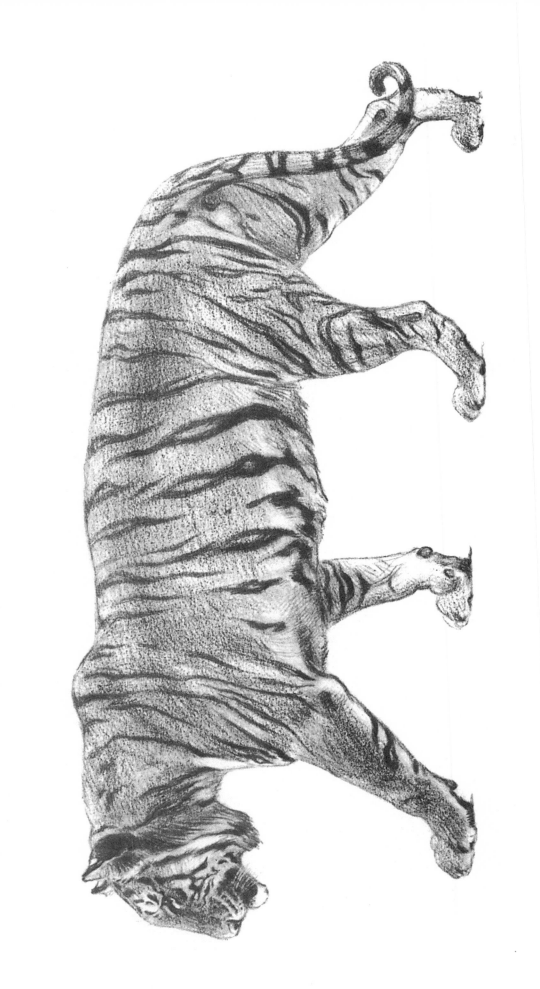

BENGAL TIGER

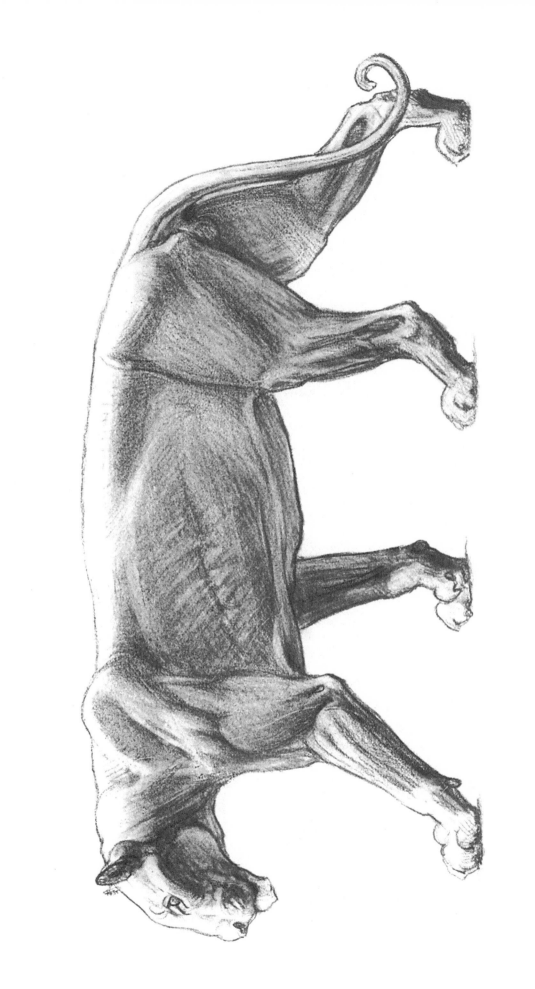

TIGER, SHOWING PLANES

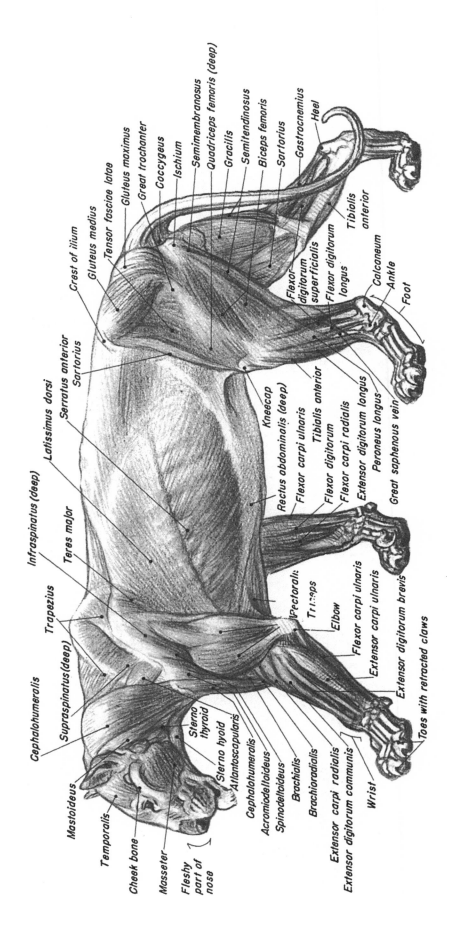

Cephalohumeralis

Infraspinatus (deep)

Latissimus dorsi

Serratus anterior
Sartorius

Crest of ilium

Gluteus medius

Tensor fasciae latae

Gluteus maximus

Great trochanter

Coccygeus

Ischium

Semimembranosus

Quadriceps femoris (deep)

Gracilis

Semitendinosus

Biceps femoris

Sartorius

Gastrocnemius

Heel

Tibialis anterior

Flexor digitorum superficialis

Flexor digitorum longus

Calcaneum

Ankle

Foot

Kneecap

Rectus abdominalis (deep)

Flexor carpi ulnaris

Tibialis anterior

Flexor digitorum

Flexor carpi radialis

Extensor digitorum longus

Peroneus longus

Great saphenous vein

Teres major

Trapezius

Supraspinatus (deep)

Mastoideus

Temporalis

Cheek bone

Masseter

Fleshy part of nose

Sterno thyroid

Atlantoscapularis

Sterno hyoid

Cephalohumeralis

Acromiodeltoideus

Spinodeltoideus

Brachialis

Brachioradialis

Extensor carpi radialis

Extensor digitorum communis

Wrist

Pectoralis

Triceps

Elbow

Flexor carpi ulnaris

Extensor carpi ulnaris

Extensor digitorum brevis

Toes with retracted claws

TIGER—MUSCULAR ANATOMY

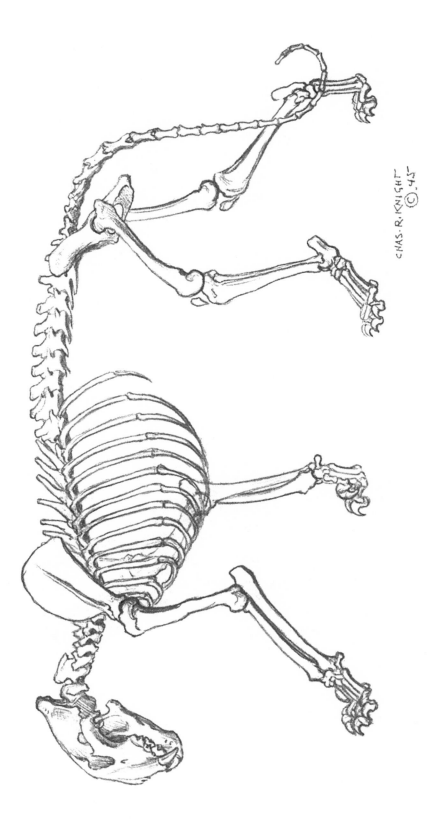

CHAS. R. KNIGHT © 45

TIGER SKELETON

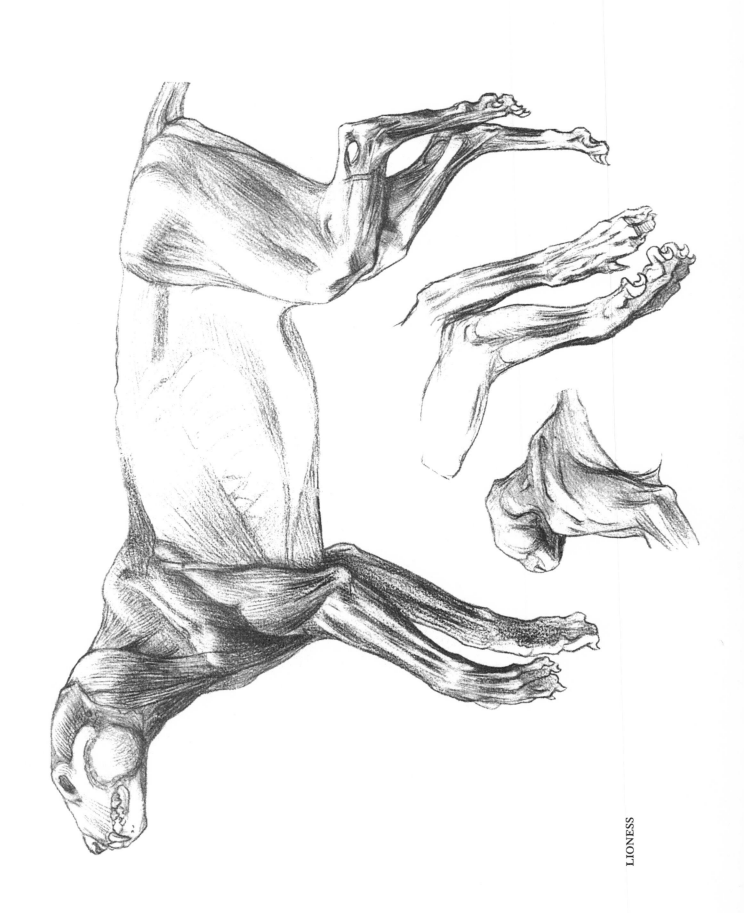

LIONESS

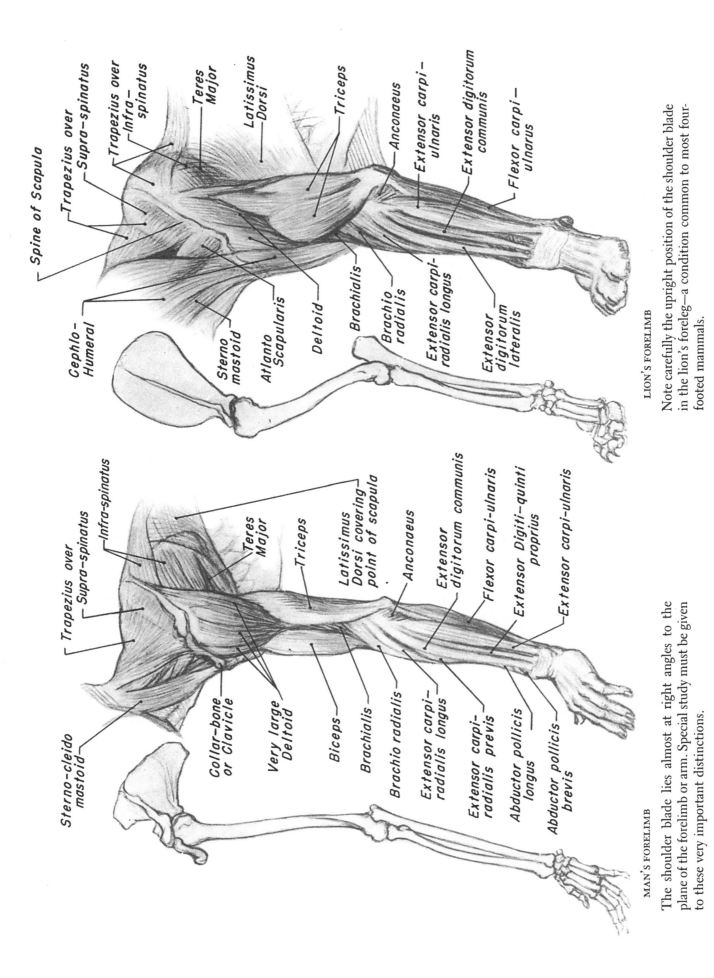

Spine of Scapula

Trapezius over Supra-spinatus

Trapezius over Infra-spinatus

Teres Major

Latissimus Dorsi

Triceps

Anconaeus

Extensor carpi-ulnaris

Extensor digitorum communis

Flexor carpi-ulnarus

Cephlo-Humeral

Sterno mastoid

Atlanto Scapularis

Deltoid

Brachialis

Brachio radialis

Extensor carpi-radialis longus

Extensor digitorum lateralis

LION'S FORELIMB

Note carefully the upright position of the shoulder blade in the lion's foreleg—a condition common to most four-footed mammals.

Trapezius over Supra-spinatus

Infra-spinatus

Teres Major

Triceps

Latissimus Dorsi covering point of scapula

Anconaeus

Extensor digitorum communis

Flexor carpi-ulnaris

Extensor Digiti-quinti proprius

Extensor carpi-ulnaris

Sterno-cleido mastoid

Collar-bone or Clavicle

Very large Deltoid

Biceps

Brachialis

Brachio radialis

Extensor carpi-radialis longus

Extensor carpi-radialis previs

Abductor pollicis longus

Abductor pollicis brevis

MAN'S FORELIMB

The shoulder blade lies almost at right angles to the plane of the forelimb or arm. Special study must be given to these very important distinctions.

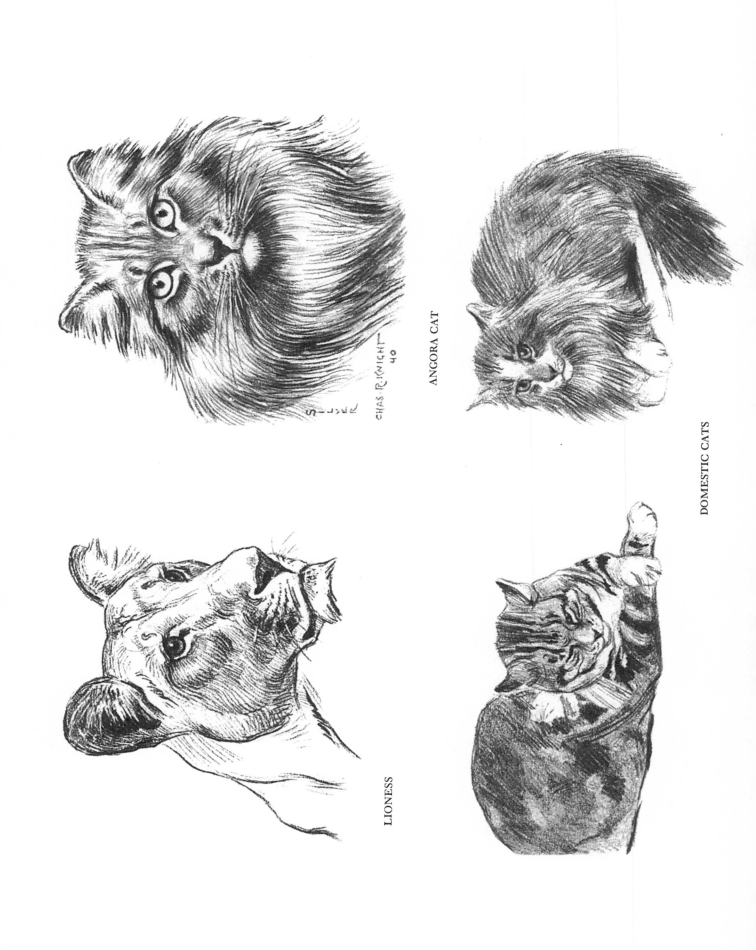

ANGORA CAT

DOMESTIC CATS

LIONESS

CHAS. R. KNIGHT
40

Tiger Heads: at Rest and in Action

We have referred more than once to the profound changes in expression that may occur in many animals under certain emotional conditions. In no other class of mammals is this more clearly demonstrated than among the various members of the feline family. It will not be difficult for even a layman to recognize this extraordinary transformation, but the necessary physical adjustments that produce the effect are difficult to understand. As artists, however, it will be our task carefully to analyze and to put down the salient characteristics of the phenomenon in order to produce even a modest replica of what has occurred so completely to alter the animal's entire physiognomy. Naturally, the emotions of a creature so far below the human standard of mentality are not particularly varied or subtle in their manifestations. Nevertheless, they seem to exert a profound control over the physical make-up of these animals. For this reason, I have chosen to illustrate two common but widely different expressions that one associates with all the members of the cat family, viz., the serene, mildly interested attitude and that of the same creature when alarmed or angry. Front and side views are presented in order to clarify the written description. As all the cats are true carnivores, they are provided with both claws and teeth with which to seize and hold their prey or to destroy an adversary. In anger they display their fighting equipment to the best advantage, and in their own peculiar way. Even our own favorite house cat will exhibit these astonishing expressions to a marked degree, but the small size of the animal makes it difficult to see clearly just what is taking place in the disposition of the various features associated with these changes. Much more clearly defined will be the same emotions in their effect on the physical appearance of an animal as large as a tiger. For that reason, I have chosen him as a model.

In repose the great brute is undoubtedly a splendid example of complete relaxation. If he is resting with head raised and not at attention, the lustrous eyes may be more or less closed, the ears somewhat raised, and turned backward so that their *inner* surfaces are visible, the long lip whiskers also directed backward, and the mouth shut. If he is interested in some object, the ears will be turned forward and the eyes more fully opened but the position of the mouth and whiskers will remain unchanged. We may judge from this attitude that all is serene. Yet in a flash all this can be changed. Something has disturbed or angered the surly creature, and everything about him responds to that impulse. Back and down go the once upright ears, folded closely against the arching neck, their top and *outer* side now in full view. The great jaws open, displaying the four sharply pointed glistening canines; the tongue is curled in an S shape at the back of the mouth; and the whiskers turn sharply forward around the muzzle. Great creases appear about the contracted lips and down either side of the fleshy nose. But it is in the eyes that one glimpses the savage character of the animal, for now these burn with a truly terrible and menacing fire.

If the reader concludes from the above that the effect is overdrawn, I can only suggest that he stand close to and in front of one of the big cats under similar exciting conditions. To understand the construction of a tiger's head and jaws, particularly in the pose just described, is not at all an easy matter. Yet the attitude is very characteristic of all the cat family, and therefore the student is especially urged to study carefully the front and side views depicted. Particular attention should be given to the position and drawing of the teeth and lips; for these parts are very difficult to see, and the teeth are complicated and absolutely set in form, their number, size, and angle of insertion into the gums being constant and characteristic. The flexible lips present another difficulty; their edges and how they enclose the sides of the jaws and teeth will not be easily understood. The peculiar shape of the *lower* lip is to be noted, its actual contour confused by a dark patch of color that occurs in a semicircular form below and behind the lower canine. This is true not only of the tiger but of most members of the family. The lip itself is divided for a short distance at this point, the *inner* part curving about the insertion of the canine, the *outer* part carrying forward in a fairly straight line toward the front of the mouth. This conformation results in a sort of small pocket, which when the mouth is closed receives the point of the upper canine. However, the effect of the very dark patch of color before mentioned will certainly give one the impression that the edge of the lip is curved sharply downward, and it will require the keenest eye to see that it really does not do so.

If I have apparently overelaborated this description, it is because most artists (including myself) are confused by the singular combination of shape and color at a very crucial position on the side of the animal's face. The long whiskers set each in its own depression are, you will observe, disposed in lines, about five in number, on either side of the nose; and the very evident creases over and around this section are caused by the contraction and elevation of the upper lip when the mouth is opened and the upper canines and the small incisors between them are bared for action.

It is my conviction that anyone wishing to draw or model a head of any angry feline should first make a careful drawing of the muscular and bony anatomy of the skull, from both front and side views. By so doing, you will familiarize yourself with

the exact shape, size, position, and number of the teeth and the wonderful construction of the skull itself, with its broad cheek (zygomatic) arches, the high crest along the top of the skull, the great size and shape of the *temporal* muscles lying on either side of this ridge, as well as the rounded mass of *masseter* muscle fitting against the broad plane of the lower jaw—a combination which enables the felines to bite with such terrific power. The nasal region is also to be examined, when the junction of the bony section with the fleshy part of the front of the nose will be better understood. You will also note, of course, the characteristic shape, position, and angle of the eye sockets with reference to the rest of the bony structure.

It will not be a waste of time to cover carefully all the points to which your attention has just been called, not only because you will then be able to grasp the baffling aspect of a growling feline, but because much the same procedure will be necessary in your studies of the head of any animal. The knowledge thus gained will prove of immeasurable value to you in your work.

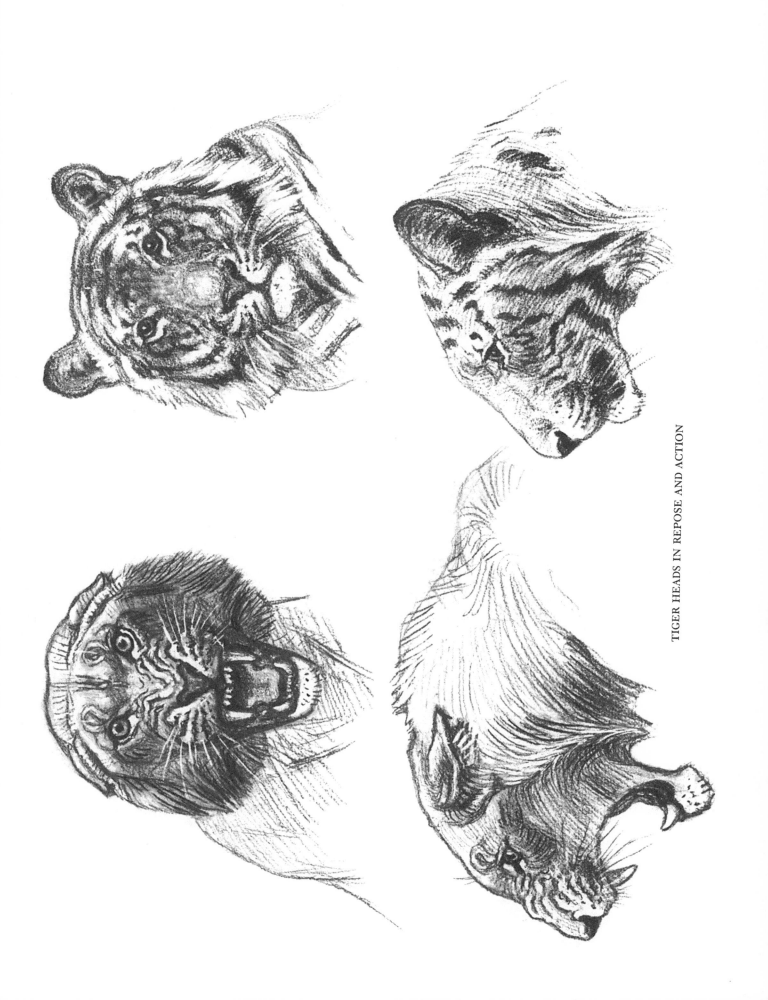

TIGER HEADS IN REPOSE AND ACTION

Dogs

The family that we know as the "Canidae" comprises three large groups of doglike animals, viz., the dogs, wolves, and foxes. Dogs and wolves seem more closely allied to one another than to the fox family, but in all the anatomy is practically the same. Even the felines do not differ widely from the dogs in this respect though at first sight they may appear to do so. The chief point of difference in the skeleton seems to be in the toes. These are terminated by curved retractile claws in all the cats. In the dogs the almost straight nails are practically immovable, and consequently the creature does not use the forefeet for seizing its prey. Dogs, to be sure, do scratch and dig holes in the earth when their quarry tries to escape into some convenient burrow, but the main function of the nails is to protect the ends of the toes in walking or running. In striking contrast to the cats, most of the dogs are fast long-distance runners, trailing their prey even at a distance by their remarkably keen sense of smell. They have long, thin, but muscular legs, deep chests and great lung capacity. Very often they do their hunting in packs or small bands, finally wearing down the quarry, no matter how powerful it may be, and destroying it by a mass attack or wounding it fatally by repeated bites in the flanks or throat.

Although many of our domesticated breeds seem utterly unlike their wild forebears, a close examination of the skeleton and muscular structure will reveal their similarity in many respects. It is simply in the matter of proportion and size that differences exist, and these are not natural but controlled variations developed through thousands of years of selective breeding. We find early paintings of greyhounds on bits of pottery, painting that might almost have been done today, and both the Assyrian and the Egyptian reliefs show several kinds of dogs, some with erect ears, others with lop ears like the modern hound. The only true wild dogs today are found in India and other Asiatic countries, except for certain strange and un-doglike species in South America. All wild dogs have upright, pointed ears, never the downward-hanging type. Our police dogs, collies, chows, and certain other domesticated breeds also keep to this primitive form, as do the foxes and wolves.

Nowhere else in the whole realm of animal conformation can such diverse types in size, form, and color be seen as in the bewildering array of artificially bred varieties of the canine family. The huge great Danes, Irish wolfhounds and St. Bernards, all giants, are at one end of this list, while the tiny Chihuahuas, Pomeranians, and dwarf black and tans are at the other. All these, we must remember, are departures in size and conformation from their wild ancestors. Chows, Eskimos, and police dogs most nearly approximate their progenitors in physical appearance. Pekingese, English bulldogs, and dachshunds are distinctly dwarflike in their general make-up.

The dog is a highly intelligent animal, but aside from the fact that fear of man has been eliminated from his consciousness the true canine character is never far beneath the surface—subdued, it may be, and softened, of course, but capable of flaring up on occasion, with serious results in many instances. The wolves, wild dogs, and foxes are also very sagacious creatures, but they naturally do not show to advantage when caught in the jaws of a steel trap or grievously wounded in an encounter with their inveterate enemy man.

In our studies of domestic dogs the trustful, spirited expression of the eye is very noticeable and must be carefully set down as one of the most charming points of interest in these splendid creatures. All the world loves a dog, and their vigorous, spontaneous movements are a delight to those who come in contact with them. If we remember also that all the different breeds, no matter how unlike they may be in general appearance and size, are fundamentally similar in anatomy, it will be of great help to us in our delineation of canine characteristics.

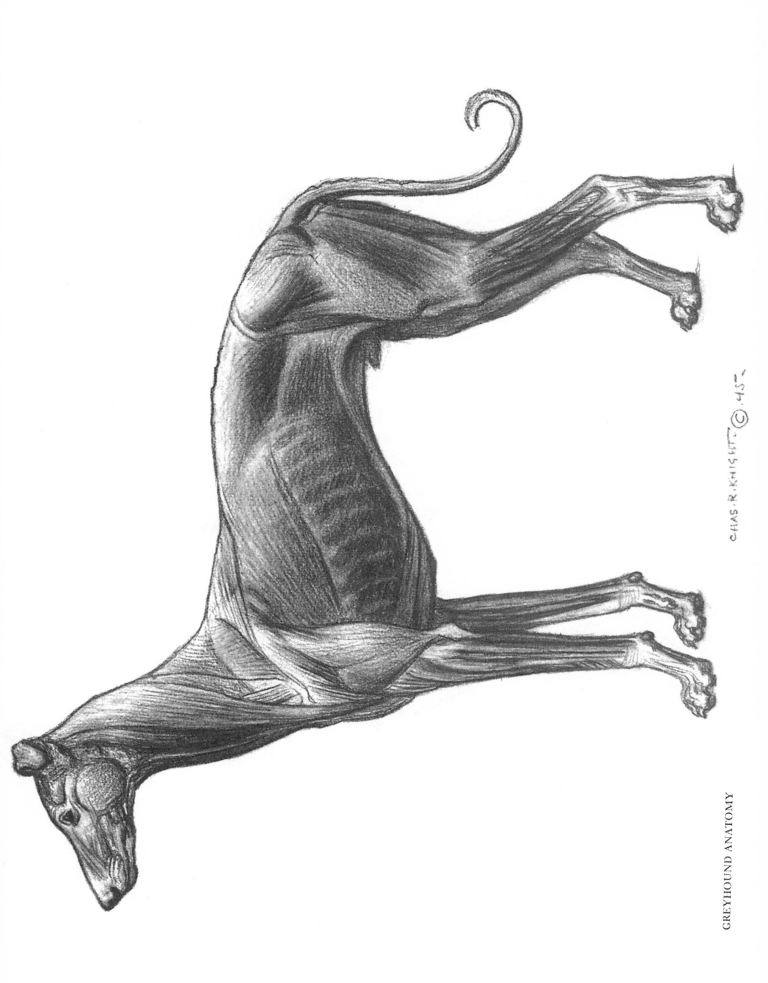

GREYHOUND ANATOMY

CHAS·R·KNIGHT © 45

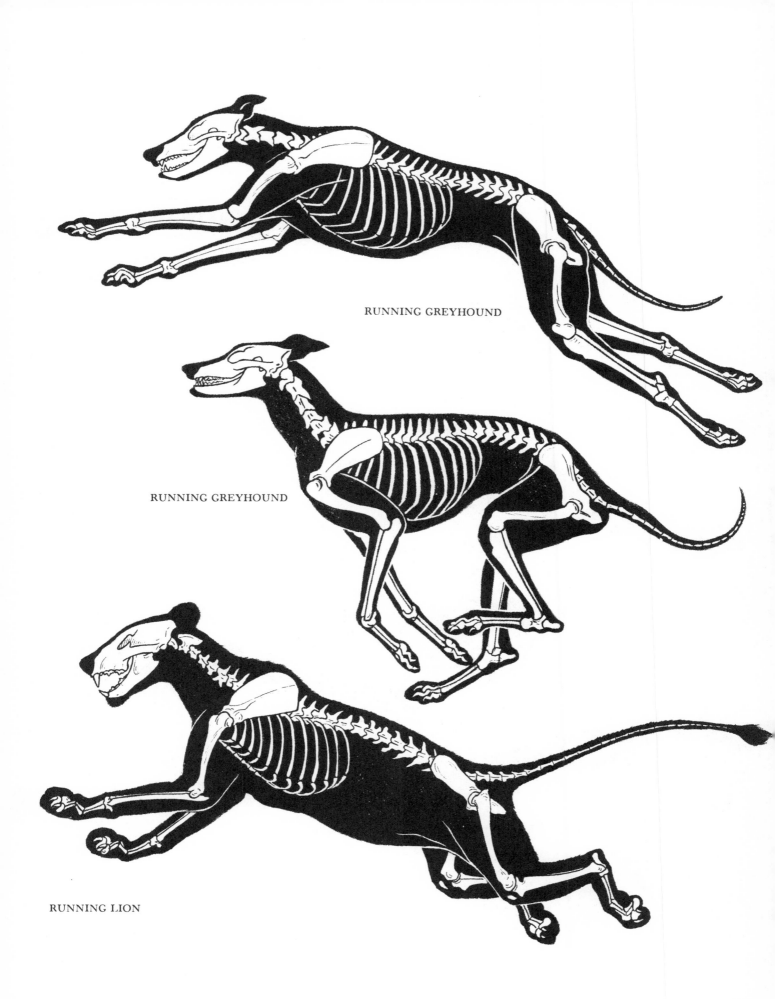

RUNNING GREYHOUND

RUNNING GREYHOUND

RUNNING LION

AMERICAN BAY LYNX

Bears

There are a number of species of bears scattered throughout the world, most of them large and powerful animals, and all, without exception, plantigrade in their manner of walking and standing, at least with respect to the hinder pair of limbs. By "plantigrade" we mean having the ability to walk on practically the whole of the foot from heel to toe after the manner of the human species. This peculiarity also permits the bears to stand upright on the hind legs under the urge of curiosity, fear, or anger. The toes of both fore- and hind feet terminate in five long, chisel-like claws used either in obtaining food or as protection against an adversary.

The *polar* or *white* bear of the Arctic regions is unique as a species and exhibits a form and color quite unlike other members of the family. The neck is very long, the head and ears are small, and the back line is strongly arched. The legs and feet are enormous, and the claws are black and rather small, barely visible under ordinary conditions as the foot is heavily furred even between the toes. The skin (strangely enough) is black over the entire body but is exposed only at the tip of the nose and around the lips. The eyes are small and dark, with little expression. The white bear is a very powerful swimmer and is well fitted for life in the bleak wastes of its northern home. Altogether a stupid, nervous beast, it is yet decidedly interesting to the artist who desires to paint or model its splendid and rhythmic form.

In North America there are several well-marked species of bears, chief among these being the celebrated grizzly of our Western country. This huge animal is a determined fighter and was once the dreaded antagonist of the Indians and of our pioneer settlers.

The still larger Kadiak or Alaska brown bears are immense creatures, specimens weighing as much as 1,100 pounds being occasionally secured. In spite of their bulk they are rather timid animals and will not attack unless wounded or cornered. when they can be truly formidable adversaries.

The black bear of our Eastern states is a very interesting fellow, as is also the so-called "cinnamon" or "brown" variety. This latter form, however, is only a color phase of the black species, not a separate type. Black bears may weigh as much as 500 pounds, but usually they are much smaller. When young all the bears are most amusing little fellows, tumbling about and wrestling with each other in a very engaging way.

In Europe we find the true brown bear, very much like our grizzly in appearance, as well as several allied species. These massive brutes, however, were far surpassed in size by the great cave bears of prehistoric times, which no doubt gave our primi-tive ancestors many qualms whenever they encountered them. Asia possesses several interesting species of the family—the Himalayan bear, the sloth bear, celebrated as Baloo in Kipling's "Jungle Books," and the Malayan sun bear, a small but extremely active and intelligent member of the family.

Anatomically the bears possess a unique skeletal proportion and arrangement, but the muscular form is not greatly different except in bulk from that of the cats and dogs. The limbs, however, are vastly more powerful in every way, and the manlike hind foot is always very much in evidence. In general, the animals are high in the shoulder, with strongly arched back, uptilted pelvis, and a very short tail. The hair tracts are very important artistically and should be specially studied; otherwise, a model or painting of the creature will lack all character and show merely a shapeless mass of fur. As a class we may describe the bears as clumsy, rather sinister creatures, very heavily muscled in the larger species, and always giving the impression of weight and solidity to an extraordinary degree.

The gait is peculiar, loose and shambling, with the forefeet especially turned inward. Though the movements are as a rule rather slow and deliberate, on occasion a bear can travel at astonishing speed and over rough ground is very difficult to follow. The race is an old one in world history, more generalized than either the dogs or the cats. The diet is extremely varied: grasses, roots, leaves, berries, fruits, nuts, honey, occasional ground squirrels, stray pigs, or even much larger animals, and fish are all acceptable as food. In the securing of this food they are peculiarly adept; digging in the earth, climbing trees, fishing in streams, or tackling some large animal are all in the day's work for most of the larger forms of the bear tribe. Yet for several species these activities are relaxed in the winter months, when in most cases the grizzlies, brown and black bears, and the European forms sink into a peculiar lethargic state that we call "hibernation." At such a time the animal goes into a profound sleep, the stomach shrinks to a small pouch, and the creature lives entirely on the excess fat that it has accumulated during the spring, summer, and fall.

In our drawings of these animals we should look for several important points so that we may be able properly to portray their singular and interesting characteristics. Chief among these is the impression of weight, coupled with the unique profile. There is a certain ludicrous quality about young bears that is greatly enhanced by their ability to stand erect and box with one another in a truly human manner. However, this humorous effect is lost as the adult animal takes on its great size and massive form. The tiny eyes then become almost invisible in

the huge face, but the heavily tufted ears are full of character and must be carefully studied for position under varying emotions.

When the bear is erect, the pectoral muscles seem to be a part of the arm itself and the entire forelimb is very loosely suspended from the shoulder girdle. This gives the animal an enormous reach and enables it to grasp an object in its huge arms, crushing it in a viselike grip, at the same time biting with incredible power and ferocity. The sight of one of these gigantic brutes towering upward in an attitude of defiance is not easily forgotten. At such times the long, powerful forelimbs armed with their trenchant talons are spread apart like the claws of a crab, and these together with the widely opened jaws spell death to anything that comes within their field of action.

Meanwhile, the little, fiercely glowing eyes blaze balefully in the enormous face, and the furry ears are laid closely against the strongly arched and powerful neck. This uncanny effect is not mere bluff on the animal's part. On the contrary, the bear is a tough and terrible antagonist when wounded or brought to bay and will fight to the last breath in defense of its young.

As models, bears are very difficult, either extremely restless or sleeping in some uncouth position from which it is difficult to arouse them. Polar bears particularly are to the author's mind one of the most exasperating of all animals, forever pacing back and forth with a never-ending series of head and leg movements very difficult to put down on paper and nerve-racking in their monotonous regularity. It therefore behooves the serious artist to acquaint himself thoroughly with the muscular and bony anatomy as well as the hair tracts of these most interesting animals.

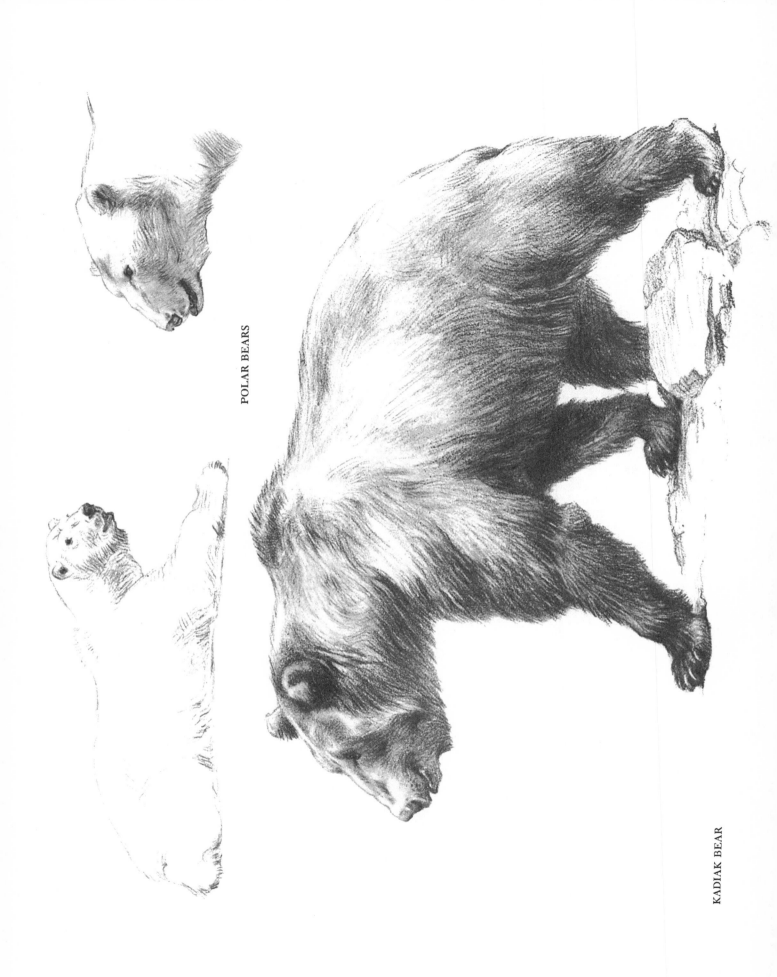

POLAR BEARS

KADIAK BEAR

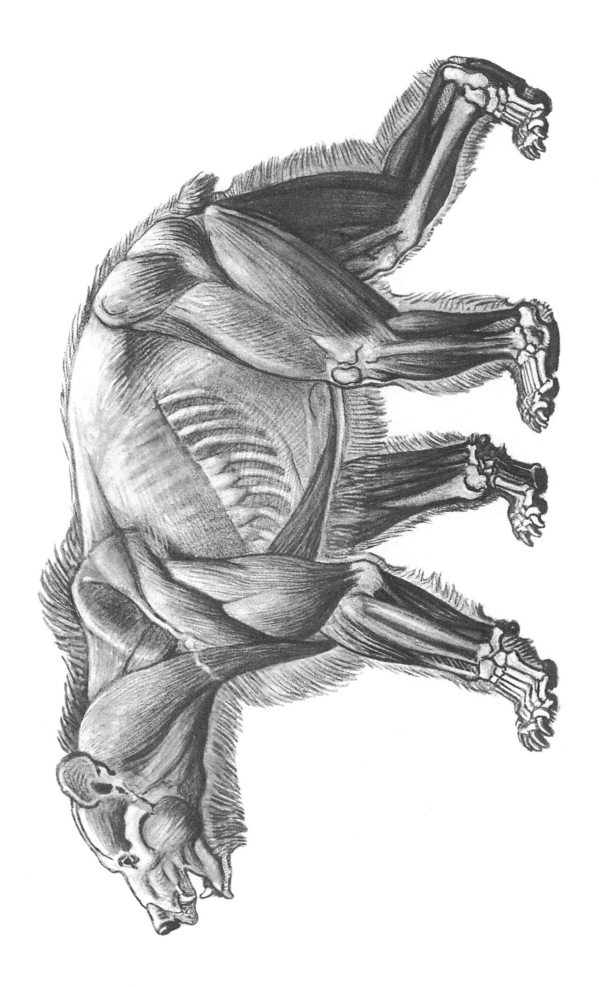

BEAR ANATOMY

Horses

The horse family, comprising the horses, asses, and zebras, are all large and powerful animals, the first two having served man for ages as beasts of burden and also in war and in the chase. Truly primitive man, however, did not employ horses in this way but used their flesh for food and their hides as coverings for himself in severe weather. As a matter of fact, huge deposits of horse bones have been found at certain prehistoric stations in France, evidence that our ancestors were fond of horse flesh, which they no doubt found easy to procure and very satisfactory nourishment as well. Just when man first came to use horses as a means of transportation we cannot definitely say, but it must have been a very long time ago.

Our own red Indians did not know the horse, although it had once existed here, so that they were astonished to see the conquering Spaniards riding these strange beasts on their raids in search of treasure. We have evidence in this country of the whole life history of the horses, from their little four-toed ancestors of Eocene times, through the three-toed phase, up to the modern one-toed horses of various species. All these, however, had apparently died out before the advent of the red man.

The only true wild horse today, Przewalski's horse by name, is found in Turkestan. It is a small, stocky, yellowish-brown creature with upright mane and long but rather sparsely haired tail. It has never been domesticated, but specimens may be seen in various zoological collections in this country and in Europe.

The zebras, of which there are several species, are all confined to Africa. The wild asses, of which there are two or more forms, come from northern Africa and from Asia.

At the present time no wild horses are found in Europe, but they undoubtedly lived there until comparatively recent times. Certainly in northern Africa and the Holy Land the horse has been used in war and in the chase for thousands of years. Indeed the Assyrians and Egyptians could scarcely have made war or existed at all without their invaluable aid.

The domestic ass, tamed and degenerate though he may be, is yet one of man's most useful and faithful helpmates, toiling under heavy loads and in all sorts of weather to serve the needs of his master. Zebras have never (except in occasional instances) been domesticated.

For long distances there is probably no animal so well equipped as the horse to travel at great speed, and for this reason the feet (both front and hind) have become reduced to a single toe, covered with an elastic horny hoof. Originally, of course, the ancestral horse, Eohippus (a small animal not more than a foot in height), was furnished with four little hoofs on the forefoot and three on the hind foot. These diminutive crea-

tures were rather like little deer in appearance but were well able to avoid the slow flesh eaters of the period. Gradually, as the ages passed, these horselike animals grew larger in stature and lost their fourth toe, developing a foot with one large hoof in the center and two small digits, one at either side. These graceful types, some three or four feet high at the shoulder, must have been exceedingly agile and beautiful animals if we may judge by their fossilized remains. At length the one-toed form made its appearance, both in America and in Europe, and with it our true modern horse assumed its place in the varied faunas of both continents.

Anatomically the horse is quite individual in the placement of certain muscles, but it presents no particular problems in this respect. Its actions, however, are much more varied than those of either the deer or the cattle, not only in a natural state, but also under the guidance of a rider or when it is being driven in harness or compelled to pull heavy loads. One may say that the horse, unlike other animals, can assume on occasion a number of unusual and artificial gaits and attitudes owing to the fact that either under saddle or in harness its motions are more or less controlled by mechanical means imposed by a mentality other than its own.

This being the case, it will be well for us to make a special study of these outside restrictions in order to see just how they may influence the animal's posture under certain more or less fixed conditions. The matter of gait is very important, as well as the carriage of the head and neck. A ridden or driven horse is of course controlled by a bit to which are fastened the guiding reins. A pull on one or the other of these reins will turn the horse's head either to the right or to the left as the case may be; if both reins are pulled simultaneously the animal will come to a stop. We are so accustomed to these actions that we are apt not to realize how utterly unnatural they are as far as the horse is concerned; yet they constitute one of the very commonest impressions that we get of the silhouette of this splendid animal. Under these conditions the head is held high, and the mouth, if much pressure is put upon the bit, will be forced open. If we give the horse its head, to use an idiomatic expression, we loosen the reins and the animal at once lowers its head and extends its neck in a horizontal position. A glance at the picture of a rider traveling through the park on a spirited saddle horse, as compared with that of a race horse in a close finish, will demonstrate at once just what is meant in this respect. The gaits of a horse under saddle are also (or can be made) artificial at the will of the rider. Indeed most well-trained horses have several gaits, which they can demonstrate whenever

a change of pace is needed. The trot, the pace, the single-foot, the canter, and the actual gallop are all possible to the carefully bred equine, as well as fancy steps known as high-school gaits in which the forelegs are raised to unnecessary heights in walking or trotting, not to mention side-stepping, waltzing, and a host of other graceful and varied movements.

We may see from this list how varied are the leg motions possible to the horse family, most of them, however, being due to long and careful schooling by competent trainers. The student of horse anatomy will find that photographs of running horses will be of the greatest assistance to him in an understanding of these complicated leg motions, though too much reliance must not be placed upon them in actual drawing or painting. Besides these more or less citified and cultivated actions of the riding horse, many peculiar poses are assumed by the animal when ridden by a cowboy at his daily tasks or in his recreation hours at a rodeo or riding exhibition. It will not be possible to do more than mention the strange antics performed, for example, by the so-called "bucking" horses, whose gigantic upward leaps, twisted bodies, and frantic rearing contortions are all calculated to unseat the rider.

In our drawings of the horse, particular attention must be paid to the shape, size, and position of the different joints of the feet and legs, these being of the utmost importance to a first-class rendering of the animal. The hoof, a horny covering, in itself is unique and requires special study, as it is set at a peculiar angle with reference to the rest of the leg.

The head, too, has its own unusual features, the sensitive and delicately modeled nostrils being very difficult to draw owing to their change of form with the strain of effort or while the animal is at rest. The eye with its range of expressions is naturally a point to which we must devote much application—its position in the head, the shape of the lids, and above all its aspect under the emotions of fear, rage, interest or relaxation. The horse's ears are also rather strange in shape and capable of quite varied movements. They are pricked forward at attention, turned upward and back at rest, or laid down flat against the head in anger. In form they are graceful and very distinctive, being small and set very high upon the top of the head.

The asses and zebras have much longer ears than the horse, but they are equally expressive of the mood of the animal. Who, for example, has not seen a poor, patient little donkey heavily laden, tottering along under its load of merchandise, the long ears drooping forlornly on either side of the creature's head? No other animal expresses so well the degradation possible under the hand of a callous master. The contrast to the magnificent carriage of its blood brother, the wild ass of northern Africa, is a painful one.

The shape of the neck in the horse varies considerably in the two sexes: that of the stallion is thick and heavy while that of the mare is by comparison rather thin and angular. Stallions in fighting rear and strike out and downward with their forefeet. Mares wheel and deliver a shower of kicks from their powerful hind legs. Mules are proverbially proficient in this respect; a blow from one of these sagacious hybrids may easily prove fatal to a would-be aggressor. In anger all horses will bite, the long, sharp-edged incisor teeth inflicting terrible wounds.

It may be seen, then, that in this superb animal we have many and varied responses and actions to note, very complicated and difficult forms to understand, and an extraordinary number of leg motions to analyze and master before we are in a position to produce a worthy picture of our model.

It goes without saying that, because of domestication, all the different types of horses, like the dogs, present the same anatomical aspects, the only difference being in the proportion and size of the various breeds. Percherons, Clydesdales, and the great Flemish breeds are the giants of the species, huge muscular animals with thick necks, stout bodies, and powerful limbs. They are naturally slow in their motions and capable of pulling heavy loads.

Besides these there are the so-called "thoroughbred" types in England and elsewhere, used for hunting, riding, and racing, and the beautiful Arab horses bred by the Bedouins for centuries, lovely, high-spirited, and intelligent creatures from whose ancient line so many of our fine stocks are derived. Then there are the ponies, Shetland, Welsh, and Norwegian, and the so-called "wild" horses of this country and South America.

These last, of course, are not really wild stock but domestic animals that have been allowed to live for a long time in a state of nature and to all intents and purposes are like their natural ancestors. Przewalski's horse, already mentioned, from central Asia is the only true wild horse of the present day. Our research into the character and form of the horse must always be governed by our realization of what really constitutes its naturally wild appearance and reactions and how much these have been modified by man in his domination of this superb and highly useful animal.

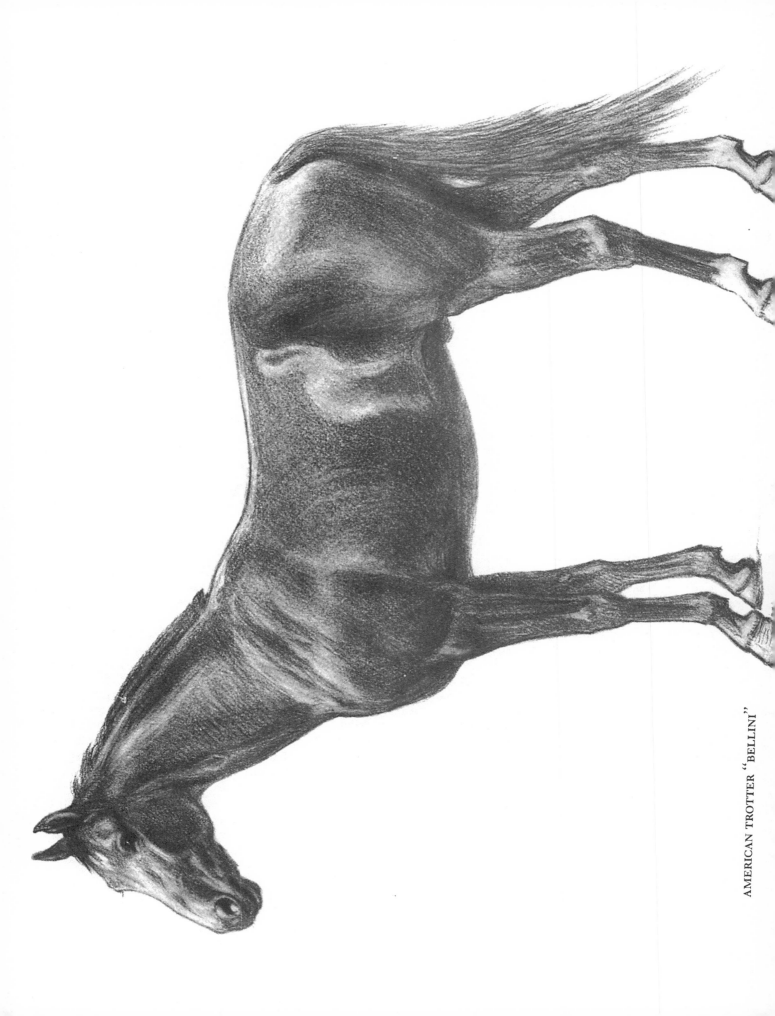

AMERICAN TROTTER "BELLINI"

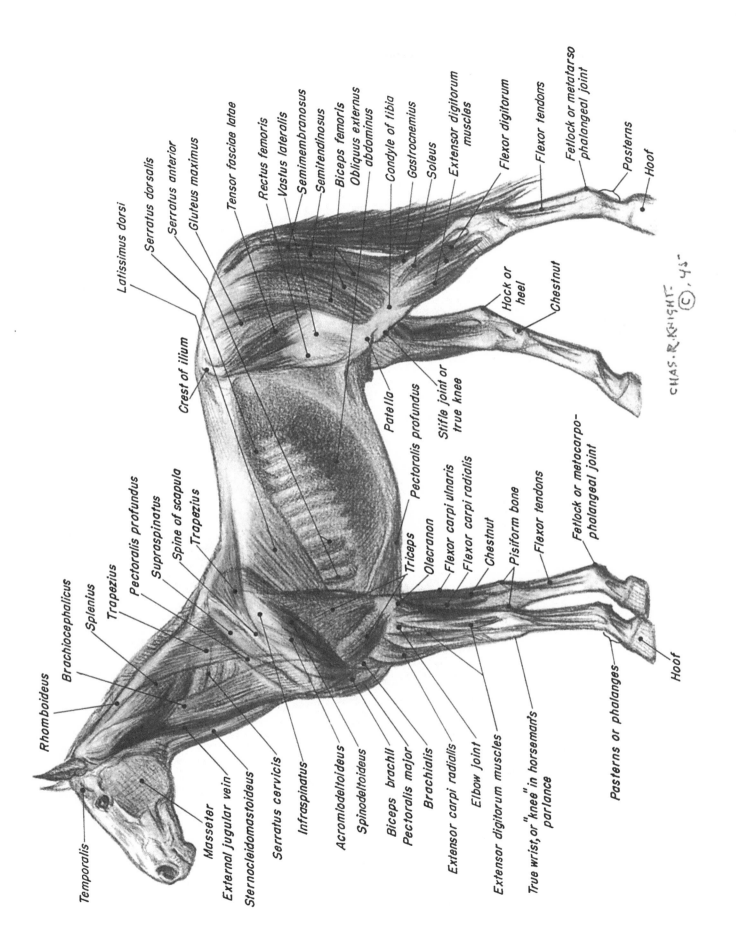

Temporalis

Rhomboideus

Brachiocephalicus

Splenius

Trapezius

Pectoralis profundus

Supraspinatus

Spine of scapula

Trapezius

Masseter

External jugular vein

Sternocleidomastoideus

Serratus cervicis

Infraspinatus

Acromiodeltoideus

Spinodeltoideus

Biceps brachii

Pectoralis major

Brachialis

Extensor carpi radialis

Elbow joint

Extensor digitorum muscles

True wrist, or "knee" in horseman's parlance

Pasterns or phalanges

Hoof

Latissimus dorsi

Serratus dorsalis

Serratus anterior

Gluteus maximus

Crest of ilium

Tensor fasciae latae

Rectus femoris

Vastus lateralis

Semimembranosus

Semitendinosus

Biceps femoris

Obliquus externus abdominus

Condyle of tibia

Gastrocnemius

Soleus

Extensor digitorum muscles

Flexor digitorum

Flexor tendons

Fetlock or metatarso phalangeal joint

Pasterns

Hoof

Patella

Pectoralis profundus

Stifle joint or true knee

Hock or heel

Chestnut

Triceps

Olecranon

Flexor carpi ulnaris

Flexor carpi radialis

Chestnut

Pisiform bone

Flexor tendons

Fetlock or metacarpo- phalangeal joint

Hoof

CHAS. R. KNIGHT- © , 45

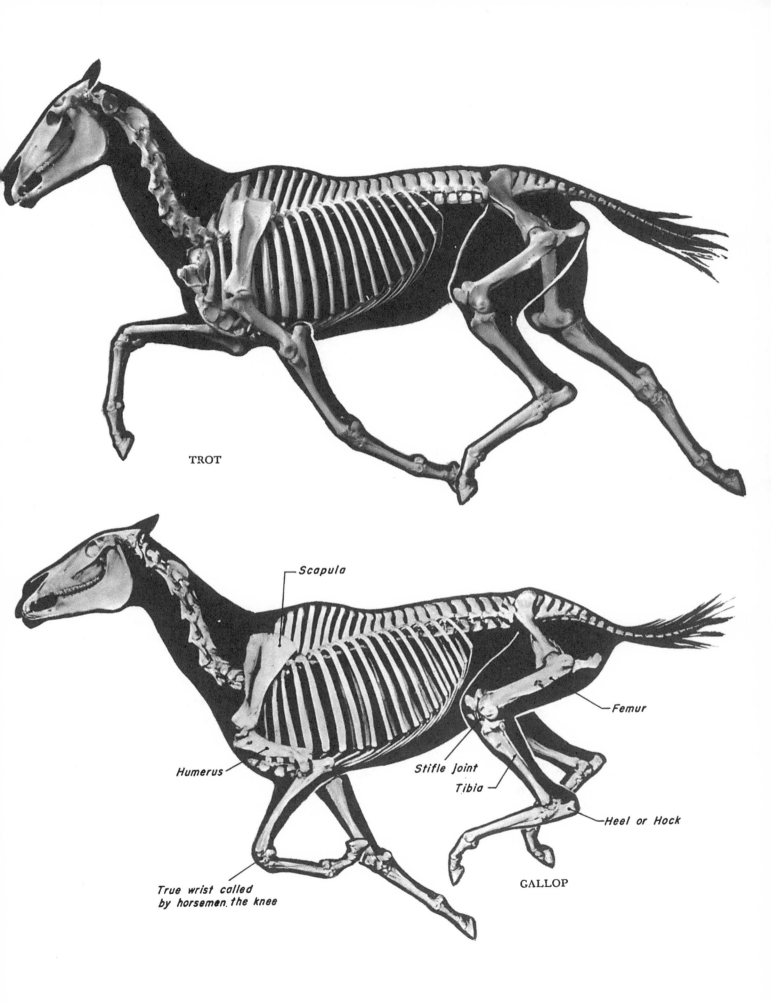

TROT

Scapula

Femur

Humerus

Stifle Joint

Tibia

Heel or Hock

True wrist called
by horsemen, the knee

GALLOP

Cattle

The cattle or bovine group comprise a number of species scattered through various continents. In Europe today, the only wild form is the European bison or wisent, a species closely allied to our own bison but taller, with longer legs and a smaller head. In prehistoric times these animals were very common in Europe and are represented by some very fine colored drawings on the ceiling of the Grotto of Altamira in Spain and in several of the French caves. A true wild ox, the urus, is also shown in several cave drawings, a type living until the time of Caesar, who made mention of it in his writings. The urus was a very large animal with large, sharp horns and may have been the ancestor of some of our domestic breeds of cattle. In Asia at least seven forms of the ox tribe are found, viz., the Indian buffalo, the domesticated zebu, the banteng, the gaur, the gayal, and the yak, besides the very small anoa, a fierce little creature from some of the East Indian islands. Africa of course has the magnificent Cape buffalo, a powerful, sinister brute with wide and sharply curved horns. This animal is a determined fighter and is very dangerous to pursue when wounded as it will lie in wait for the hunter and charge from heavy cover in a fierce and relentless rush that is often fatal unless a lucky shot brings it down before any damage is done. There are several minor races of buffalo in Africa and also some strange domestic zebulike breeds with enormous horns. No wild cattle are found in South America, but Greenland and the northern part of the American continent produce that singular creature the musk ox, a small but very heavily furred bovine with downward-curving horns. This unique species is able to withstand the rigors of an Arctic climate and lives on the frozen moss that covers the uplands and plains of its Arctic habitat. It will be seen from this list that the wild cattle comprise a small number of species but all very interesting in form, horn development, and color.

Domestic breeds, especially in Europe and America, are of the greatest importance from an economic point of view and differ very markedly in shape, size, and color. As a rule, pictures of cattle are of the domesticated varieties, and their anatomy is given in the plates as being of the greatest use to art students. Long and intensive breeding has worked wonders in the actual bone shapes of our domestic cattle, the pelvis being very much wider and more prominent than in the wild species. No wild forms have large udders, for their weight and size would prevent swift movements. There is usually a distinct difference in the two sexes as regards the size and shape of the horns, cows having a leaner and more bony appearance, while the bulls develop a thick neck and are altogether more graceful in general make-up. In wild species the bull bison with its shaggy head and huge shoulder hump is much more impressive than the cow. The gaur, one of the Indian species, is also a most splendid-looking creature, quite unique in the form of its body, the head graced with great outward-curving horns. Among the domestic types we have the lovely, soft-eyed, fawn-colored Jerseys, Guernseys, and Alderneys and the large black-and-white Holstein-Friesian breed (all fine milkers) as well as the heavier beef cattle, Herefords, Aberdeen Angus, and many others. For years, England has been the home of intensive cattle breeding, exporting splendid specimens to all parts of the world. The half-wild cattle of our Western plains, the celebrated long-horn types, were possibly descended from individuals brought over and released by the Spanish invaders. Today their places have been taken by superior beef-producing breeds imported from England.

The buffalo, so called, or American bison ranged the Great Plains of this country by the millions until the middle of the last century. Their numbers then became terribly depleted by wanton slaughter until the race was threatened with extinction about fifty years ago. By dint of much hard work and careful handling the bison has been saved from complete annihilation until today many hundreds roam the great Western forest and game preserves both in this country and in Canada.

The cattle, while not profoundly different from the horses in the general conformation of their body muscles, are all cloven- or two-hoofed creatures as compared with the horse's one hoof on each foot. This naturally imparts a very different appearance to the foot and leg region of the animal's skeleton and is a definite feature to look for. The feet also have two small hoofs (which do not touch the ground) one on either side of the main pair, making four characteristic points of interest on each foot.

The presence of horns on the head and their use by the animal for defense and offense give to the family certain very characteristic poses under exciting conditions. An angry bull, for example, lowers its head and prepares to charge an adversary, while a horse under the same emotions raises its head and neck to the fullest extent and, if a stallion, rushes forward, rears, and strikes with both forefeet; the contrasting methods of action result from the totally different conformations of the two creatures. Cattle can and do kick, but the blow is more forward than backward and is consequently much less dangerous than that of the horse. Indeed, all types of bovine animals depend upon their horns in fighting and in goring an adversary, and here we have one of the salient characteristics that distinguish the family from others already considered.

All cattle lie down by first bending the forelegs at the wrist joint and then letting themselves fall easily to the ground

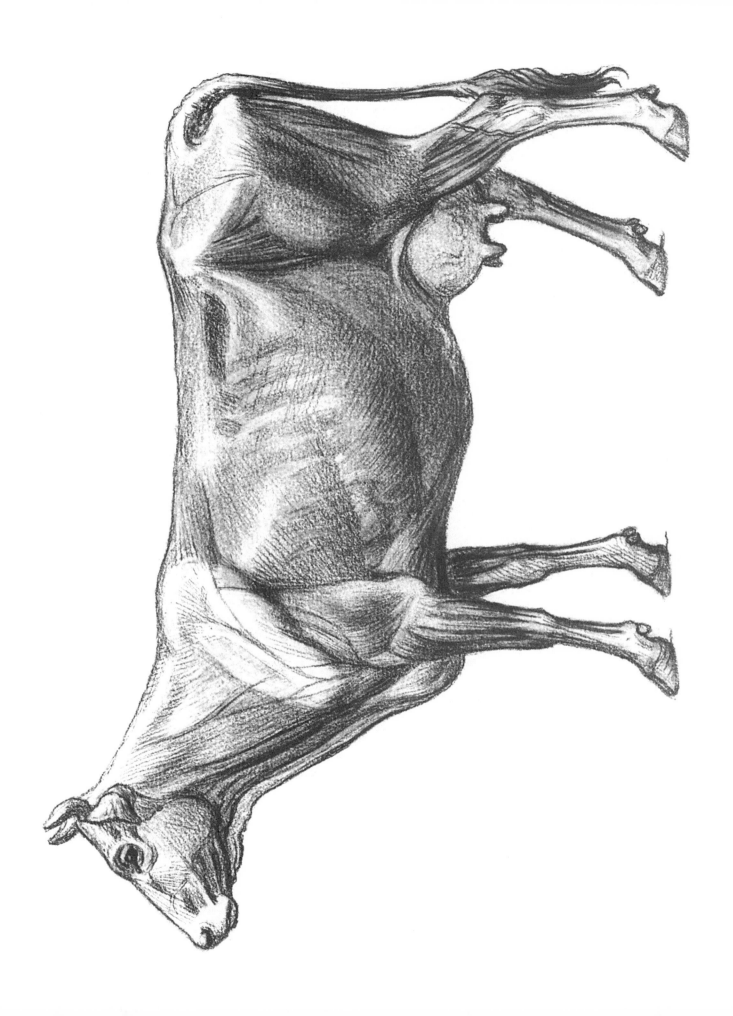

on the hinder pair. In rising they reverse the operation, rising first on the hind legs and straightening first one foreleg and then another. Horses, on the other hand, proceed in exactly the opposite way in each case, a singular difference of action not easily accounted for or explained.

To artists, at least those of the last two or three hundred years, the patient kine chewing their cud at noonday or standing knee-deep in some softly running stream have always appealed as the last word in rural contentment and charm. The old Dutch painters loved these homely subjects and did some very fine work in this field. England too has had its cattle painters, and the United States has been well represented by several very able men. In France, Troyon was a great exponent of the farm scene, and Van Marcke in Holland did some splendid work, his groups of handsome cattle being justly celebrated. The wild species have received very little attention from painters; specimens are difficult to see except in zoos, and these are often rather abject in appearance. Our American bison deserves more attention from the artist than it has yet received; the color and form of an adult bull make splendid material for a picture, and for the sculptor nothing could be finer. For some strange reason paintings of wild cattle are considered in the realm of "sporting" pictures, whereas a herd of cows feeding or resting in the meadow is regarded by certain artists as a legitimate subject for a bona fide work of art. Why this should be so it is difficult to imagine, but the fact remains nevertheless.

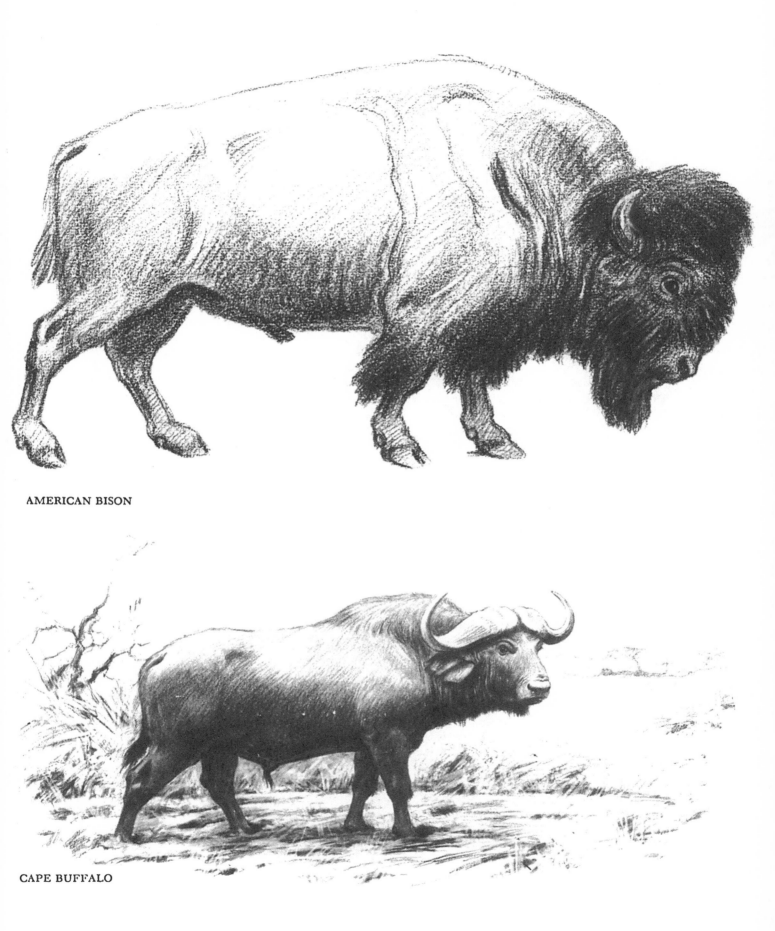

AMERICAN BISON

CAPE BUFFALO

Deer

These beautiful and graceful creatures, whose light and delicate movements are a delight to the eye, merit a special place in this survey of animal forms. Alertness and a certain tense quality are evident in most of the smaller species, while grandeur and statuesque silhouettes distinguish the larger varieties.

In the deer we are dealing with essentially wild animals in every instance, as the family, with the exception of the reindeer, has never come under the dominion of man. In general muscular form they are not unlike the clumsier cattle but except for the moose are much more agile and are capable of great and sustained speed in running. As one might suppose, these traits have led to a reduction in size of the cloven hoofs and a corresponding thinning and strengthening of the lower legs and the muscles and tendons that control them. Deer always walk or stand with the hocks or heels held very closely together, a fact that must be well realized by anyone wishing to portray them either standing or walking. In running, the deer makes a succession of tremendous leaps for the first few hundred feet and then settles down to a very fast and powerful gallop.

Some of the small and more primitive types of the family, mostly found in Asia, carry the back in a decidedly arched manner; but our own species, the Virginia deer, mule deer, elk, and moose, are all practically horizontal on the back line. The head is often held high, the neck almost at right angles to the body and the head again horizontal. On occasion, of course, the neck and head can be stretched out in almost a straight line, as in running through low brush, or the neck can be curved downward, lowering the head and throwing the horns forward, as when the animal is angry and intends to charge. Male deer in the rutting, or breeding, season engage in terrific combats, which may end in death for both the opponents: it quite often occurs that their horns become locked in such a way that it is impossible to separate them and as a result both the unfortunate creatures die of exhaustion and starvation or may be killed by marauding wolves.

Fine drawing, as well as much knowledge of the psychology involved in a given attitude, is always necessary adequately to represent any member of the deer family. Eyes, ears, head, neck, body, and legs must all be coordinated into a consistent whole, or a poor effect will result. The eyes of a deer are very expressive, often large, dark, and lustrous, sometimes turned backward in anger, showing the white at the front of the iris. The ears too give great expression to the deer's head; they are usually very large, graceful, and constantly on the alert for sounds from every direction. A startled deer with head erect and ears standing almost straight out is a pretty sight. The moist and sensitive nose trembles with the desire to locate and analyze the danger, and the feet and legs are placed in an attitude of intense rigidity, ready at an instant's notice to speed the timid creature on its way to safety. Grace, if you will, but not sinuous grace, as in the cats, distinguishes these elegant creatures; and there is a certain hard, taut firmness about them. Steel-like tendons clothe the delicate limbs, and the compact, pointed hoofs only increase the effect of great speed and violent action.

Sir Edwin Landseer, already mentioned with reference to his animal pictures, devoted much time to the delineation of the red stag of the Scottish Highlands, a magnificent animal not quite so large as our elk but decidedly more graceful and vivacious in its postures. These splendid beasts he incorporated in a large series of celebrated canvases, showing the animals at bay or challenging or fighting with each other, all highly interesting and forceful renderings.

Our own Virginia deer is among the most elegant of the entire family but is difficult to see in a wild state; and while it lives after a fashion in confinement, it does not develop the beautiful horns of the wild specimens, nor does the smooth and shining coat retain its luster.

The American elk or wapiti is perhaps our grandest deer. While not so huge or striking in contour as the moose, it is a much more beautiful animal, with the magnificent horns carried low along the back and the head uplifted on the thick and powerful neck. Elk live in very picturesque mountain country in several of our Western states. One of these great creatures against a background of mountain, rocks, and forest is a sight to be remembered.

Largest of all the deer tribe, the moose stands in a class by itself because of its tremendous size, weight, and peculiar antler and nose construction. Unfortunately this animal does not thrive well in captivity so that one must get a glimpse of it stepping through the dark recesses of its forest home or, more fortunately, as it comes to drink and feed in some mountain lake or stream. Under these conditions we may gaze in amazement at its huge bulk and strangely shaped body. The very long, straight legs, abbreviated tail, and great, bulbous drooping nose and upper lip, combined with widespread palmated antlers standing out on either side of the head and the long, pointed ears carried high or laid flat against the powerful, hairy neck, make the moose the strangest of all the deer family. All in all, the creature is more grotesque than beautiful in outline, though its precise character is hard to define in words.

In all species of deer with the exception of the caribou or reindeer, the females are hornless throughout the year, but the

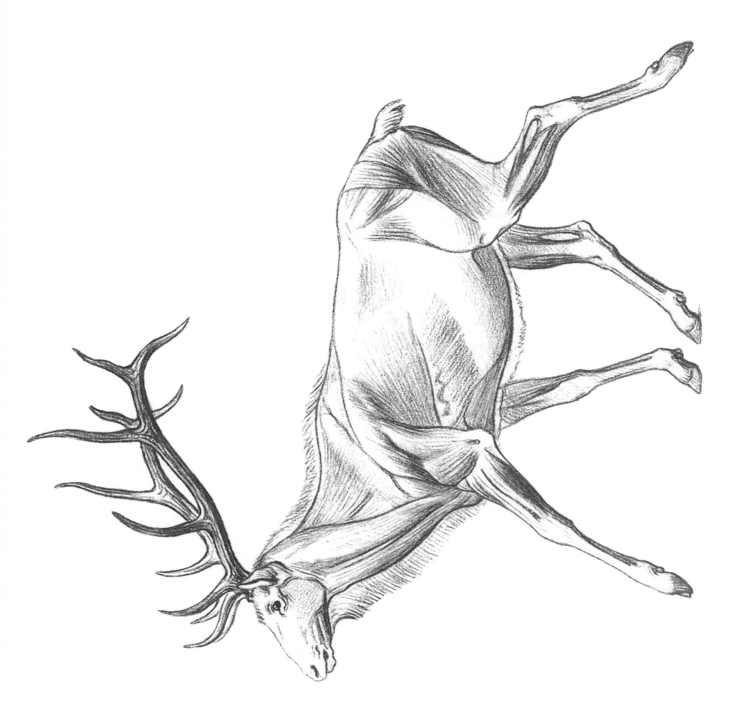

WAPITI OR AMERICAN ELK

males fully develop these extraordinary appendages in the breeding season. They are shed after the strenuous mating period and begin to grow again as soft, velvety knobs directly from the bony bases on the skull. The shape and size of the antlers differ in each species of deer and are absolutely characteristic. Too little attention is paid by the artist as a rule to these differences of form, which could give so much character and spirit to his drawing. The intricate curves and lines of growth must be closely studied; otherwise the antlers will assume a treelike appearance quite out of keeping with the real facts. The surge of life is very evident in all the deer family and must be indicated in any representation of them. They are all singularly wild and timid animals but under certain conditions can be dangerous and terrible antagonists. During the breeding season, a profound change, both mental and physical, occurs in the male deer: the neck thickens, the horns have attained their full growth, and the animal is ready to fight at the slightest opportunity. Nature has temporarily transformed the creature into a veritable demon, the sex urge drawing it into demonstrations of energy and vindictiveness quite impossible at any other time.

The deer as a family are among the most beautiful and interesting of the many wild animal forms. They rouse the old hunting instinct in certain persons, but others are content to study them entirely from the aesthetic point of view.

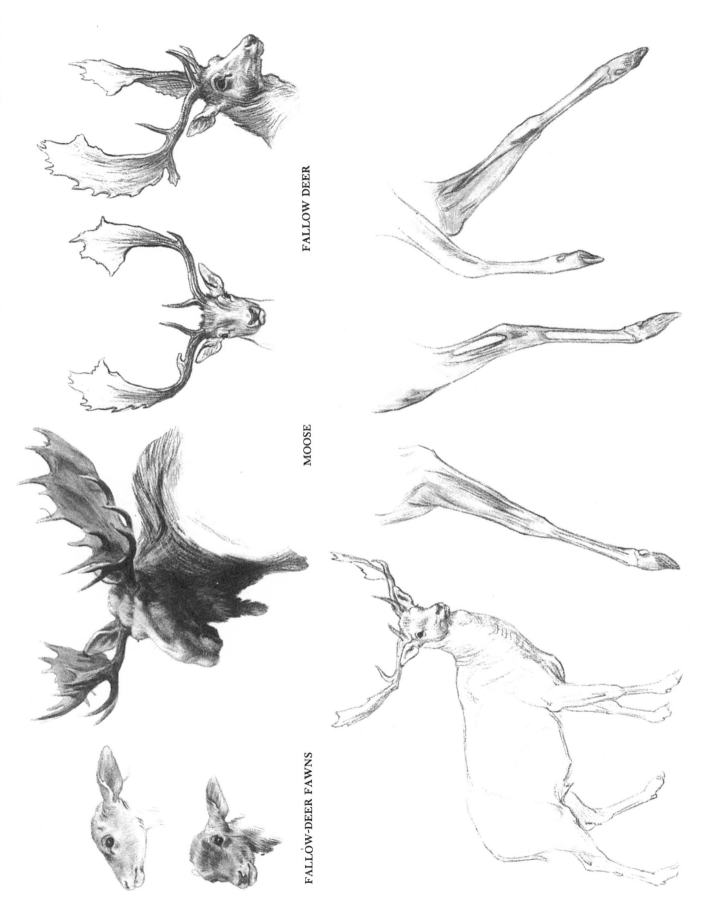

FALLOW DEER

FALLOW-DEER LEGS

MOOSE

FALLOW-DEER FAWNS

FALLOW DEER

Antelopes

There are many species and types, some large, some small, belonging to this large group of horned animals. Most of them inhabit Africa, but a few are found in Asia, and one species, the prong-horned antelope, is a native of this country.

In former days, the great plains of South Africa were alive with hundreds of thousands of antelopes of many species, but today they are confined principally to central and northern Africa.

It is hardly possible to give more than a very general summary of this large family; nor is it necessary for the artist, for they closely approximate the deer in their muscular and bony anatomy. The horns, however, are very different. In the deer these are bony growths from the skull, being shed annually at the base and forming again to be ready for the next season. Strictly speaking, they are not horns at all, but true bone, nourished by great blood vessels that dry up when the growth is completed, leaving deep channels in the newly formed antler. In the antelopes, cattle, goats, and sheep, however, there is a bony core that rises from the skull, and this is sheathed in a mass of real horn, a substance like that of our own fingernails, which under the microscope is seen to consist of a number of hairlike filaments joined tightly into a tough, elastic material. This horny envelope is never shed as in the deer but continues to develop until the animal reaches maturity, assuming as it does so all manner of strange and fantastic shapes, characteristic of each species.

Antelopes vary tremendously in size, the great African elands attaining the proportions of an ox, while the tiny dik-diks are not much bigger than a rabbit. Among the larger types, the splendid sable antelope with its great scimitar-shaped horns is most striking in appearance, as is also the kudu, whose head ornaments assume a spiral lyrelike appearance. The gemsbok and beisa antelopes have long, straight, daggerlike weapons pointing backward from the head. The grotesque gnus with down-curving horns pointed forward are amazing in their complicated running antics, and the several species of hartebeests are the bane of the hunter because of their watchfulness and the difficulty of approaching them. The gazelles, small in size but exceedingly graceful in form, are the fleetest of all the species. They are found in India and Africa and even on the sterile wastes of The Gobi and in Siberia. North America can boast of one beautiful antelopelike species, the pronghorn. It is unique in its horn development; for it not only grows a bony core surrounded by a horny sheath, like all the other types, but also sheds this horny covering from time to time.

All that has been said about the care required in drawing the deer family applies equally well to the antelopes. They offer the artist many suggestive silhouettes for decorative work.

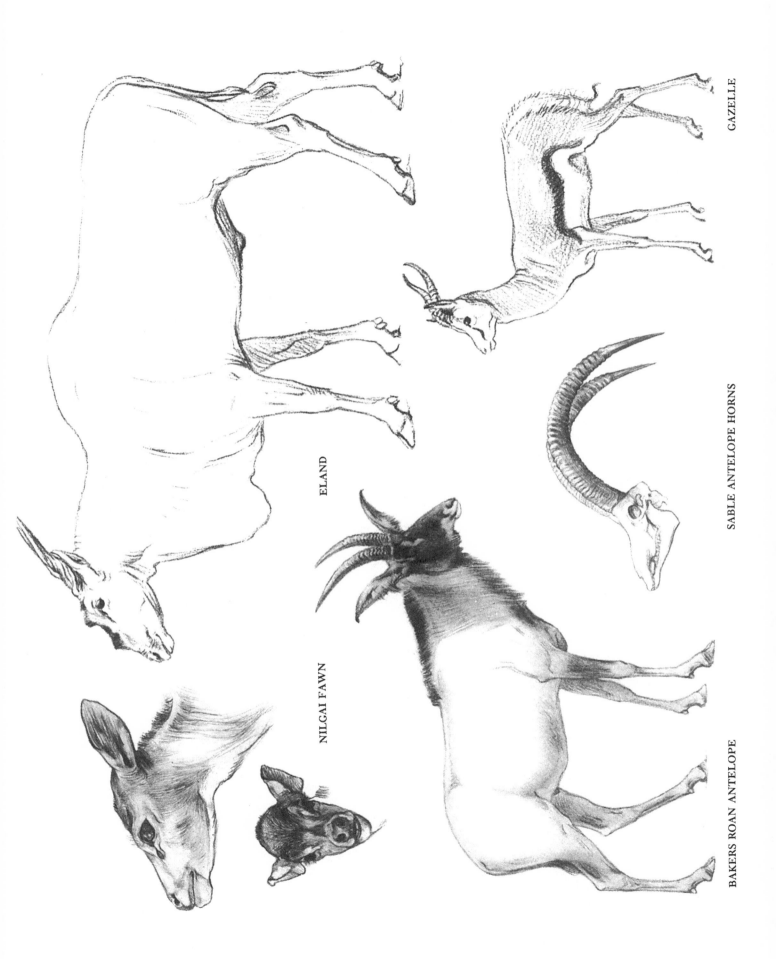

GAZELLE

ELAND

SABLE ANTELOPE HORNS

NILGAI FAWN

BAKERS ROAN ANTELOPE

Sheep and Goats

Our last division of the horned animals contains some very fine species that have never been domesticated and also a number of bred varieties each with some peculiarity of form or color that differentiates it from the others. Among the wild forms, our own Rocky Mountain sheep is outstanding as a magnificent example of the family. The great rams carry huge, rounded, curving horns, weighing twenty-five or thirty pounds, with which they can deliver tremendous blows when fighting. A mountainous country is always their favored habitat, and indeed that of all the other types of sheep and goats. For such large animals they are exceedingly agile and can ascend and descend the most difficult places with comparative ease. In Asia there are several grand forms to be found. One of these, the Marco Polo sheep, so named for the great traveler, is the largest of all the sheep group. The Sardinian mouflon, though smaller, is also an interesting variety. The ibex, a goatlike animal, inhabits Asia, Africa, and parts of Europe. These carry horns with a very much larger curve than the sheep; altogether the animals really are quite like our domestic goat in habits and character.

We should pay attention to the shape of the feet in the goats. They stand in a different manner from all other animals, owing to the odd shape of the hoof, which gives them their great mountain-climbing ability. A glance at a domesticated animal will show just what is meant in this regard, and it is a point well worth noting.

Domestic sheep have figured so largely in art that they deserve at least a casual reference to their anatomy, though the average type is so covered with wool that the muscles on the body are entirely concealed and only the legs and head are visible in their true form. Certain breeds like the Merinos are excellent for modeling; their long wool is disposed in curious heavy ridges and folds over the body, and the rams, especially, have fine curling horns. They are very statuesque in appearance and have a character all their own. Wild sheep, by contrast, have no wool, at least none visible, but are covered with very dense, short hair, which allows the form to show to the full extent. Nothing could be finer than these superb creatures as an inspiration for the sculptor, but unfortunately they are rarely seen in captivity. Domesticated lambs and kids seem to be favorite subjects and are charming little models, full of appeal for those given to sentiment. The pupil of the eye is horizontal in the goats and sheep, instead of being more or less a circle as in the cattle. This gives their physiognomy a peculiar quality that must be fully recognized as a special character.

The Egyptians did many ramlike beasts, grasping well their distinctive points of character. The Greeks and Romans were fond of ram's heads used in a decorative way, for example, as cups of bronze or as ornaments on buildings.

It may be said in concluding this short survey of the horned animals that as a class they are not gifted with great intelligence, nor are they very varied in their poses and expression as are the dogs and cats. Yet domestic cattle and sheep are often wonderful in color against a rustic landscape and give just that touch of homely farm life which has made them for hundreds of years a favorite subject with the painter.

While we have tried to picture both for the painter and for the sculptor the possibilities inherent in the group as a whole, their number and variety are so great that only the more noticeable and useful characters of the principal species have been suggested.

Again, let us remember that they are all anatomically very similar but that the silhouette, the color, the horns, and even the mentality differ greatly in the five great families, viz., the cattle, deer, antelopes, sheep, and goats. What those characters are can be learned only by much research, but close study will prove of tremendous value to anyone desirous of adequately portraying them.

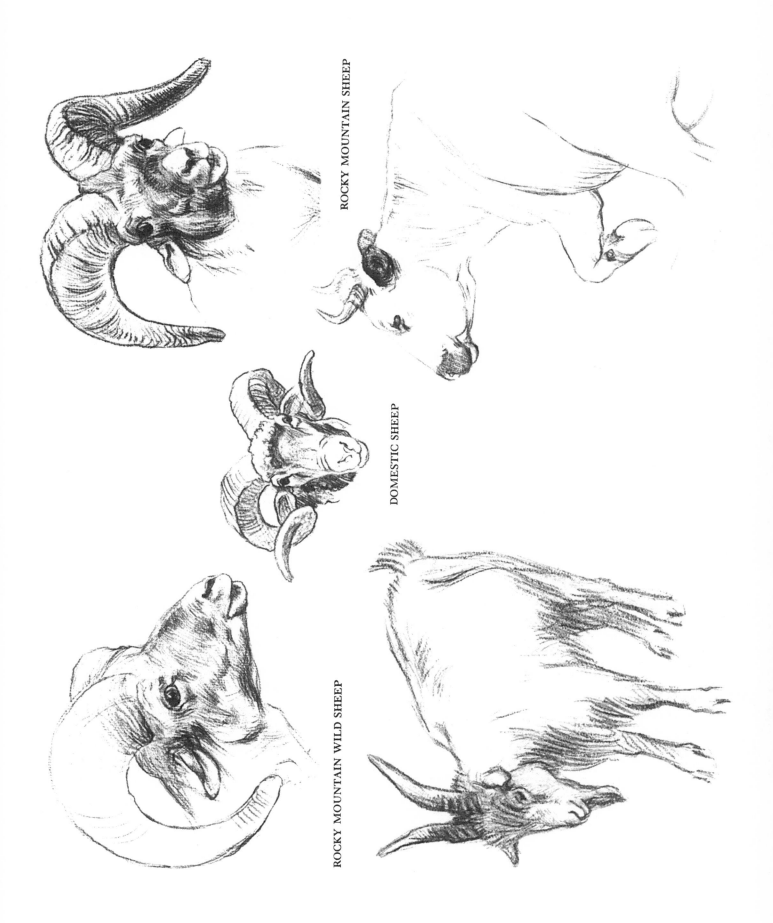

ROCKY MOUNTAIN SHEEP

DOMESTIC SHEEP

ROCKY MOUNTAIN WILD SHEEP

Elephants

To judge by numerous paintings and models of elephants, no class of animal is more generally misunderstood in its general construction by the artist, sculptor, or painter. Few of the representations are correct, though why this should be so it is difficult to say. Perhaps the very bulk of the elephant is a deterrent to the average student, who therefore fails to grasp the peculiarities of its anatomy.

The existing elephants are represented by two very large species and possibly a third or pygmy variety. The Indian elephant still found wild in India is a highly intelligent beast, some ten feet or more at the shoulder in large specimens, with angular, flopping ears, long, postlike legs, two gleaming ivory tusks (carried by the male), and a curious and most useful trunk (an elongation of the nose and upper lip) depending from its upper jaw. With this trunk it secures its food and drink and without it would promptly die for the lack of everything that supports life. The African elephant possesses all the foregoing points, with certain differences. For example, the ears are much larger, the back line is different, the legs are longer and thinner, and the tusks are much larger and are carried by both males and females.

Certain unique features in the bony anatomy of the elephant are difficult to understand unless analyzed. Chief among these is the fact that the elephant has extremely short feet, both fore and hind; by this we mean not merely the toe portion of the foot but the bones extending upward to the wrist on the forefoot and to the ankle and heel on the hind foot. Owing to the very great weight of the animal its legs appear to stand almost vertically in general outline from the back line to the ground; this, of course, is a mechanical necessity caused by the huge size of the ponderous body that they support. In this character as in many others, elephants differ from all other animals, and we must be prepared to look for it when studying them.

Another most puzzling part of the elephant's anatomy is the shape of the tusks and their insertion into the head. In the first place one must realize that the tusks are the *incisor*, not the *canine*, teeth and grow from a section of the skull which is in front of the eye, not from a point behind it. So many artists, particularly the Chinese and Japanese, give the impression in their models of the tusks emerging from the corner of the mouth —an absurd and incorrect place to indicate them. Nothing is more necessary in the correct modeling or painting of an elephant's head than the proper shape, growth, and insertion of these tusks. The author has found it of great value as a guide in placing the great teeth properly to draw or model them so

that a line continued through the center of the tusk from point to base will come directly to the middle of the eye. In this way a major construction problem is rendered comparatively simple. Tusks have a complicated growth, making their shape rather hard to understand unless one knows the secret of this seemingly difficult riddle. We must not think of them as developing in a one-direction curve. On the contrary, the curve is in the form of a corkscrew, first down and out, then up and in, as the tusks grow longer. In other words, in young elephants the points of the tusks are directed almost straight downward. Later they begin to curve outward a bit, still later to curve upward, and last of all to curve slightly inward toward the middle line of the trunk. There must be no indecision in the drawing of the tusks. They are smooth, hard, and shining, in absolute contrast to the rest of the creature. If they are incorrectly rendered, all semblance to the real thing is gone and what might otherwise be a good study is destroyed.

Because of the elephant's bulk the planes of the body are very evident in a strong light but not so noticeable from a near view or in poor illumination. For this reason it is always advisable when possible to look at an elephant in the open and in bright sunlight, when the lights and shadows on the body will be much more evident. Too many attempts fail miserably to represent the creature because the artist knew nothing of these planes; the result can be only a rounded, stuffed-looking production without any true character.

In head and ear shape and body contour the two species, African and Indian, differ very considerably. The African elephant, for example, has a small head, flat on top and with huge, almost triangular ears, the lower tips of which project below the profile of the lower jaw. From the front view the bases of the tusks are widely separated, making the rather short trunk very broad at the insertion of the tusks into the head. From the side view the back line is lowest in the middle, rising both to the shoulders and to the hips, and the pelvis has a decided slant downward toward the insertion of the tail. The legs are very long, slim, and straight, the skin is coarse and heavily wrinkled, and the feet are small in comparison with the Indian species. The body is short from the front to the back, and the head is carried low or gives that impression because of its flatness on the top.

The Indian elephant is quite a different-looking creature. The head is large, with two great rounded protuberances, or domes, composing the high forehead. The tusks are comparatively small, the females rarely carrying any. The trunk is long and thicker

toward the tip than in the African species. The ears while large are only about one-third as large as in the African variety; yet they are a very striking adjunct to the head and must be drawn with care. The profile view of this species shows the high point in the middle of the back, sloping slightly either way. The head is also high, an effect caused by the rounded forehead, and the legs are stout and solid as is also the whole body. This gives a chunky, massive appearance to the Indian species that is wanting in the other type.

No other animal but the whale is as large as the elephant, nor does any other animal resemble it in form; we must therefore be very careful of our data if we are to draw or model one with any degree of accuracy. Naturally a massive and grand effect is our first consideration, but this we shall not be able to attain unless we understand the underlying elements that go to make up this impression.

These great intelligent creatures are most adaptable to sculpture, but they also have a distinctly paintable side. On state occasions the Indian rajahs have for centuries made use of them as riding animals, gloriously caparisoned with rich Oriental rugs hanging on either side of the howdahs, or riding seats, and with their polished tusks encircled with bands of silver and gold. Designs in colors are painted on their foreheads and long, swaying trunks, so that the whole effect is brilliant in the extreme. When several of these mighty beasts move forward silently along a road glittering under a hard tropical sun, escorted by horsemen and gaily bedizened runners, the impression is certainly one of barbaric splendor not to be seen anywhere else in the world.

The normal walking gait of the elephant is a long, apparently slow amble, but actually the animal moves with considerable speed because of its long legs. At a run the progression is accelerated into a curious jerky motion, not graceful but in so large a beast not without a certain grandeur. No other animal, of course, has the majesty or carriage of a full-grown elephant as it strides forward with swaying trunk, the huge ears held close against the massive head or flapping slowly back and forth with every motion of the gigantic body. Graceful the elephant is not, but as an animal he is without doubt the most impressive sight in all nature.

We all know the elephants, usually of the Indian species because of their greater tractability, that are associated in our minds with some of our happy childhood days. The author well remembers the thrills of those early circus parades with the gilded wagons full of fierce wild animals and the long lines of elephants ridden by beautiful circus ladies, somewhat the worse for wear but glorious nevertheless in our uncritical eyes. We weren't much interested in anatomy then—animal or otherwise —but now that we have grown up and some of us have elected to be painters, these things come back to us with all their positive charm, and we long to put down on canvas impressions of the great, swaying beasts as they headed for the circus grounds and the shining white tents of the "Greatest Show on Earth."

To analyze this little vision of a bygone day is what we as artists must do if we would paint a group like this and get any sort of character into it whatsoever. First we must seize the rhythmic movement of the long, heavy limbs and strive to understand the proportions, silhouettes, color, and distinctive characters of the great brutes and also their decorative possibilities. The light, the air, the color of the trees and the crowds and their values one against another—these are all the problems of the artist, but without the solid groundwork of the elephant's construction as a basis from which to work our little painting rhapsody will never be realized on canvas, and only blobs of futile color will reward us for our time and trouble. Let us then consider this lordly pachyderm with all due deference to his majestic mien, his size, and his high degree of intelligence and try to understand the many unusual features embodied in his massive frame.

Of the great prehistoric elephants, the mammoth and the mastodon, nothing need be said here except to call attention to the very large size and the shape of the tusks as compared with the modern species. Only a specialist along these lines will need to pursue the study further. We know that in general muscular form and body the mammoth and mastodon were similar to their recent relatives. The mammoths or at any rate the northern varieties were covered with thick coats of long, reddish-black hair, which must have very much altered their appearance in life as compared with the naked-skinned African and Indian types of the present day. The student interested in such matters will find splendid mounted skeletons of these magnificent extinct creatures in several of our great museums. A detailed examination of the actual mounted skeleton of an elephant, either recent or fossil, will be of invaluable aid from any angle of artistic research.

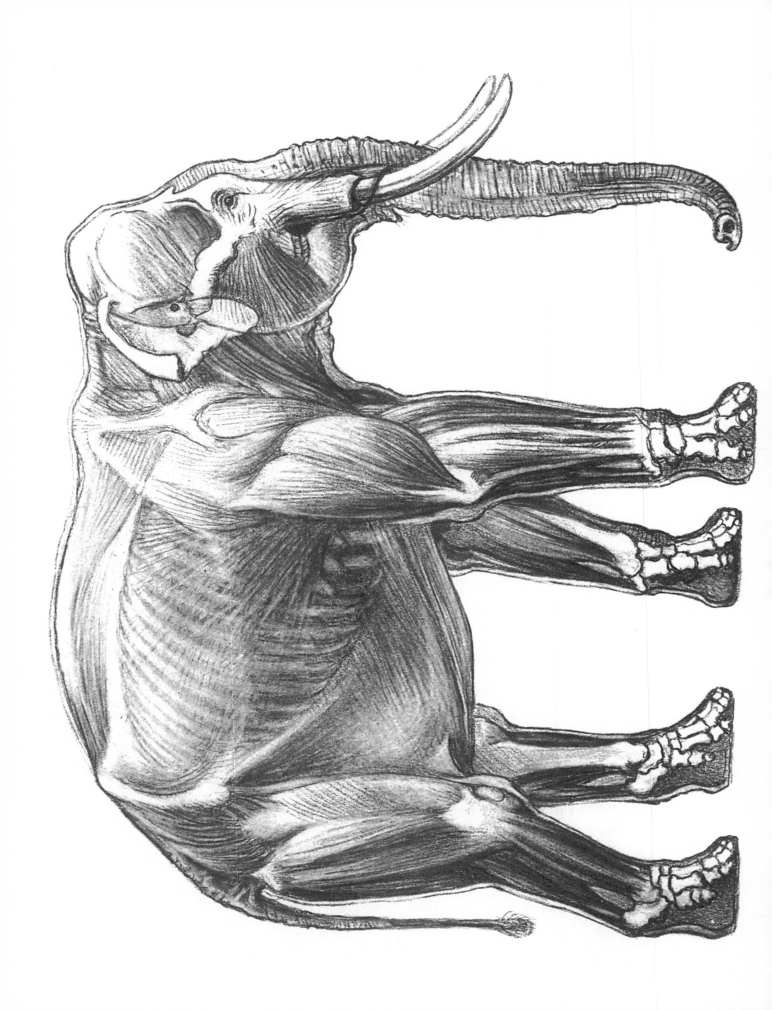

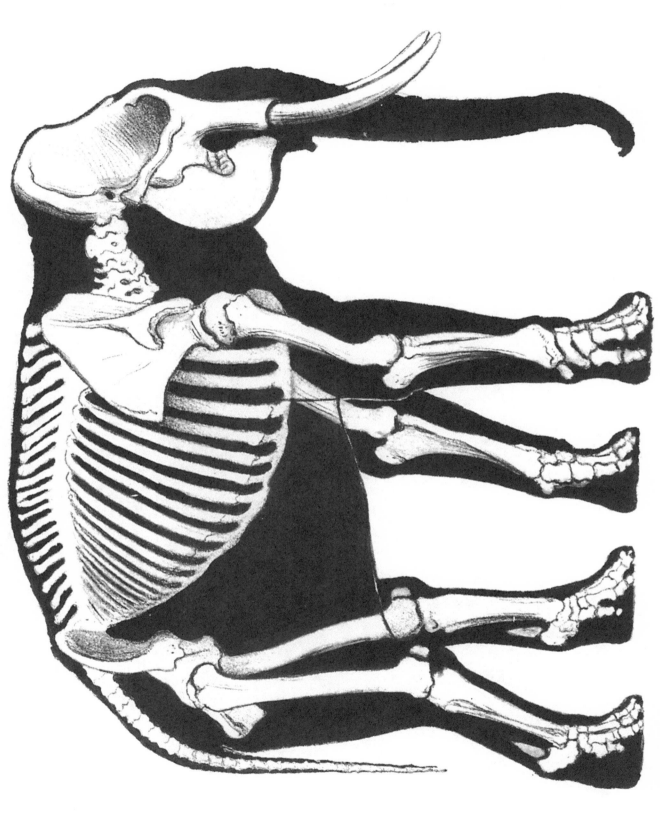

INDIAN ELEPHANT SKELETON

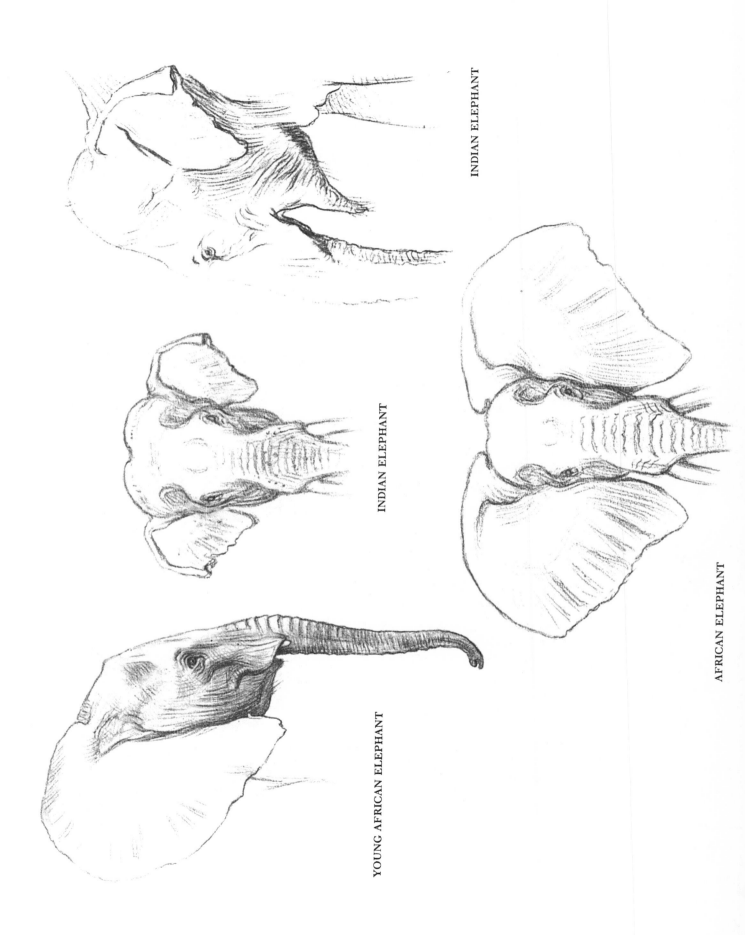

INDIAN ELEPHANT

INDIAN ELEPHANT

AFRICAN ELEPHANT

YOUNG AFRICAN ELEPHANT

Camels

There are at the present time no truly wild representatives of these singular animals either in Africa or in Asia, but in prehistoric times herds of camel-like or llamalike beasts of every size and proportion wandered over the open spaces of our own country and other parts of the world. Today we have the single-humped camel or dromedary in northern Africa and the large two-humped Bactrian species of northern and eastern Asia. In South America also there are camel-like creatures still to be found in the species known as the llama and several allied types. These are all much smaller than the true camels, and none of them show any signs of a hump.

Curiously enough, this most striking feature of the camel is not indicated in any way on the skeleton, being a fatty mass of flesh used as a food reservoir by the animal to draw upon in case of necessity. Camels can also go for several days without water, a fact that makes them invaluable to their Arab or Mongolian owners in the sandy wastes of the great African and Asiatic deserts. As a family the camels are unique in silhouette, the very long, upcurved neck, humped back, and long, thin legs terminating in soft, padded feet giving them a character all their own. They seem especially adapted to desert surroundings, where there is frequent danger of suffocation from sandstorms. This is guarded against by the long, slitlike nostrils, which can be closed against the wind-driven particles of sand that when sufficiently dense can be fatal to the luckless beasts and their drivers. The eyes are heavily shaded by long lashes, and the ears are very small and placed close to the top of the head. Strangest of all the camel characters are the great padded feet, which prevent the creature from sinking into the soft sand yet which also give a sure foothold on rough, stony ground.

In disposition the camel is a most disagreeable and sometimes dangerous brute, whining or grunting or biting and kicking viciously when in the mood. In walking or running the animal exhibits a singular appearance, the long legs apparently crossing and recrossing each other in a most puzzling rhythm. At the same time the head is held high in a stiff and ungainly manner. A rider perched astride the animals hump is thrown forward, then backward, with every movement of the ungainly beast. The camel, however, can travel long distances at a fair rate of speed. While the gait presents difficulties for the artist, the form of this singular creature is quite without precedent in the animal world and for this reason has deserved more than a passing notice.

As a subject for the painter, the camel under the deep blue sky and in the brilliant sunlight of its native land commands our attention as an object of more than ordinary interest. The effect against the setting sun of a train of camels, the long necks poised in an upward curve, humped bodies and slender, muscular legs all etched upon a brilliant golden background, is one that stimulates the imagination of the beholder.

In eastern Asia much use is made of the two-humped species as beasts of burden and for many other economic purposes. The fine and durable wool, or hair, is of great value to the Mongols, who comb it in great masses from the bodies of their ill-smelling and refractory charges. The Mongol drivers are unsurpassed in their knowledge of these powerful and sometimes dangerous animals and by a judicious mixture of force and persuasion seem able to get great service from them. In winter the huge, richly colored beasts are covered with a thick, dense coat of brownish hair longer on the underside of the neck and at the elbows. In summer most of this hair is shed in great patches, which give the creatures a forlorn and unkempt appearance. In action and character the species resemble their African relatives, though the double humps naturally impart a very different contour to the back.

The llama of South America is a close relative of the camel but as has been said carries no hump. It is used as a beast of burden by the Indians in high mountain country, but its small size makes it quite unable to carry heavy loads. The llama, as well as the alpaca, vicuña, and guanaco, provides valuable wool from which the natives weave cloth. No particular interest attaches to this picturesque creature. The anatomy is practically that of the camel, though all parts, especially the feet, are more delicately constructed.

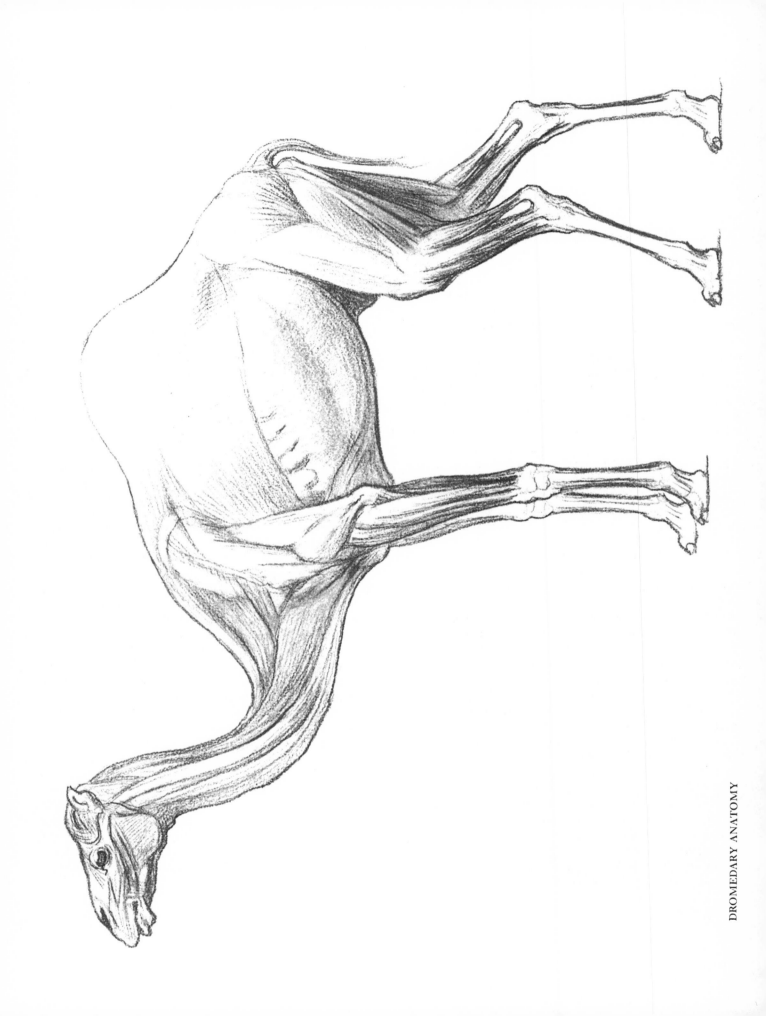

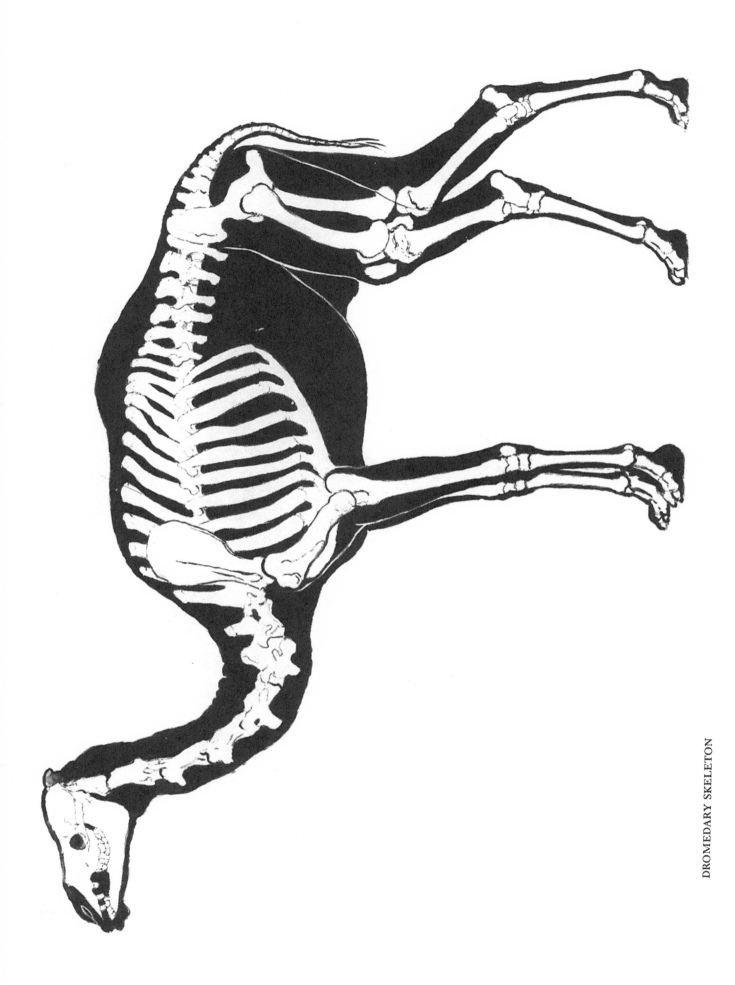

DROMEDARY SKELETON

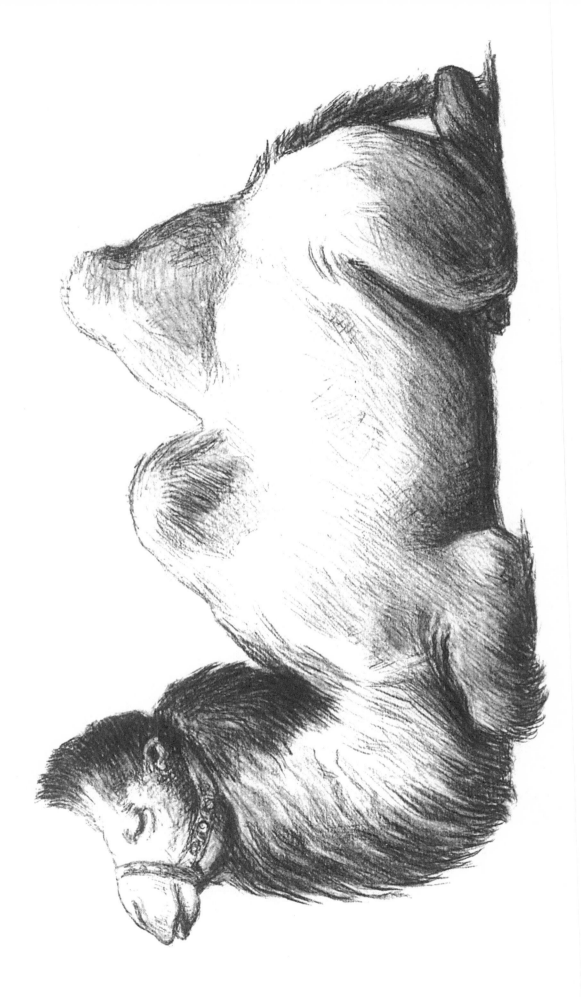

BACTRIAN CAMEL

Swine

The pig family is a decidedly interesting one in many ways, though it does not include a large number of species. The true wild boars, *Sus scrofa*, are found in Europe, Asia, and Africa, while smaller varieties inhabit certain East Indian islands. In this country and in South America the race is represented by two species of peccaries, the white-lipped and the collared forms. The grotesque and singular wart hog and the Red River hog are well-known African species, as is also a huge and rare brute known as the "forest pig." Asia has the very extraordinary Barbirussa, an almost hairless animal with a loose and heavily wrinkled skin and four long, recurved tusks, two of which (the upper pair) actually pierce the skin of the face, turning backward in a graceful curve until they almost touch the forehead. Wild boars of more or less the European type are other Asiatic forms. This meager list practically covers the wild species of swine.

The ancestry of the numerous domesticated breeds is not known. Some authorities consider China as their original home, but nothing definite has so far been ascertained on this abstruse and difficult subject. However that may be, we are all familiar with the pink, black, or orange high-smelling porkers of our childhood vacation days on the farm. With what delight we saw the hired man trudge to the pigsty carrying huge buckets of skimmed milk and house refuse, which he proceeded to empty with a splash into the long feeding troughs already half filled with hungry, squealing gluttons, each determined to oust the other fellow from his vantage point in the bread line!

In outward form and general proportions these sty-bred varieties are certainly different from their wild cousins; yet the skeleton structure and the muscular anatomy are practically the same in both types. Wild boars are slab-sided, long-legged creatures with upright, hairy ears, huge heads, and short but *straight* tails. A thick coat of coarse, greenish-black hair covers the entire body, elongated on the back and neck into a ridge, or crest, of stiff, almost upright bristles. In contrast to this striking silhouette the homebred forms present a squat, round, and ungainly profile, with more or less drooping ears, a rather sparse hair covering, and a distinctively *curly* tail. Nevertheless, these uncouth animals when subjected for several generations to almost natural conditions will appear as the so-called "razorback hogs" from our Southern states, closely resembling in form the true wild boars of the countries across the sea.

Wild pigs of all lands are exceedingly fierce and terrible fighters when brought to bay and can inflict ghastly wounds with their keen-edged tusks. These tusks are in reality a specialized development of the canine teeth, and their arrangement in the jaws is unique among animals. The upper tusks curve outward and upward on either side to the mouth, while the lower pair set closely against them when the lips are closed. The constant friction thus produced wears both pairs to a knifelike cutting edge and gives to the face of the boar that strange and sinister expression so characteristic of the species.

In silhouette the boars are without parallel among animals and should be very carefully studied from this angle by anyone wishing to model or paint them. The powerful snout (an almost triangular piece of cartilage surrounding the terminal nostrils) is used for digging up roots, tubers, or other edible substances. Huge, hairy ears stand out from either side the head but are laid back against the neck when the animal is angry or frightened. The small, greenish-yellow eyes, glazed under excitement, complete a most weird and unusual physiognomy. The crest of bristles already mentioned begins at a point on the forehead and extends along the back to the base of the tail, still further enhancing the crisp, angular outlines of the body. The legs are very straight, especially the hinder pair, which are nearly vertical from the hips to the ground. The small cloven hoofs and the prominent dewclaws enable the animal to travel well on soft and boggy soil.

The combined effect of these bizarre characters must be seen to be fully appreciated. Let us imagine as a case in point a boar hunt in prehistoric times, when man's only weapons consisted of wooden or stone-headed spears, heavy clubs, and crudely made flint implements. The desperate and thoroughly aroused quarry has come to bay at the base of a great beech tree, whose wide-spreading roots offer some protection from a flank attack. Heavy white foam flecks the huge jaws, and the gleaming tusks are held ready to slash and tear any unfortunate dog or man that may come within their reach. Indeed, several dogs have already been killed or grievously wounded, and one of the hunters lies prostrate and moaning in agony from a fearful gash in the thigh. Slowly but surely, however, the press of snarling dogs and equally ferocious human beings close in upon the savagely fighting boar, which battles gamely to the last gasp.

The fracas ended, sinewy hands grasp the still warm and reeking body of the wild pig, its feet are tied together, and it is slung from a stout pole and carried home in triumph. Women and children press forward to see and touch the dead monster, as the exhausted hunters cast the body to the ground. The animal is at once cut up, and great fires sear and burn the reeking, appetizing flesh, which is eaten greedily by the ever-hungry mass of uncouth humanity. A grisly and dramatic episode, if you like, yet one often experienced by our primitive ancestors. The scene serves well to picture for us the outstanding characteristics of the pig family—ferocity, courage, sagacity—all part of the group as a whole, and ones which we must understand in order properly to portray the true life appearance of these singular animals.

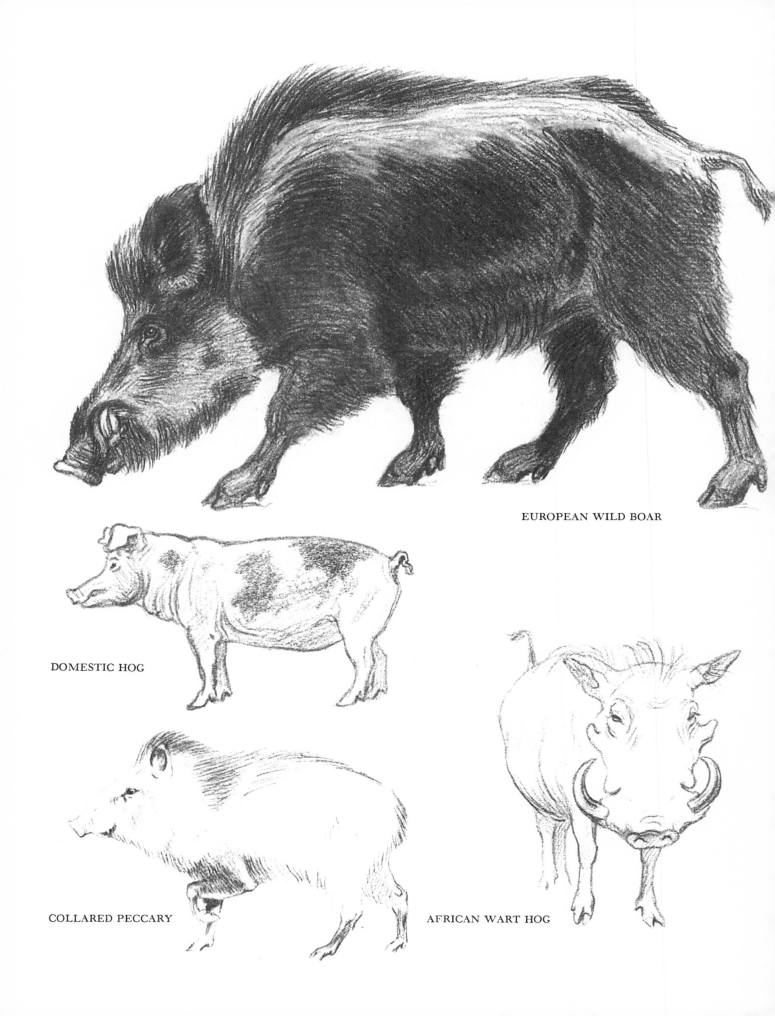

EUROPEAN WILD BOAR

DOMESTIC HOG

COLLARED PECCARY

AFRICAN WART HOG

Seals, Walruses, Sea Lions

With the exception of the whales and the manatees, no other branch of the mammalian stock has become so truly aquatic as the seals, walruses, and sea lions. In these strange creatures the limbs are reduced to paddles, the hip region is much shrunken, and the whole body is streamlined to an extraordinary degree. Scientists regard these changes as secondary adaptations; for all the mammals at one period of their history were dwellers upon the land, and the reentry into the water of certain types occurred ages ago. During this extended period both whales and manatees have become strictly fitted for a water-living existence, the hinder pair of limbs disappearing almost completely so that they are unable to leave the water. However, the seals, walruses, and sea lions are able to get about on terra firma, though in a more or less restricted way.

Of the three groups, the sea lions are much better fitted for a land existence than their near relatives, owing to the fact that their long flippers are not nearly so reduced in size and are quite capable of holding their weight as they clamber about upon a rocky seacoast. Sea lions have small external ears, while seals and walruses have merely an earhole at either side of the head.

There are several species of sea lions. The fur seals of the Pribilof Islands, whose undercoat of exquisitely soft fur has long been used as a costly adornment when fashioned into articles of clothing for women, belong to this group, as well as the great Steller's sea lions of the North Pacific and the California species celebrated in the San Francisco area, where they exhibit their wonderful swimming and diving powers to delighted tourists. This is also the species most often seen in circus performances and in zoological gardens, where its antics are a never-ending source of amusement and interest to our urban population.

Apparently no other mammal (not even the cat) has such a flexible backbone as this fish-eating, noisy seafarer, which can bend backward with perfect ease and touch its diminutive tail with its heavily bewhiskered muzzle. The swimming is done apparently by the use of the forward pair of flippers; but when the creature leaps upon some convenient rock or platform, all four limbs come into play and it can then, when so inclined, exhibit a fair burst of speed for a short distance. The gait, however, is merely a powerful shuffle from one side to the other and not a true run or walk as is the case with more highly developed land animals. In the water, the beautiful, glistening creature is perfectly at home, leaping like a porpoise in long curves or swimming below the surface at tremendous speed and with tireless energy. This magnificent control is of course necessary to

the animal's very existence, for it feeds entirely upon living fish or squid, which it catches in its open jaws as the hunted creatures dash to and fro in an effort to escape.

Because the California sea lion is, as I have said, by far the best-known type, I have chosen it as my anatomical model. At a glance, one sees its distinct affinity with all other four-footed mammals even though the proportions and general outward character of the limbs are distinctly unlike those of the usual pattern. To begin with, the sea lion's forelimbs are so modified that the animal rests the weight of the body not upon the soles of the feet but upon the wristbones, which, when the animal is sitting upright, are sharply bent almost at right angles to the arm and shoulder, the long toes and tiny nails being well protected on the underside by flaps of leathery skin, which project well beyond their bony tips. The whole ingenious contrivance is of course merely a highly modified form of the foreleg and foot fashioned into a long, flat, flexible paddle, or flipper. Much the same peculiar formation applies to the hind foot; this also is converted into a flipper, but in this case the whole region of the pelvis is so reduced in size as to be hardly recognizable to a layman. The femur, or thighbone, is very short, the tibia and fibula are quite diminutive, and the long foot rests flat upon the ground from the heel to the toes. The knee is much involved in the body contour; consequently the animal cannot advance the limb in the manner of a true land mammal but must shuffle along in a clumsy and flat-footed manner. In the water, these same flippers will be extended backward and used as a rudder to guide the swiftly moving creature in any direction desired.

For the sculptor particularly, sea lions exhibit some most interesting poses. They sit with upraised heads and necks in a very characteristic attitude. It is most necessary to understand what is taking place beneath that shining, moving mass of skin and flesh and blubber—where the neck bends upon the body and how the shoulder blades are indicated by extremely subtle planes and contours, ever changing as the lithe and sinuous creature twists and turns itself in a series of baffling and complicated motions.

The anatomy of the seals and walruses is practically the same as that of the sea lion, but the short front flippers and neck of the seals preclude any fast pace on land and force the creatures to shuffle along on their bellies—a slow and arduous method of progression. Artistically, therefore, we instinctively turn to the sea lion as our model. Really beautiful studies can be made of this most interesting and elegantly formed creature.

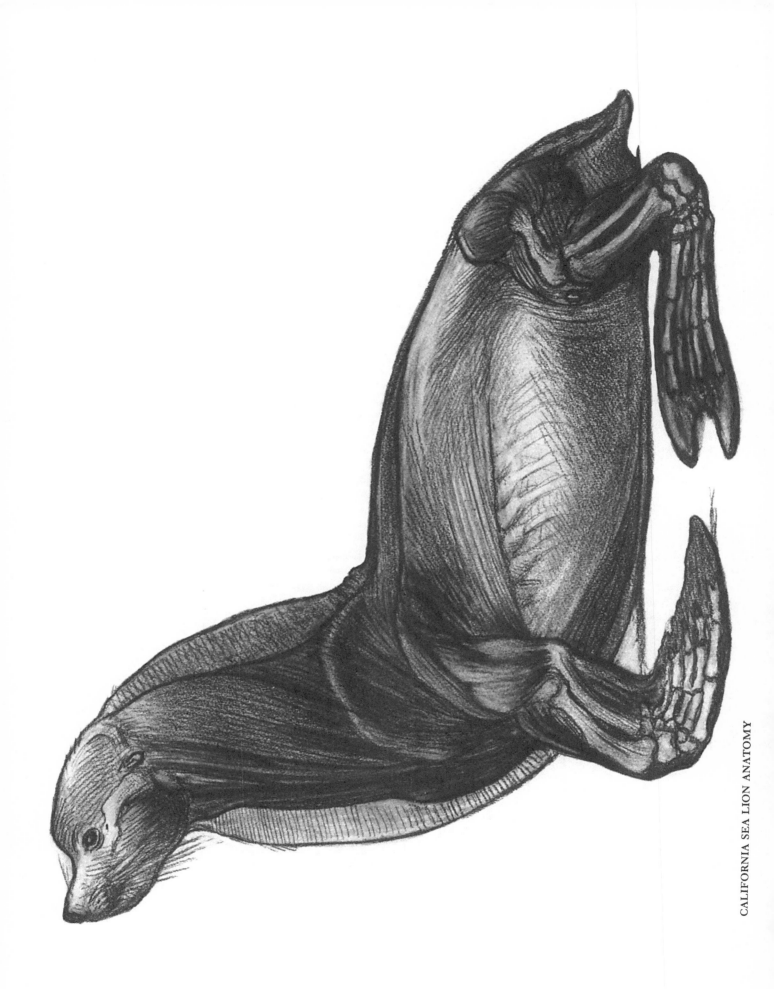

CALIFORNIA SEA LION ANATOMY

Rodents

The large and important rodent family comprises many curious and interesting physical types. In sheer number of individuals due to certain prolific species, they apparently outstrip any other group in the mammalian order. There are several important divisions of the family, among them the rats and mice, the hares and rabbits, the squirrels—both tree and ground forms—and the beaver-muskrat group. Besides these there are the various types peculiar to South America, *viz.*, the capybara, largest of all rodents, the agouti, the paca, the cavy or guinea pig, the viscacha, and the much-prized chinchilla of the high Andes. The last has the general appearance of a large and heavily furred squirrel. Most of the South American species have very short tails, which are practically invisible in the larger forms. The fore- and hind limbs are of nearly equal length, so that the creatures do not hop but walk in a normal way. The porcupines of India, Africa, and our own Northern country are all armed in truly terrifying fashion with a mass of long, needlelike, easily detachable quills. If the porcupine is alarmed these fantastic spines are more or less erected and the animal turns its back and stands in an attitude of defiance. Our own species is smaller than the other two but is equally well protected, though the quills are much shorter. Woe betide any young or inexperienced dog that tries to seize one of these prickly creatures! In an instant the unfortunate canine is howling in agony, his mouth and nose filled with the dreadful quills, which cannot be easily drawn out because of barbs along the shaft but must be pushed on through the lips or tongue.

The skull of a rodent is perhaps its most unusual physical character. The front part of the face is peculiar in form, owing to the great development of the upper and lower incisor teeth, which imparts a most striking profile to the entire head. Primarily gnawing instruments, these strangely developed teeth are so constructed that they impinge upon each other in a most unusual way. A glance at my drawing of a beaver's skull will explain what I mean. It will then be seen that a pair of incisors descend from the upper jaw to meet the upturning pair from the lower jaw, the tips of the latter working just inside those of the upper set. Owing to a unique structure of the muscles of the head, the lower jaw is pushed backward and forward in gnawing, the four great teeth acting like chisels to chip away any hard substance on which the creature may be working. Beavers, as we know, are especially proficient in this line. They fell trees of considerable size as with the blade of an ax. The branches are lopped off and the bark and shoots either used as food or incorporated in the wonderful dams behind which the creatures construct their dome-shaped houses and in which they live in winter, resting and raising their young, safe from marauding foxes, wolves, minks, or even man himself. All rodents have the power and urge to gnaw except the rabbits and hares. These chew from side to side, a point that scientifically removes their species from the true rodent line.

Squirrels, as we know, make short work of the hard shells of a hickory nut, neatly chipping away the flintlike substance, which easily defies anything but the sharpest chisel. The attitude assumed by a squirrel under these conditions is one that we as artists must study closely in order to understand what is taking place. The animal when tempted by a nut advances cautiously, seizes the food firmly in its handlike forefeet, and sits back sharply upon its haunches, curling the long and beautiful tail in an S shape over its back. It then presses the nut hard against its lower jaw and begins to gnaw away the tough shell. Almost like magic, the little chips fly as the alert animal shuttles the nut back and forth against the sharp incisors. Seemingly in an instant a hole is opened through the resistant substance, and the coveted meat either swallowed or held in the capacious cheeks. "Simple and easy," we say. Yes, for a squirrel, but how impossible for us unless we have a hammer or a nutcracker conveniently at hand. In this little incident we have seen a true rodent demonstrate his most outstanding ability, and at the same time we have observed the peculiar face with its sharply receding lower jaw, the wide-set, side-seeing eyes, and the hard, tense, muscular body almost concealed beneath the soft fur. Color and texture as well have come under consideration and must all be checked in our memory as part of what constitutes the rodent character.

Rabbits, owing to their mild disposition, and their ability to live well and multiply in captivity, are perhaps the most familiar branch of the rodent tribe. The lovely, soft, long-eared creatures assume all manner of picturesque and interesting poses. Their delicate ears may be down or raised brightly in attention. The body may be stretched to its full length and again contracted into a furry ball. Soft, delicate colors—black or white, a mixture of both, or exquisite shades of fawn, gray, or deep brown—enhanced by a most delightfully bright and shining fur texture make rabbits very suitable for painting. The well-defined hair tracts, unique silhouette, and great variety of pose are all equally appreciated by the artistically inclined student. A knowledge of subtle body planes, correct proportion, and the massing of the furry sections will be of great use in expressing the beauty of the tribe as a whole.

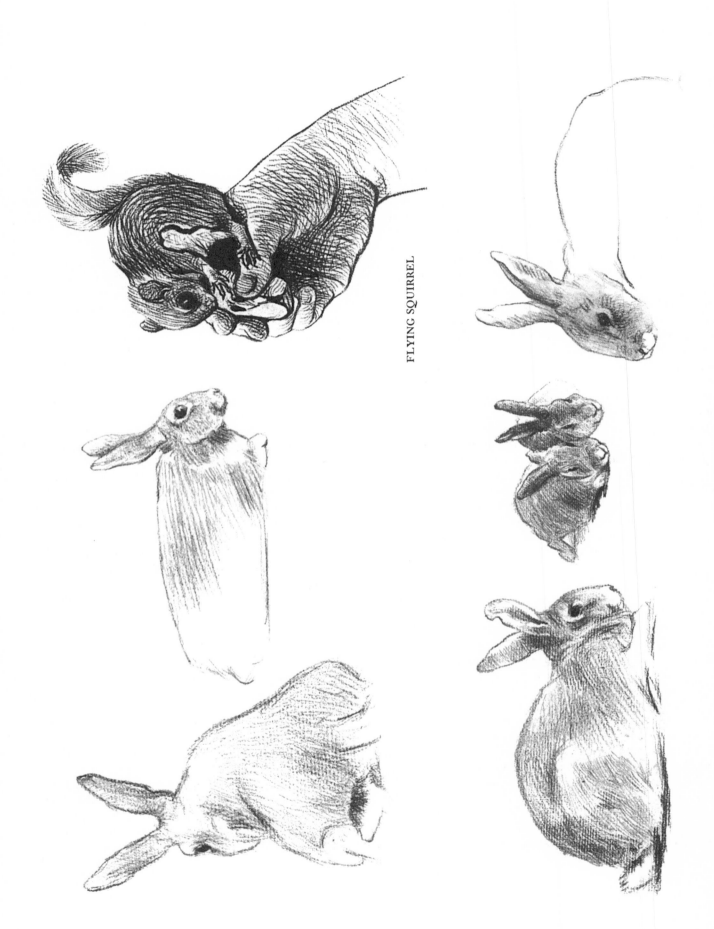

FLYING SQUIRREL

DOMESTIC RABBITS

Young Animals

Since the young of most animals differ considerably in general proportions from their elders, they will require careful study. There are great variations even between the young and the very young, particularly among the carnivores, or flesh eaters.

The carnivores are distinctly immature at birth and in the case of bears almost embryonic in their physical development. Kittens and puppies are at first very wobbly little creatures, with small, rounded ears, soft feet, and thin, short, pointed tails. The bleary eyes are bluish in tone, and the animal can crawl about only with difficulty. Soon, however, a great change comes over these tiny weaklings. The ears begin to grow enormously, the eyes become bright, alert, and intelligent, and the once small feet and legs, particularly in puppies and the big cats, are now big-boned to the point of clumsiness, while the once wispy tail essays to assume its adult shape and proportion.

Nothing perhaps in the whole realm of animal life is more delightful than the gambols of a group of half-grown kittens or puppies. Kitty is of course much more graceful, more agile, and also (even at an early stage) more sinister. To us for whom animal study will perhaps become a profession, these intriguing movements are of the greatest importance, for they introduce us to the very mainsprings of the animal's character. Light as air, moving with lightninglike rapidity, or creeping stealthily upon imaginary prey, the baby feline displays all those deep-seated ideas and actions that will be of great use to it in later years. See how noiselessly the little creature advances upon its adversary, body crouched close to the ground, bright of eye, ears erect, every muscle ready for action, and how in one quick rush with outstretched limbs and claws extended it hurls itself upon a baby brother or some swiftly moving object. If brother is perchance the victim, he gives as good as he takes and for a moment there is a rapid exchange of blows as the fierce little fellows grapple in very realistic style. Again the moving ball (replaced in later years by a bird or mouse) is pounced upon, seized by the two grasping front paws, and bitten into with very well simulated ferocity.

It is stimulating to see this little play, no farce but surely a rehearsal for what some day will be a real tragedy, for the gambols of all young animals are but a preliminary exercise to the desperate struggles of adult life. Baby lions go through exactly these same maneuvers, thus fitting themselves for future battles, perhaps against a tough old buffalo or a sharp-horned antelope, a melee wherein the king of beasts will need every ounce of his great strength and all his muscular agility. Personally, I can think of no finer practice for the student of animal motion than con-centrated observation of young animals at play.

Puppies, true to their type, are tremendously interesting, always performing their little canine stunts along their own particular lines. See how they rush, growl, seize an object with their tiny teeth, hang on for dear life, worry it or some other puppy as the case may be, and generally though in a somewhat clumsy way exhibit most of the doglike traits of their intelligent parents. Dogs, however, develop more slowly than cats, particularly in the matter of speed, and until they are adult do not show to any great extent that extraordinary ability to follow by scent so beautifully demonstrated by the adult animal. The sustained running powers of a full-grown dog are of course one of its most astonishing traits. Nevertheless, the puppy does his best to emulate the grownups, tearing about in every direction, falling over obstacles (his leaping powers are small), but not actually developing any great burst of speedy progression until the great day arrives when, with all his muscles developed, with nose to the ground and at tremendous speed, he can follow up the fleeing deer or fox, a mature and dangerous canine in every way.

From a muscular and skeletal point of view, young animals are more or less undeveloped. Their muscles are small, soft, and not well defined. But every bone and every bit of flesh and tendon is working as it will work eventually, though the general proportions may differ widely from those in the adult animals. Even in the joy of watching our kittens perform their delightful antics we must not lose sight of their wonderful construction and what makes the wheels go round so faultlessly. One might say that, in general, loose joints are characteristic of young animals, especially in dogs and many grazing hoofed types. There is not that tautness and steel-like elasticity evidenced by the older animal. Baby joints are often big and swollen looking, not trim and angular as they become later, and colts and calves certainly have enormously long legs and little feet. However, all grazing animals without exception (horses and cattle, sheep, goats, deer, and antelopes) are very precocious at birth, a calf or a kid being able to stand within a very short time. This must be so, of course, from the very nature of things, since nice little calves and lambs and other such small fry are toothsome morsels for hungry flesh eaters. Mares with a colt can and will show fight, but the baby has small chance of survival unless he can move about with some agility or can run a short distance, then drop down and hide if possible. Fawns are exceedingly good at self-concealment, their spotted coats rendering them almost invisible in high grass or dense foliage.

Colts are pretty little fellows as they run beside the mares across some clover field, but they are not graceful. They jump

playfully about, to be sure, but in an awkward manner, as do calves at a similar age. Lambs and kids are most intriguing little fellows, full of life and energy, leaping upon any convenient rock with sure-footed ease even at a very early age. Kids in particular are most agile, butting each other while standing erect, head against head, as they will do later when powerful horns have grown upon the thick, tough skull and the males will spar and fight in sober earnest in the mating season. Young goats have always been a favorite with sculptors, as indeed they should be, so devious and intense are all their movements, while the delicately fashioned bodies show well all those little vagaries of hair tracts of which we have spoken in another chapter. The feet of a goat are very indicative of its mode of life, the tough strong hoofs being able to hold tightly to the rocky and dangerous terrain so beloved of the entire family. Sheep, certainly domestic sheep, are not specially addicted to rocky country, but their wild relatives are the equal of any goat or ibex when it comes to climbing up or down apparently impossible precipices. To accomplish these feats requires not only power but unsurpassed sure-footedness, a clear eye, and a steady head. Even our domestic baby goats and lambs show to some degree these outstanding characters, and when we model or paint them we should try to express these singular traits to the best of our ability.

Perhaps no wildwoods baby is more generally interesting than a bear cub as it ambles about after its solicitous mother or stands erect like a little man, curious, muscular, with an insatiable appetite and a most remarkable ability for getting into trouble. Because of the manlike hind foot (resting almost from toe to heel on the ground) bears can stand upright with comparative ease, and they often assume this position even in a state of nature. Young bears especially are good tree climbers; but as their weight increases, the adults become less and less arboreal. Though born in a very incomplete state of development (they are practically hairless and more or less blind for weeks), the cubs quickly reach a stage wherein they can perform almost incredible feats of strength and agility, traveling long distances with the mother bear over rough and difficult country or climbing steep rocks and ascending trees to a very considerable height. Our American black bear is a particularly good climber, but grizzlies rather avoid heavily wooded regions.

The fact that the upright pose can be so easily maintained releases the forelegs and feet for uses other than walking, so that bears, both big and little, box with great facility and also seize and hug an adversary, at the same time biting with more or less severity. Two little bears will thus square off, the arms and clawed forefeet flailing the air with rapid strokes as they clinch like wrestlers, roll over and over, and vastly enjoy this rough-and-tumble play.

Bears have large and powerful breast muscles and great ease of movement in the long, flexible forelimbs; models or paintings of them give plenty of scope for violent action. The feeling of bulk, however, must always be present in any rendering of the massive form, as they are above all things stocky, broad, and powerful even at a tender age. Observe also the hair tracts so plainly seen and so important in these creatures. The planes of the body and head are also very distinct and must be carefully rendered or the animal will look stuffed and swollen instead of angular and powerful. Bears of any age are not graceful, but they have a character all their own. Unique in their movements they make splendid subjects at all ages for the sculptor.

Young animals in general we may sum up as being not very graceful, except in the case of the cats, lacking the powerful, taut, steel-like quality of the full-grown creature. But their charming ways, baby faces, and extraordinary variety of pose make them highly desirable subjects for artistic translation. Not only their anatomy but their peculiar psychology as well will be a never-ending source of pleasure and real study for the animal enthusiast. Above all, be sure to make them look *young*, not merely little mature animals. This can be accomplished only by noticing the points to which attention has just been directed.

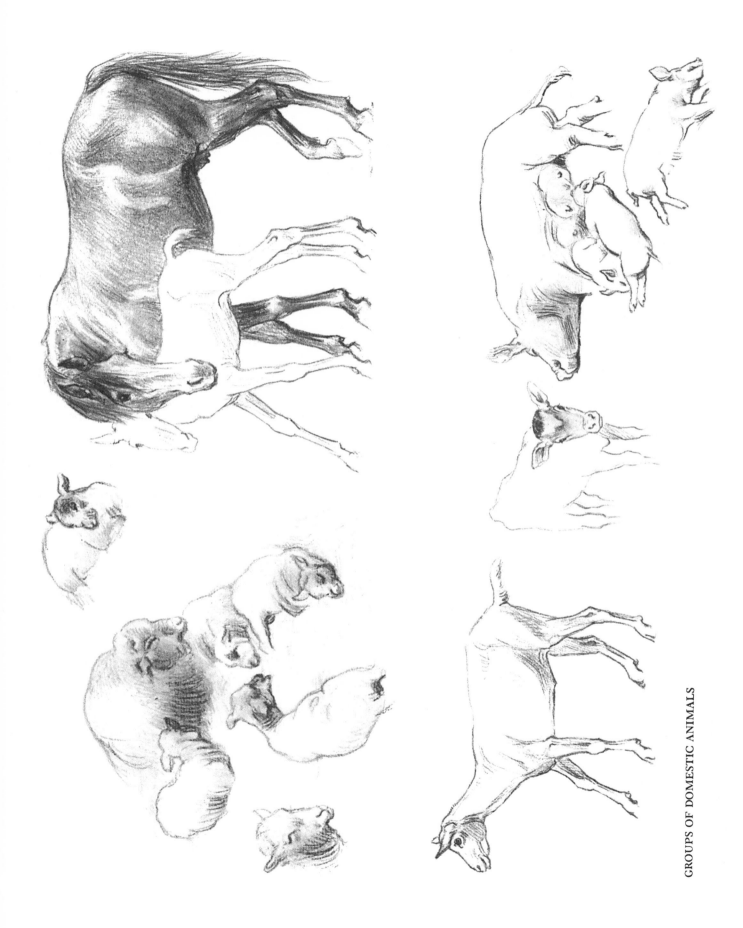

Exotic Types

While we may say that, in general, mammals employ their four limbs as a means of progression, there are several exotic types to which this rule does not strictly apply. Chief among these is the kangaroo, an Australian marsupial, or pouched animal, a creature of such extraordinary hopping or leaping ability that it is recognized as the acme of perfection in this line. There is a vast discrepancy in size and function between the short forelegs armed with sharp, recurved claws and the huge, heavily muscled hinder pair terminating in long, straight nails. To be sure, the front limbs do partly support the animal, especially when it slowly advances while feeding—or resting. At this time they are used like a pair of crutches, except that the crutches are held closely together, the long hind legs swinging forward on either side and coming to rest squarely on the ground from heel to toes. At other times they function as hooks, either to bring food within reach of the mouth or when, the animal standing erect and in an attitude of defense, they grasp and hold an adversary so that the great hind feet can deliver a terrific and disabling forward and downward kick. While in this extraordinary posture, with head thrown back, hind limbs straightened, and the thick, muscular, sharply bent tail pressed hard against the ground, the kangaroo presents a silhouette unique in the animal world.

Undoubtedly these same hind limbs constitute the most interesting part of the kangaroo's anatomy, for in them lies the secret of the animal's enormous leaping power, driving it forward when alarmed in a series of astounding hops or jumps, the violent action being assisted by the stiffly held tail, which rises and falls like a pump handle, at the same time balancing the creature in its onward rush.

There are several species of kangaroo, one a tree-living variety, much smaller than the great gray and red forms but conforming to the usual anatomical formula. They all carry the young, which are absurdly small and undeveloped at birth, in a pouch on the belly of the female. Within this pouch the newly born infant finds shelter and food, attaching its little mouth to a nipple through which flows the life-giving milk—all the nourishment it will receive during a long period of growth. When able, it will crawl out of its warm, luxurious home and feed with the mother on tender plants. But at the first sign of danger back it will go into its haven of refuge to be transported to safer climes by its energetic parent.

Besides the kangaroo, Australia possesses a number of strange-looking marsupial types, some wolflike, others having the appearance of squirrels, as well as big-headed flesh eaters, the so-called Tasmanian devil, for example, and phalangers, koalas, wombats,

and many others, all strange and all confined, with the exception of the phalangers, to the continent and its adjacent islands.

Our own Virginia opossum is a marsupial also—a stray from the main Australian group and considered by authorities to be the world's most primitive mammal, possessing as it does not a few quite reptilian characteristics. The very embryonic young, some ten or twelve in number, like the kangaroo baby live after birth in the mother's pouch, each attaching itself to a nipple until such time as it can fend for itself. Then all the little crew crawl on the mother's back where they cling to her long hair and get free transportation while she pursues her search for food—fruits, insects, chicken, berries, a highly varied and always nourishing diet.

None of this assemblage of strange animals is built upon the kangaroo plan. They are strictly normal in their movements, and the fore- and hind legs are much the same in length. Our own rabbits and hares, however, as well as an African rodent, the jerboa, again show the discrepancy in length between the fore- and hind limbs and move, though to a lesser extent, in the kangaroo manner.

We all know our wild cottontailed rabbit and the dreamy-looking long-eared bunnies ensconced in their hutch in our own or a neighbor's backyard. They too shuffle slowly about in feeding or astonish us by a series of vigorous gyrations, leaping lightly over great obstacles by means of the great muscles in their long hind legs and kicking viciously when seized by the elongated, soft ears, reputedly the only proper way to handle them. Rabbits have very short tails, which stick straight up when the animal is running. The body carriage, unlike that of the kangaroo, is almost horizontal. They hop in a series of long, powerful motions and can travel at great speed and for long distances.

In the armor-banded armadillos, those strange prehistoric-looking animals from some of our Southern states, Mexico, and South America, the powerful legs and heavily clawed feet are used for digging tunnels or runways underneath the surface of the ground in search of food, as well as for shelter and protection against enemies. So enormous are the front claws in certain species that the animal actually walks on their downward-pointed tips, a unique method of progression in the world of mammals. Besides these great weapons, the animal can roll itself into more or less of a ball, the head and forelimbs curling forward to meet the upturned hind limbs and muscular tail; in this position, the creature presents a baffling surface of hard plates to any potential flesh eater, which may seek in vain to penetrate this most unusual defensive skin covering.

It seems a far cry from these uncanny earth-bound monstros-

ities to the lightly constructed family of flying mammals known as the bats. These little beings have very much elongated fore-limbs and fingers, but in contrast to the feathered birds the flying surfaces of the wing are composed of a tough, very elastic membrane, which is stretched between the widely distended, downward-curving fingers and attached firmly to the knee of the hind limb. Powerful breast muscles cause these widespread, oddly shaped wings to move with great speed as the bat dashes through the dusk in pursuit of the insects upon which most species subsist. Certain large East Indian forms, known as "fruit bats," or "flying foxes," are vegetarians. They present a curious sight when sleeping, hanging head downward from the branches of the trees, the intricately folded wings wrapped closely about the pendent body. So-called "flying squirrels" do not actually fly but can plane downward for considerable distances, assisted by the tightly drawn folds of skin extending along both sides of the body, between the fore- and hind legs.

In tremendous contrast to the foregoing, the rhinoceros, while not unusual in its muscular and bony development, presents by virtue of its thickened hide and horned nose one of the strangest contours to be found among the mammals. In the single-horned Indian species, for example, great folds or plates of heavy skin sheathe the ponderous form over certain well-defined areas, while from the tip of the creature's nose rises the rather short but sturdy horn. Both the African types—white and black—carry two horns, which are longer and slimmer than those of the Indian form. The animals themselves are long-legged and active, and the skin is much less heavily folded than in the Indian species. They are technically related to the horses and tapirs, and in the distant past all three races quite closely resembled one another. In spite of their clumsy appearance, the two African varieties are very quick on their feet, are good long-distance runners, and at times are inclined to be aggressive. The unique profiles of these odd animals render them excellent material for a sculptor, the lack of hair showing clearly the planes of the long, rangy body and the more or less plated skin giving variety to the surface treatment.

Though the pachyderms are classed as a group, they represent widely different types in form and characteristics. The rhinoceros, hippopotamus, elephant, and tapir each has its very singular profile. Mentally the elephant eclipses the others in its extreme sagacity and general astuteness under varying conditions. The hippopotamus, vast, uncouth, short-legged, with enormous head and jaws, its eyes, nostrils, and ears all set close to the top of the skull, is a water-living animal. There, protected from its enemies, it sleeps, swims, and cares for its young, coming out to feed at night upon the banks of the lakes, rivers, and streams of its native Africa. Tapirs, both the South American and the Asiatic species, are also very fond of water, but they can and do spend far more time on land than the great African monster. A small proboscis like a miniature trunk

hangs over the lower lip of these primitive creatures, and the body silhouette is unique, the pelvis almost vertical, and the very short tail pressed closely against the body.

While all these various forms are quite distinct each from the other, they can hardly compare in unique proportions with the towering animal known as the African giraffe. Long-limbed and long-necked to a degree, this remarkable animal yet presents no very unusual features in its muscular anatomy, the neck containing the number of vertebrae (seven) usual to most mammals and the stiltlike legs being much like those of the antelope. The head, however, is unique in that it carries three small skin-covered horns, one broadly based on the forehead and two (as in other horned animals) on the top of the skull. Only one other animal, the okapi (quite new to science) possesses this unusual type of horn structure. The okapi too is a native of Africa; it lives in the densely forested Congo country, whereas the giraffe browses upon the leaves of certain trees and shrubs in open, parklike regions of the great continent.

In drawing the giraffe, one must not be overawed by its extraordinary proportions or confused by the grotesquely blotched skin, which is of a lovely golden-brown color, broken by delicate lines of creamy white into an irregular honeycomb pattern. After the abnormally long neck and legs and the very short, sloping body, the curious junction of the neck and shoulder region will at once attract our attention. At this point the forward ends of the long shoulder blades project sharply across the line between the neck and breast, giving a very definite and unusual silhouette. In fact, so odd, so attenuated, and so highly specialized is the giraffe that the old farmer's remark on seeing one for the first time, "There jest ain't no sech animal," seems particularly appropriate in describing it.

There are, of course, many other species of mammals fitted for special niches in Life's great gallery, but they are far too numerous to more than mention here. In most the underlying construction is not very different from that of the better known types. The various monkeys are a case in point—ranging all the way from the manlike apes through the baboons to the numerous species of smaller monkeys scattered throughout the world. South American spider monkeys, for example, have long prehensile tails, with which they can grasp objects with fingerlike facility. Indeed, this most useful contrivance is constantly employed as a fifth hand or foot, the long-armed, long-legged creature dangling in this way in perfect safety from a tree branch or other fixed point of vantage. Only South American monkeys possess this singular power, the many long-tailed species from Africa and Asia being unable so to employ their tails.

Certain lemurs, especially the ring-tailed variety, carry their long, black-banded tails in a graceful S curve above the back. The South American sloths creep slowly about under the branches of trees, hanging upside down by means of their long, recurved claws hooked firmly to the overhanging limb. Otters

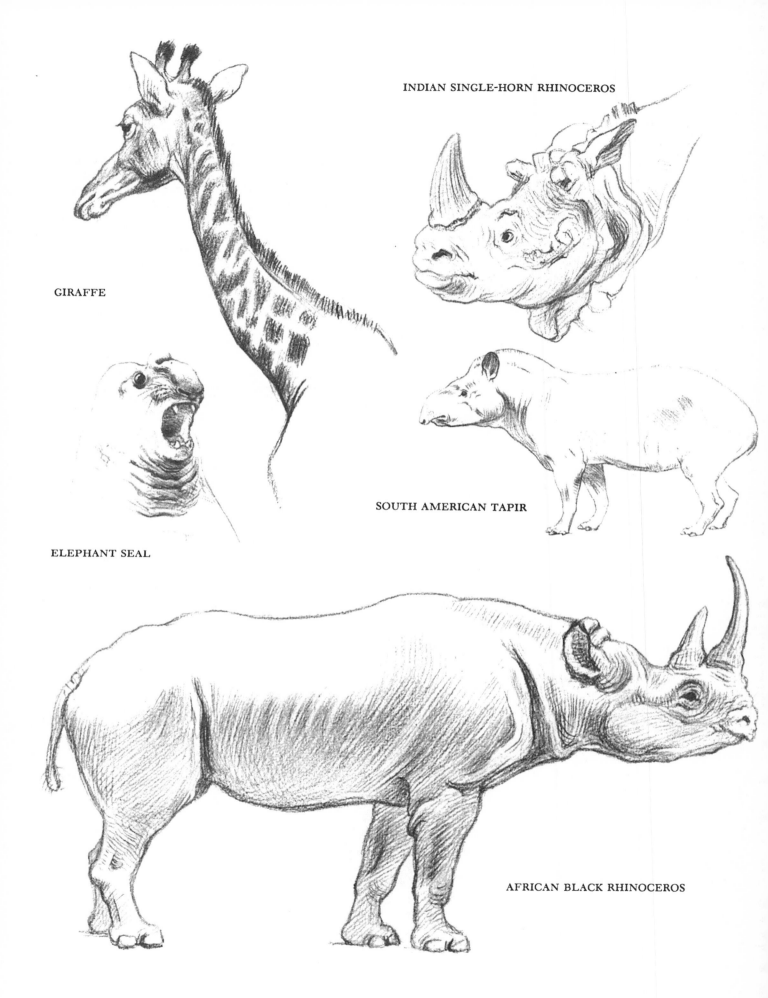

GIRAFFE

INDIAN SINGLE-HORN RHINOCEROS

SOUTH AMERICAN TAPIR

ELEPHANT SEAL

AFRICAN BLACK RHINOCEROS

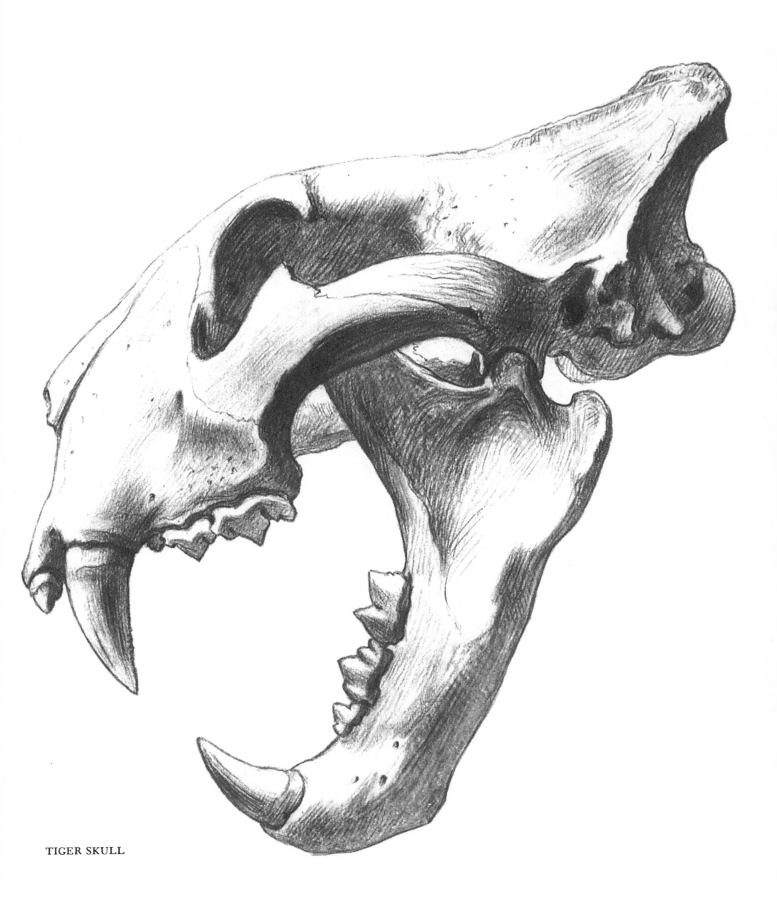

TIGER SKULL

are almost seal-like in their swimming capabilities, the long, sinuous body and tail weaving through the water with the greatest ease and speed. They are affectionate and very playful animals but determined and desperate fighters when attacked. An otter in the water is one thing, but an otter on land is quite another, for here it progresses in a series of shuffling gallops, the back distinctly arched and the hind legs sadly inefficient as walking or running members because the knees are well within the body form, precluding much free motion.

In this very brief résumé of more or less exotic species of mammals, some of the more striking types have been chosen as examples of divergent construction, but the artist will realize that in the last analysis all animals are decidedly individualistic. With practice and observation, he will soon be able to grasp at a glance just what constitute the *special* attributes of his model and wherein it may differ from the more common expressions of animal anatomy and psychology with which he is better acquainted.

Animal Expression

Undoubtedly the eyes of any living creature indicate to a greater or lesser extent the inner feelings and emotions by which the bodily actions are controlled. In the human species and in varying degrees among less intelligent mammals the expression changes from time to time; fear, anger, curiosity, and the gentler and happier states of being are all mirrored in this wonderful seeing mechanism. This being the case, we are prone to glance first at the eyes of all the higher animals, feeling instinctively that within their depths we shall be able to read just what is passing through the creature's mind and to shape our own actions accordingly.

Naturally, the eye of man, owing to his extraordinary brain development, exhibits by far the most varied and complicated series of expressions to be found in any animal. But the apes, dogs, cats, and many other types of mammal also have very revealing eyes, which under the stress of passing emotions dilate or contract, become bright with excitement or glaze in anger or alarm. To an artist the subtle shades of meaning conveyed by the organs of vision are of supreme importance. What portrait painter, for example, does not study their ever-varying lights and depths and shades of color, how the lids around them are formed, and what happens to them as they reflect the inner moods? The soft glance of love, the bright, coquettish look, the hard and even savage glare of hate or anger, and the introspective impersonal gaze of the thinker—these are but a few of the many degrees and types of expression which confront those of us who essay the human animal as a part of our art work.

Monkeys, at least certain species and the great apes in particular, also exhibit a certain number of moods or phases of emotion and changes in the eye expression, but even these are very limited compared with our own capacities in this direction. Fear, anger, interest, and a minimum of concentration they do show, but in this respect they cannot compare with the domestic dog. Within the eyes of a pet dog dwell a number of the most heart-warming and even soul-stirring glances found among mammals. Just how the spaniel, for example, acquired that adoring, languishing, pleading eye we cannot say. But words are not necessary to convey the meaning of this concentrated regard, which seems a far cry from the hard, cold, crafty, and suspicious stare of his close relative, the great timber wolf. In this dour and wary animal the light, greenish-yellow iris is in strong contrast with the small, dark pupil. The fierce light behind the baleful gaze is easily understood by a human being, who shrinks instinctively under the gaze.

All the cats, both large and small, have highly developed and characteristic eyes. In the larger forms the pupil of the eye reduces to a circle, not a vertical line as does that of our domestic species. This is a point to be remembered in drawing or painting them. A mistake here is quickly noticeable by an expert, and the artist himself will not be able to impart a true impression of the creature unless he grasps this point of peculiarity. Lions have fairly large, glowing, golden-yellow eyes, which on occasion may alter considerably in expression. When the creature is at rest, they are deeply sunken beneath the shadow of the heavy upper lids but light up instantly when the big feline becomes interested, alarmed, or angry. Tigers possess singularly cold, greenish eyes, which glaze with anger or concentrate in a terrific exhibition of feline ferocity. Leopards, and jaguars, especially the former species, stare boldly and menacingly from their hard, bright, cruel eyes, seemingly able to look straight through one and beyond. The wide, insolent glance is quite in character with the inner make-up of these sinister cats, perhaps the most daring and intelligent of all felines. The house cat, whose eyes are vastly larger in proportion to the animal than are those of its great relatives, possesses, as has been said, the vertical, slit contracted pupil instead of the small circle so characteristic of all the larger species. This singular property naturally imparts a peculiar effect to the regard of our domestic tabby and seems to enhance the menace in its glance. We are accustomed to the look, and so we are apt to discount its terrifying effect on a smaller animal or bird. On analysis, however, I can conceive of no more dreadful apparition to meet than such a creature enlarged to the size of a Bengal tiger. The unfortunate mouse or sparrow confronted by what seems to its diminutive self a similar monster must perforce be petrified with fright and thus be likely to fall an easy prey to the ferocious killer.

Quite in another class is the lustrous eye of a gentle horse, evidencing confidence and affection. In fright or anger, however, the same creature will roll back the whole glistening orb and expose the white at the forward point, its whole expression thus being utterly changed.

The eyes of cattle may or may not be pleasing in effect. Among the domesticated breeds, the Jersey cow possesses lovely, large, soft eyes, enhanced by a dark ring of hair about the edge. The bull has a naturally lowering look, the white often showing at the back of the eyeball when the fierce creature lowers his head to charge a real or imaginary enemy. The American bison and the African buffalo both have hard, intent, truculent eyes, those of the former surrounded by a large ring of curiously disposed hair tracts and those of the latter almost covered by heavy, overhanging eyelashes under which the glowing orbs stare balefully.

Goats and sheep have unusual eyes in that the pupils are long and horizontal, giving to these animals their characteristic appearance. The deer and many antelopes display some delightful variations of the eye, though the soft expression of many species belies their true character. Camels and giraffes also have beautiful, soft, long-lashed eyes; in the former, a very disagreeable personality is masked, the lashes merely serving to protect the delicate vision from sun glare and sandstorms.

Bears have singularly small eyes scarcely visible at times in their huge furry faces. There is some doubt as to the power of their vision, but they make up for this possible lack by their keen sense of smell and hearing. The eyes of a bear when fully aroused can gleam and flash in a truly terrific fashion as the great brute, rising to a standing position or crouched low with head down, prepares for battle.

Although, as has been said, the monkeys cannot compare with man in the variety of emotions conveyed through the eyes, their extremely mobile features, combined at times with brilliantly colored lips and noses, can impart a number of amusing, grotesque, and sinister variations to their usually rather masklike faces. Indeed, we must not ignore in our study of this important phase of artistic anatomy the large part played by the peculiar setting of the eyes in each species and how much depends upon the surrounding construction of the face itself. Gorillas gaze gloomily out from under the heavy bone ridges of the brows, while chimpanzees make all manner of amusing and very human grimaces, laughing, shrieking, and crying, their wrinkled noses and long, mobile lips adding greatly to their buffoonlike appearance. Orangutans, especially when young, look mournfully at the visitor; the older specimens exhibit when alarmed or annoyed a very savage glare. It is in the baboons, however, that grotesque color and strangely developed bony contours attain their most singular and bizarre pitch. Male mandrills, for example, exhibit very oddly shaped nose ridges, brilliant blue in color with the end of the snout a scarlet hue. The chin is adorned with a sharply pointed beard of yellowish hair. From this maze of varied tints the fiercely brilliant little eyes concentrate with a devilish gleam under the heavy protruding brow ridges. At the same time the animal may indulge in an exhibition of his long, sharp canine teeth, particularly on the side toward the observer—altogether a most weird and in some ways a most repulsive performance, quite in line, however, with the saturnine character of these cunning and ferocious animals.

One might continue indefinitely describing all the facial and eye peculiarities of each species of animal. But at least a few familiar types have been summarized, and the necessity has been shown for a very careful study of this highly important index to the character of any given mammalian type.

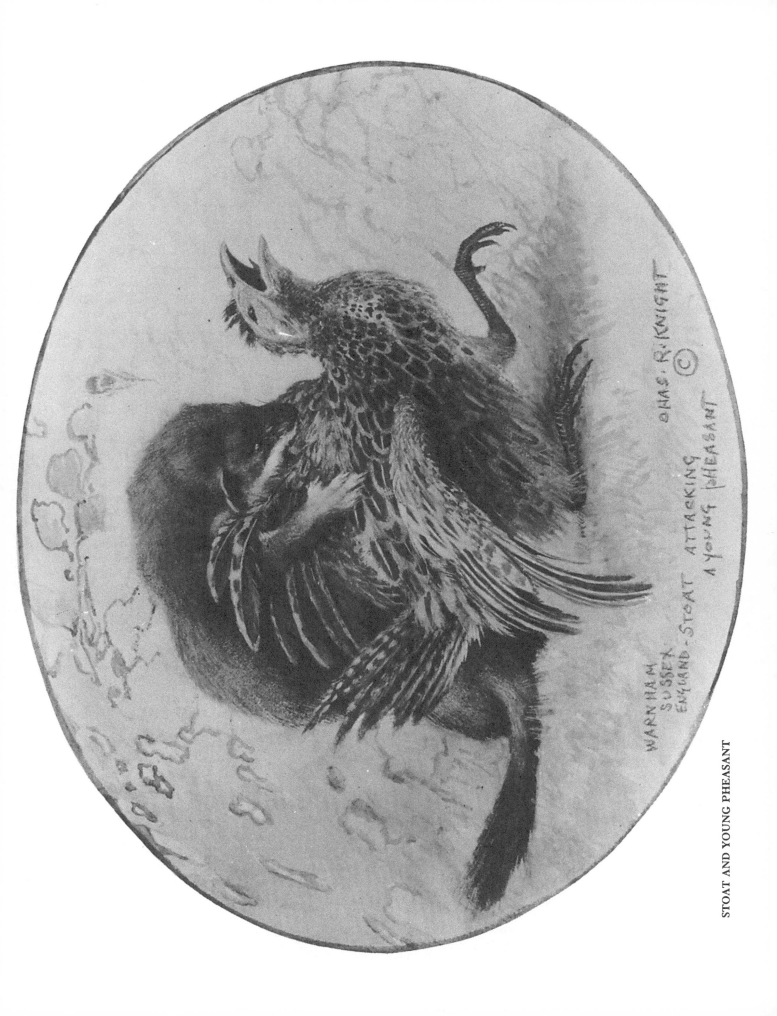

STOAT AND YOUNG PHEASANT

How Animals Lie Down

All animals must of necessity rest and sleep at intervals in order to restore their energy, and many and various are the poses assumed by different species in order to secure this most vital relaxation. Even fishes appear to sleep; at any rate, many of them go into a quiescent state of semiconsciousness, which, in their case, amounts to the same thing. Reptiles, too, spend much of their lives in a kind of trancelike slumber. Even the snakes, whose eyes cannot close, because they are lidless, sink into a lethargy under the effect of cold or a heavy meal.

Many birds have curious resting poses, some species turning the head and neck backward and burying the beak under the soft feathers of the back or beneath the wing. Just what these resting positions are and what disposition is made of the various sections of the body constitute, of course, a promising field of study for an animal painter.

Mammals, in particular, with their more or less lengthy, well-defined legs and joints, must be closely observed for the artist to understand how and in what direction the limbs are folded when they decide to rest. Needless to say, most animals in death or in moments of severe exhaustion are in a prone position, lying flat upon the side with neck and legs extended or drawn up close to the body. But under normal conditions this extreme pose is a rarity. The animal will usually drop to the ground in a characteristic manner, the limbs being arranged in such a way as to enable the recumbent creature to rise with the greatest facility.

Fortunately, our domestic animals will give us invaluable hints as to many of these positions, especially as most of them have lost all fear of man and therefore conduct themselves naturally in his presence. In addition, the fact that the principal domesticated species represent several very important families of wild animals renders them doubly useful in our particular field. For instance, the common house cat is an excellent example of all the feline race—lions, tigers, etc.—while the horse gives us an idea of the zebra and wild asses. Dogs resemble closely the wolves, jackals, and foxes, and the cow serves as a representative of the bison, buffalo, yak, zebu, and other bovine forms. Even the deer and antelopes do not differ widely from the cattle. Goats and sheep tell us what we need to know about the ibex, wild sheep and goats, etc. Naturally, in these various types there will be many minor changes in proportion, size, coloration, etc., but the basic principles of the muscles and the shape and action of the bones will serve as a most needful guide in any study we may wish to pursue.

Undoubtedly, in the grace, variety, and ease of their movements, no other race of animals quite compares with the cats.

Every action is replete with a sinuous agility as well as a sense of controlled power. Even in the many resting poses, one always feels these peculiar qualities, as well as their ability to relax and the ease with which they sink into a profound sleep. So powerful are the muscles of a cat compared with the weight of its bony frame that all attitudes, no matter how complicated, are assumed with perfect ease. The creature—and of course I speak of all species—often sits down in the usual graceful reclining position, forelegs either outstretched or doubled at the wrist, hind limbs with knees up, the entire foot resting on the ground, head and eyes straight ahead. However, our temperamental house cat and all its tribe can and will place themselves in a number of different and equally characteristic poses, lying on the back, lying curled in a ball, flat on the side, or twisted half to one side with the hips and hind legs prone upon the ground.

In the house cat all these structural arrangements are evident to the expert eye, but the long hair, loose skin, and small size render them difficult to distinguish. They are much more clearly visible in a large, heavily boned, short-haired animal, such as a lioness or puma. Should we wish to draw these big cats in the ordinary reclining pose, it will be seen that in the main they closely resemble the house cat in the attitudes just described; but, owing to the far greater size and bulk of the lioness, for example, all important points will be more easily distinguished. We note again the erect carriage of the head and neck, the forelegs stretched well forward, the high shoulder blades (with the backbone sunken between) being almost horizontal and clearly indicated against the side of the body and where they join the bulging joint of the humerus, or upper foreleg. This particular junction is of great importance in the drawing of any animal and will be referred to from time to time in the description of other skeletons. The humerus now descends almost vertically to meet the lower leg bones at the elbow joint, which, like the heel, rests upon the ground. From this contact the lower limb advances toward the wrist joint and the bones of the forefoot.

The very characteristic profile of the back line, which in the cats is highest at a point about midway between the back of the shoulder blades and the forward point of the pelvis, must also be noted. The pelvis itself is sloped at a downward angle of about forty-five degrees from front to back, and the knees topping the upraised end of the femur are raised almost to the back line. From this point the hind leg (tibia and fibula) descends more or less vertically to the heel, which rests firmly upon the ground and then extends forward to the tips of the toes. All in all the carriage of the creature is formal and statu-

esque and combines feline grace and power to a remarkable degree.

Now that the bony arrangement of the reclining position in the cats has been briefly described, it will pay us to see what happens to the muscular structure under the same conditions. The heavily muscled neck nestled deeply between the shoulder blades is barely evident, except at the top where it joins the skull, but the shoulder muscles are very prominent and the planes of the form distinctly evident. The spine, or ridge down the middle of the scapula, will be indicated by a depression in a well-nourished animal, the bulging muscles at either side sinking it into a groove, but the shape of the ridge of the shoulder blade will still be clearly seen. Strongly marked muscular bulges (the deltoid) join the base of this blade to the upper leg and merge with the form of that portion of the limb.

Also descending from the back of the large, more or less flattened shoulder we see the great triceps muscles, connecting that region with the elbow. The foreleg is not unlike our own forearm, rounded, solid, with long ropelike muscles extending from the elbow to the wrist. On the side of the lioness, just behind the forelimb, the serratus muscles may be seen, several small, pointed muscles on and between the ribs, which extend rounding, backward, toward the upraised knee joint of the hind limb. A certain space, however, does occur between the rear line of the ribs and the knee, the upper part filled by the heavily rounded, horizontal back muscle, along the side of the vertebrae, and below that a softly outlined depression extending downward to the animal's belly line.

In the main all these planes just described are vertical in aspect, so that from an artist's point of view they remain more or less in shadow, excepting at the top side, where they round along the back line into the full light.

The muscles of the hind limb owing to its doubled-up position are very much bulged and forced together, a fact that makes them stand well away from the vertical body plane in strongly rounded curves. The angle of the knee joint is modified somewhat by a stout skin flap, extending from the knee downward to the side of the body.

The above remarks only roughly define the principal points to be observed in drawing the living lioness. Yet they call attention to these points in a very practical way and will be found equally applicable to all the members of the cat family. As a matter of fact, one might almost duplicate this description to include members of the canine race—dogs, wolves, jackals, foxes—with the difference that the high point of the back is considerably nearer to the pelvis than in the feline group.

When it comes to horses, asses, and zebras a somewhat modified story will be necessary, owing to the greater length and stiffness of the limbs as compared with those of the flesh eaters. All the equine stock recline in what appears to be a somewhat awkward and constrained position, in marked contrast to the supple, graceful attitudes of the cats. The horse never lies down with the limbs disposed symmetrically, but in a sideways twisted position as regards the hips and hinder pair of limbs. This pose causes the weight to be carried on the under hip and thigh while the foot on that side from the heel to the toe lies flat upon the ground, protruding sideways beneath the animal's belly. One foreleg is always doubled back at the wrist joint (the horseman always insists on incorrectly referring to this as a knee), the other foreleg projecting stiffly forward in a more or less bent position.

The act of lying down is performed in a peculiar way. The animal first drops sideways on its haunches, and then the forward limbs are allowed to bend slowly until the torso rests upon the ground. In rising the action is reversed. The forelimbs are gathered with difficulty beneath the creature's body and then straightened, raising the fore part clear of the ground; this is followed by a tremendous heave of the hind limbs, pushing the haunches upward until the animal regains its feet. The entire action is laborious. Sometimes a weak or exhausted horse cannot get up at all, so great is the effort required.

Fortunately, however, the equines as a race are quite capable of standing for hours, dozing as they rest upon three legs, first bending one and then the other of the hinder pair at the heel and at the same time resting lightly upon the downward-pointed toe. Indeed, some horses, especially in a stall, will almost never lie down, preferring to sleep standing with drooping head and muscles relaxed but quite rested and comfortable upon their postlike legs.

The many species of cattle, sheep, goats, antelopes, and deer all perform the lying down operation in just the opposite sequence to that found among the horses. They sink first on the wrist joints of the forelegs, then collapse slowly upon the hinder pair. In rising they first stand upon the hinder pair, then struggle to the knees (wrists) of the forelegs, finally acquiring the upright pose. The action, however, is apparently more easily accomplished than by the equine stock, whose long legs seem much in their way under these conditions.

Elephants are unique in their reclining pose. (The student is urged to study carefully the appended chart in order to understand the text better.) To begin with, the elephant kneels upon his true knees, i.e., the first joint of the leg below the hip, but when down (owing to a very unusual feature of the creature's anatomy) the entire lower limb, from the knee to the heel and toes, projects straight backward along the ground. This peculiar action is caused by the fact that the hind feet of the elephant are very short, so that they cannot bend forward again at the heel as is the case with other animals. This is a very strange way of bending the hind limb and must be studied carefully or it will be found confusing. The forelimbs are disposed in a manner unlike those of other mammals, and the almost vertical shoulder blades are a departure from the average position.

The massive foreleg projects forward from the ground-touching elbow to the wrist, which is slightly raised, the foot being

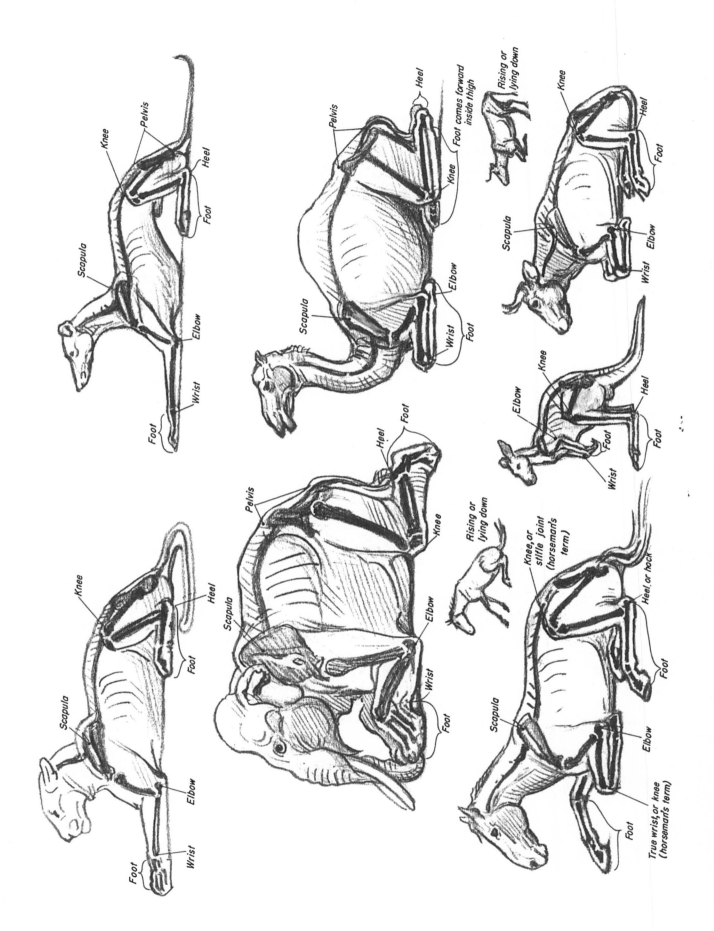

LYING-DOWN ATTITUDES

bent down again, so that the sole is flat upon the earth. The ponderous head is held at about the same angle as in the standing pose. The whole appearance of the great creature is dignified, sculpturesque, and highly individual, unlike anything else in the realm of animal life.

Camels and llamas are again unique in the recumbent posture of the limbs. They, like the elephant, kneel; but the hind foot is so long that, instead of projecting straight backward, the heels are raised slightly from the ground and the foot comes forward again, but *inside, not outside*, the thigh, the toes being just visible touching the ground behind and almost in a line with the heavily padded knee joint. The long forelegs are doubled back sharply at the wrist joint and pass under the forearm as in the deer or cattle.

The foregoing description has been given in some detail because the various reclining attitudes are likely to present difficulties to the student. However, he can be assured that a thorough familiarity with the above-mentioned mechanisms will be of the greatest assistance in his grasp of this apparently abstruse item of animal anatomy.

Skeleton of Man Compared with Greyhound

In order to furnish the student with a comprehensive comparison of the skeleton of a man and a dog, we have placed them side by side, one pair upright, standing on the hinder pair of limbs, the other on all fours, the man in the attitude of a sprinter at the take-off of a race, the greyhound in its normal standing pose. In the upright position, the striking difference in the apparent location of the shoulder blade is very evident. That of the man is barely visible on the profile because of the fact that the scapula is turned almost at right angles to the plane of the body. In the dog, the same bone stands almost vertically and is seen in its full contour and length from the top of the back to the junction with the humerus, or upper armbone. This difference of position in the shoulder blades is a most important point to understand, for it often proves a stumbling block to the artist, who at first glance sees little relation between the shoulder arrangement of a four-footed animal and that of a man. In the latter, because he is habitually a two-legged, not a four-legged, creature walking only on his hinder pair of limbs, the arms, or forelimbs, freed from their function as locomotive organs, are employed in a great variety of complicated movements. A large and well-developed collarbone connects the shoulder joint with the base of the neck. As a consequence, most of the arm motions originate at the tip of the shoulder, where scapula, humerus, and clavicle, or collarbone, meet.

Again we note that, while the man is standing on his entire foot from heel to toe, the greyhound is poised on the tips of its toes, the long foot up to the elevated heel being in an almost vertical position. This is an important thing to remember. With the exception of bears and a few related animals and the great apes and baboons all mammals stand more or less on the *tips* of the fingers (forefoot) and the *tips* of the toes (hind foot).

In the sprinting attitude man is for the time being a four-footed animal; but the pose is only momentary, for he leaps instantly to the upright, two-footed position at the sound of the pistol. We see, however, that even in this position his shoulder blades are lying practically flat across his back, barely visible on the profile, and that he is standing on the tips of his fingers and toes, as does the greyhound in its normal stance. The great length of the hinder pair of limbs in man, of course, precludes any possibility of walking or running in this position, but at what distant point in his history he assumed the upright attitude is difficult to say. Even the great apes walk or run on all fours, standing erect perhaps for an instant, but they cannot maintain the upright position for any length of time and are essentially quadrupedal in their movements. Man, we may well say, is therefore the only upright walking mammal, his arms corresponding to the forelegs of other animals, his legs to their hinder pair of limbs.

Further (and a most necessary point to think about), man's principal joints correspond with those of most other mammals. In short, he has shoulder blades, which connect with the humerus, which in turn is attached at the elbow with the radius and ulna of the forearm. These join the bones of the wrist and continue to the digits of the hand (forefoot). This similarity applies to the rest of his skeleton. There is a pelvis with the femur, or thighbone, connected to it by a ball-and-socket joint. A tibia and fibula, a heel and a hind foot with toes are common to man and animal alike—in fact, there is a repetition of the general joint formula for all the mammalian stock throughout its many gradations of size and proportion.

In retrospect, we may reiterate the necessity for a most careful study and comparison of the shoulder region in man and his fellow mammals. We may also stress the fact that the point of juncture of the humerus and shoulder blade is of paramount interest to the student. In man it is more or less fixed in place, whereas in other animals it moves forward and backward as the creature walks or runs. A glance at the muscular arrangement in this same region is also most enlightening; and again we can identify many muscles common to all types. These will also be modified in accordance with their special functions and will assume different shapes and sizes to suit the requirements of a widely varying host of living creatures.

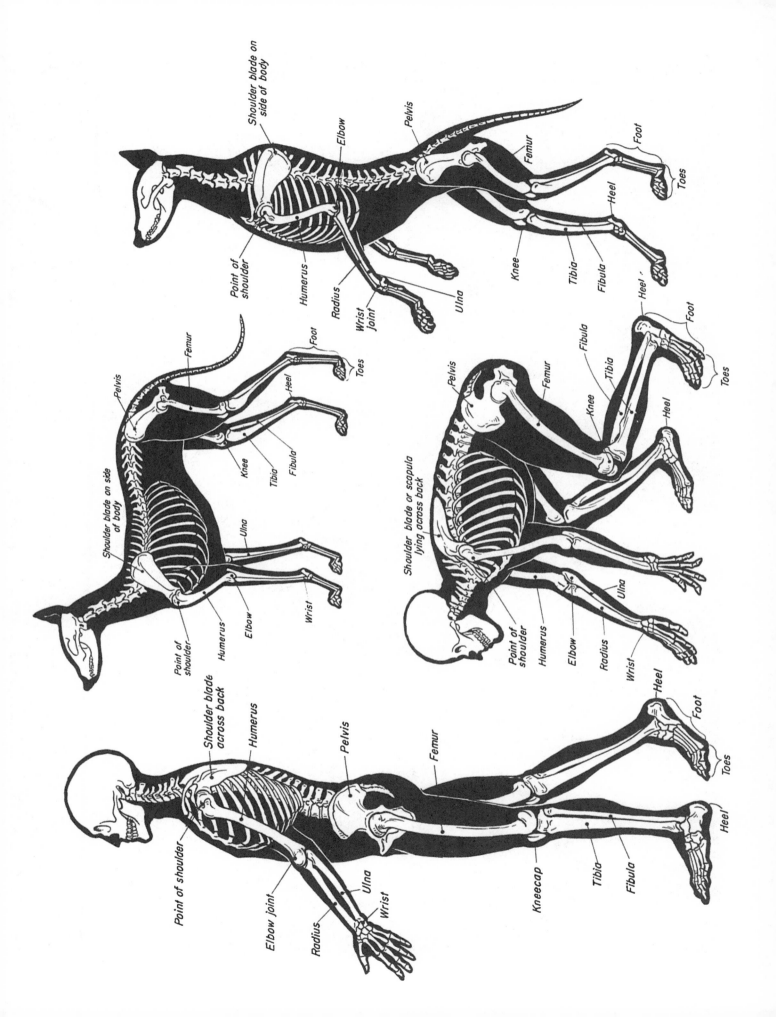

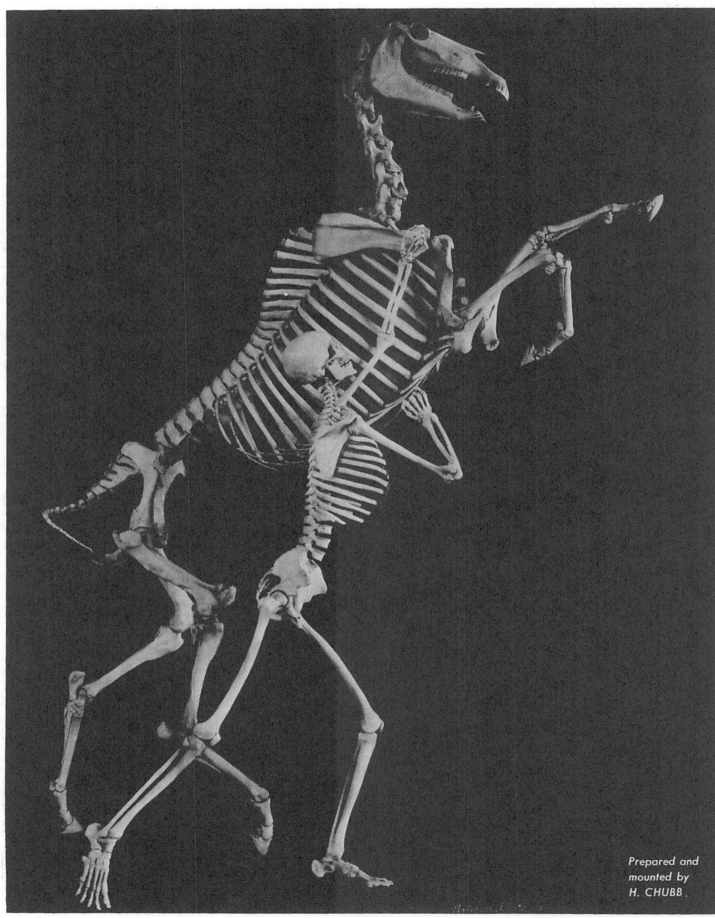

Prepared and
mounted by
H. CHUBB.

HORSE AND MAN

Hair Tracts

It is not only the muscular and bony forms of an animal that are of interest to the art student, but the hair tracts as well. Their position, direction, and effect on the contour of the body contribute very largely to the appearance of the creature as a living, breathing entity. We are confronted here with a very complicated subject, but the more we know about these tracts the better we shall be able to see, to analyze, and to draw, paint, or model what otherwise might remain a confused maze of hairy surfaces without definite form or construction.

A knowledge of tracts as they are manifested upon the bodies of different species of animals will materially help us to discern the finer points of any given creature and to impart to our production that crispness and beauty of texture and expression so necessary to a successful rendering. For example, the mane of a male lion is in many ways his most distinguishing feature, contributing vastly to his lordly appearance; but unless we understand the underlying construction of this mane, in what direction the various sections grow and how they are divided, our drawing is apt to be merely a superficial affair, quite destitute of character, shapeless, meaningless, and clumsy in the extreme. Comparatively few students realize the necessity for knowledge on this point; the majority regard the mane merely as a jumbled mass of long, matted hair, totally without definite form and merely something to be slurred over carelessly, either in paint, clay, or pencil. The dismal results of this attitude only confirm the foregoing statements. For this reason we must if we would do a really fine bit of work delve a bit into the facts about the growth of this wonderful mane and see whether or not we can do a better job next time.

For special study a young male lion is preferable. The mane is fairly short, and the peculiar growth of the hair is far more clearly defined than in older specimens. One can make out without trouble the prominent cowlick, or whorl of hair, on the upper front surface of the shoulder blade. Notice how some of the hair grows upward and forward toward the top of the neck, forming a ridge, or crest, by the meeting of this hair with that of the opposite side. Notice that other hairs appear to grow in all directions from this central point, not only upward and forward, but downward and forward along the sides of the neck and jaws. Here it meets the hair of the facial region, which in turn grows backward from the forehead and cheeks, with the resulting peak at the top of the head and the manlike side whiskers so characteristic of the lion. Indeed, who has not seen a similar hair arrangement (cowlick and all) upon the neck and shoulders of some particularly hirsute athlete? Men who shave will recall the fact that they guide the blade downward and

backward on the cheeks and upward and forward on the neck and the underside of the lower jaw, i.e., with, not against, the general hair growth.

Sculptors in particular should learn everything possible about the hair tracts on the various species of animals that they may be called upon to model, for close observation of this point will enable them to impart an interesting and convincing finish to their work. Barye, the great French animal sculptor, was an expert in this field. In his many beautiful bronzes, the lions, tigers, bears, dogs, etc., are all tremendously virile and alive, their structural perfection being greatly enhanced by vigorous and accurate surface treatment. Large dogs and wolves exhibit some most interesting hair growths; the peculiar V-shaped blanket of long hair over the shoulder is a noticeable feature, and the cowlicks of hair are distinctly visible on the breast, or pectoral, muscles. Bears are splendid subjects for a clever sculptor who knows how to take advantage of their many evident hair divisions. Nothing could be more unsatisfactory, however, than the average model of a bear, its clumsy bulk covered by meaningless masses of hair and looking as though it had just emerged from a molasses barrel.

With these facts in mind, one may detect many hitherto unnoticed types and directions of hair growth on various species of animals. Horses, for example, have a very definite region just in front of the knee, or stifle, joint of the hind leg; this growth imparts a most unusual appearance to the animal, the shining coat of a well-groomed horse catching beautiful reflections at this point quite different from those upon the other parts of the body. The accurate painting of a thoroughbred horse is much enhanced by a knowledge of these conditions, enabling the artist to convey that sense of strength and well-being so noticeable in the living animal. Goats are excellent examples of what hair direction and division can do to make a rather ungainly animal a splendid model for a sculptor. Statuesque qualities are here very apparent, even the kids showing interesting hair accents, while a male or billy goat resplendent with curling horns, long beard, mane, and leg and body adornment is a truly inspiring sight. Our great American bison is another animal whose hair growths are most impressive, the massive head, humped back, and heavy beard and leg decorations giving a grand and inspiring mien to the magnificent beast. Curious whorls of hair are also very evident about the eyes of the bison, where the fine, short coat radiates in a unique manner from the central eye point. As all these hair sections grow in certain well-marked directions, they must receive equal attention, for they do much to define the contour of the animal.

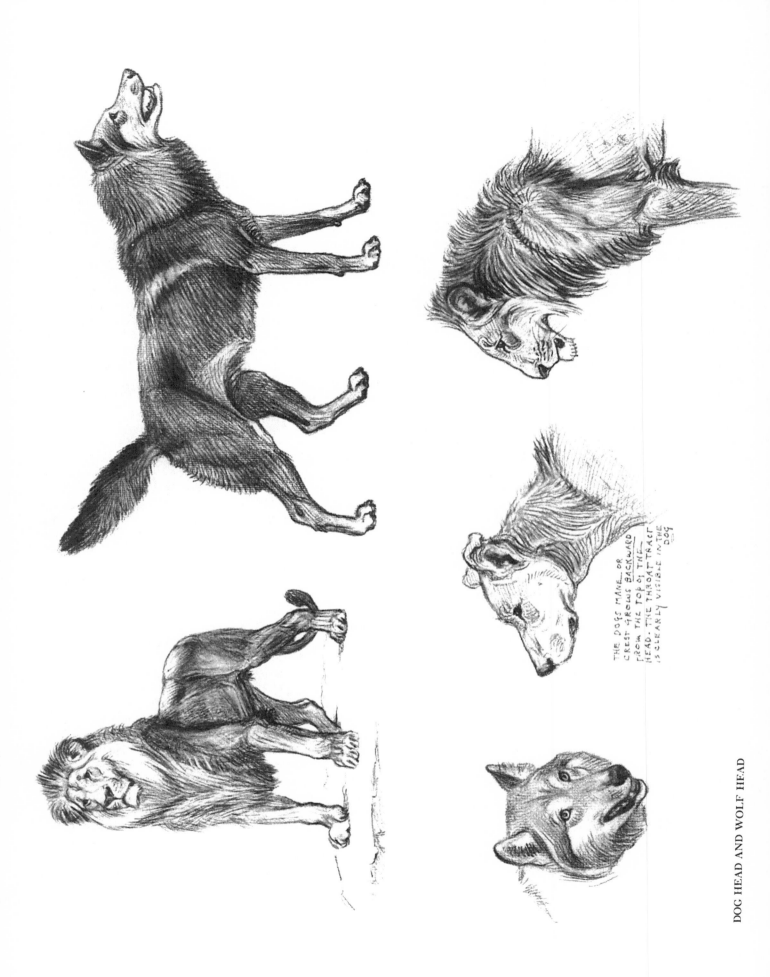

THE DOGS MANE OR
CREST GROWS BACKWARD
FROM THE TOP OF THE
HEAD. THE THROAT TRACT
IS CLEARLY VISIBLE IN THE
DOG

DOG HEAD AND WOLF HEAD

The great apes—gorilla, chimpanzee, and orangutan but most especially the gorilla—exhibit these various tracts and hair directions to an extraordinary degree. Naturally as the apes are so like ourselves in many ways, these peculiarities may well exist upon our own comparatively hairless bodies, though they are not as a rule very evident. Gorillas are completely hair-covered except for the face, the palm of the hand, and the sole of the hind foot. The breast muscles, however, are practically hairless, in contrast to the more or less hairy chest of a man. There is no differentiation, except in slightly greater length, of the neck mane and the hair of the head. Man is unique in this respect, the body hair being more or less short while the head hair in both sexes is long, thick, and different in appearance. The arms of the gorilla are extremely hairy, more so than the rest of the body, and this hair shows most clearly the tracts and directions in which we are interested. If the reader will make the following experiment, he will always be able to keep the direction of these important tracts in mind, realizing at the same time that what one sees in man holds good for the gorilla as well.

Sit in a squatting attitude, elbows on knees and forearms raised vertically, hands and fingers dropping loosely from the wrist joints. Now suppose that rain is falling; the water as it strikes the upraised wrists will flow downward to the ends of the drooped fingers and also down the forearms both outside and inside to the elbows, where it will be met by the stream descending from the shoulders down the upper arm to the same point—a human watershed in effect. I personally do not know who thought up this curious little experiment, but it actually demonstrates the very complicated hair-growth directions most accurately.

There is one point, however, that we must remember just here, and that is the effect of the downward pull of gravity upon any but the shortest hair coat. To take again the lion's mane for example, a very long and heavy mane grows as does a shorter one, upward and forward from the shoulder whorl, but the pull of gravity will cause the tips of this long hair to fall downward and backward, thus confusing the onlooker as to its original direction. Even in the gorilla, the forearm hair is sometimes so long that in the standing pose with the arms straight down, the hair, which is growing more or less upward on the inner and outer sides of the forearms, will droop at the tips. As in everything else, in the science of drawing if one knows one sees and can proceed accordingly, discounting apparent incongruities and accidental appearances while seeking out the fundamental points and ignoring the lesser ones.

It is to be hoped that the foregoing remarks will be of much use to the prospective student, for they deal with a little-known phase of animal drawing. One may be assured that a close study along the lines indicated will be of great assistance in the proper delineation of any animal form.

How One Paints and Models an Animal

In the course of a life devoted mainly to the painting, drawing, and modeling of animals, one gradually acquires a method of procedure that, while purely personal, may interest and benefit students of the subject. A most important requisite, of course, for any work of this kind is an intense interest in everything connected with its accomplishment.

As a small boy, all sorts of living things intrigued my youthful imagination and inspired my endeavors to place on paper somehow and in some way a representation of the animal forms to which I was so devoted. There was no special art consciousness about these attempts, merely a primitive urge to depict what I saw before me, much no doubt in the manner of the ancient cave-man, who loved to grave and color upon the walls of some remote cavern the shapes, tints, and actions of the various wild beasts that existed in his immediate neighborhood. In any case my first ventures into the field of animal delineation were undoubtedly very crude affairs, but I soon learned to copy with fair accuracy pictures from my various animal books, absorbing meanwhile all available knowledge as to their habits and general methods of life. Fortunately for me, my father, while not a professional man, was always deeply engrossed in the study of natural history, and many were the trips we made to the old zoo in Central Park, New York, and to the American Museum of Natural History in the same city. In this way my juvenile yearnings were more or less satisfied while at the same time my eyes were gradually being trained to observe with ever-increasing accuracy just what shapes and figures constituted the animal life in the world about me.

Our excursions to the zoo soon deflected my mind to a certain extent from the collections to be found at the museum, but I nevertheless had already made friends there among the staff of taxidermists engaged in mounting the numerous birds, mammals, reptiles, and lesser creatures for the edification of the public. These men though older than myself were also seeking the truth as to the inner construction and exterior aspect of all forms of animal life, so that we had a very definite bond of sympathy in our daily tasks. I loved to hang about the mussy little wooden shop that in those days passed for a taxidermists' studio, there to feast my eyes upon what seemed to my prejudiced gaze a galaxy of treasures in the form of mounted animals, birds, skins of various kinds, and plaster casts of dead specimens. Even the walls were decorated with heads and horns, trophies of the chase from all quarters of the globe. To anyone not keenly set upon such things this bizarre conglomeration would have been truly distasteful, but to me it proved a veritable mine of knowledge and instruction. Above all, it stimulated a desire to understand just how an animal is put together, how its joints work, and the form and position of the various muscles that cover the bony structure. Lifelike attitudes were always a prime factor in our studies—actual poses, characteristic of each species, specific silhouettes, and many other technical and artistic points of great value to me in later years. The old place was in fact a school wherein we all studied to the best of our ability Life's fascinating pages, eagerly discussing each new problem as it was presented and forever striving for that perfection which I realize now was impossible to attain. Thus enthusiastically engaged, my intensely concentrated mind was naturally profoundly influenced by contact with these men. I firmly believe that this long period of preliminary training had a lasting influence upon my future career.

One must remember also in this connection that the years of which I speak (the nineties of the last century) were particularly barren insofar as this country was concerned in the arts of animal painting and sculpture and that facilities for studying these subjects were chiefly distinguished by their absence. Indeed, I soon found that I was very much alone in my profession; for with the exception of one or two men, years older than myself, there seemed to be no really skilled or serious animal painters in the country. To be sure, a certain number did essay rather feeble pictures of cattle and sheep, but wild-animal representation was certainly at a very low ebb.

One may imagine, therefore, how confronted as a student with these arid conditions I stuck closely to my museum associates, who though not artists appreciated serious work along these lines. Shortly, under their stimulating advice, I began a systematic study of living animals at various zoological gardens, drawing and painting them at every opportunity. In fact, I still possess many of my first feeble attempts in this direction; while far from good, they do evince an effort on my part to put down the various attitudes in the activities of sleeping, walking, eating, and drinking that made up the lives of my models. Tigers, lions, bison, camels, elephants—I drew them all meticulously, trying to follow their subtle contours as they altered and shifted under the stress of changing emotions.

It was, of course, splendid practice, the very best that I could have secured, but I still lacked the deeper knowledge of artistic expression, an appreciation of the subtle forms of line and shadow indication and variation, and the discernment by a really trained eye in the accomplishment of a very difficult task. During these years I was a student at the Metropolitan Museum of Art, drawing in the classes for ornamental design, where nat-

urally I learned the various styles of architecture and conventional treatment of many things. I thoroughly enjoyed my studies but soon realized how little I really knew of the more advanced side of drawing, particularly that of the human figure. Fortunately in those days the Art Students' League was a tremendously virile institution, employing a number of very expert instructors, such men as George de Forest Brush, Frank Dumond, Willard Metcalf, H. Siddons Mowbray, Kenyon Cox, and many others who had just returned from their studies in Paris and were thoroughly imbued with its fervent art spirit.

In the opinion of all these men, drawing was a prime necessity in any artistic production and accurate rendering in light and shade a task requiring all one's skill and knowledge. I learned under their expert guidance what to look for when confronted with the three-dimensional form of any living object, its contours, its action, and the way the shadows fall across the complicated planes and surfaces. Thus, without realizing it, I was gaining facility and sureness of hand and eye, qualities that were later to prove of invaluable assistance to me in my studies of living animals. Above all I grew to admire deeply the splendid and intricate mechanism of the human form, the delicate tints of the flesh coloring, and the graceful lines of the figure. It was an easy transition therefrom to the great field of animal portraiture to which I seemed inevitably attracted. For here were spread before me new and beautiful manifestations of life in all its varying phases, which, as a result of my small amount of added knowledge in the art of representation, I was now much better able to indicate in pencil, color, or plastic form. This was after all as it should be; for drawing is drawing, no matter what the subject, and exactly the same rules of light, shade, contour, perspective, and construction apply equally well in every instance.

Naturally, as the years passed, I acquired a technique of my own in my approach to any given animal subject. While no claim is made as to results, yet it will be found, I hope, a logical method of procedure, which may serve as a guide to those who wish to follow its various phases. First, however, let me say that there are many things to think about before one ever sets pencil to paper, points about the animal's anatomy, habits, environment, mentality, etc., all of which will tremendously reinforce your eye and hand when at last you stand face to face with a living, moving animal. To begin with I should suggest a trip to a museum, where a close scrutiny of a mounted skeleton and a perusal of some good anatomy book will acquaint you at least in part with the special characters of the creature you wish to represent. Thus specially fortified you will feel not quite so helpless and confused in your first attempts at animal drawing. Do not select too difficult a subject for your maiden effort. Try something comparatively simple, a quietly resting creature of some sort, not a fast-moving, brightly colored and patterned tiger or leopard, whose glittering maze of stripes or spots will surely prove a most difficult thing to portray. Observe at once and very carefully the silhouette, always indicative of a species and very often of an individual. This exact shape is tremendously important; without it all your later work will be practically wasted. As you progress in your studies, the truth of what I say will be still more evident. You will learn that each species has its characteristic pose, unique outline, and general carriage which serve at once to identify the various types.

Proper proportion of mass is also necessary, and the feet or head of your model must not be too large or too small. Also, be searching in your scrutiny of the shape of the feet and legs. Naturally all races of man, whether white, black or yellow, have practically the same physical structure and the same number and shape of fingers and toes. But in animals there will be many and decided differences in these sections of the body, and what constitutes these differences will be your special task. For example, all the cats, lions, tigers, etc., have five toes on the forefeet and four on the hinder pair. Their claws are sharp, recurved, and retractile, i.e., they can be drawn back against the toe bones in such a way as to be invisible beneath the fur. Their legs are thick, heavy, and well muscled. The dogs, wolves, and foxes have nonretractile claws, and their limbs are delicately built though hard and sinewy in appearance. Cattle, sheep, deer, and antelopes have cloven hoofs, i.e., a pair at the end of each foot, and in most cases two smaller ones at the side. One can easily see from the above examples the necessity for acquainting oneself with the facts about the various types of feet and limbs and how a lack of knowledge on these points will only add to the difficulties to be encountered.

The joints and their proportionate size and position in the animal's framework will next occupy your attention. It will greatly simplify matters to realize that all mammals have approximately the same number of joints. They may, however, vary definitely in distance from one another and in the particular way in which they function, for example, wrist and heel, and the junction of the shoulder blade (scapula) with the upper armbone (humerus).

In this connection attention must be called to what is perhaps the most confusing feature of an animal for the average art student who has worked in the life classes at an art school. Because man is an upright animal, walking only by means of his legs, certain very definite changes have occurred in the position of the shoulder blades as compared with those of a four-footed animal. In the human species (and of course in the gorilla, chimpanzee, orangutan, and gibbon) these bones are placed as has been said across the *back*, being barely visible on the side profile of the body. In other words, they lie almost at right angles to the drooped arms. In all other mammals, however, the shoulders are carried in a more or less *upright* position, one at either side of the body, and as a consequence are plainly visible from the side view. One must not, however, become con-

fused on this point but attempt to understand the fundamental difference between your life-class model and the animal on which you are working at the zoo. Compare therefore the drawings in a book of this character with that of the skeleton of a man, and note carefully the divergence in appearance already discussed.

Practice and familiarity with the varying animal forms will naturally be an absolute necessity to a successful rendering and will vastly clarify your impression of the creature as a whole. Make it a rule to study carefully the species upon which you are to work, and analyze before you begin the actual drawing the points just mentioned. Look for each joint in turn, remembering what has been said about the general agreement in number among all mammals, and you will be surprised how with a little application you will be able automatically to trace the various important characters of each animal. As your proficiency along these lines increases, there will come to you a sense of assurance and understanding that will enable you to seize upon and transmit to paper a really well constructed and rational picture of your model, having weight, grace, and power, and not merely an outline with nothing of interest inside it. In other words, you will be drawing with character (simply another name for *knowledge* of what you are doing), and your work will stand the test of both scientific and artistic criticism.

One must realize also that each group of animals has its special series of actions in running, walking, reclining, drinking, fighting, eating, etc., and it will be your business to inform yourself on these points. Not only anatomy but psychology as well enters into this part of your study, as they control the poses assumed by each species under varying emotions. The matter will be greatly simplified when one fully realizes this important fact. We may be sure, for example, that all the cats will do things in the same way. Horses, asses, and zebras have their own special action; cattle, sheep, goats, deer, and antelopes seem governed by a closely related series of movements; elephants stand widely apart from all the rest; camels and llamas follow along parallel lines in any movement they attempt.

Action to most of us means merely *muscular* action, but as a matter of fact, one can very well indicate action by placing the bony skeleton in the desired position, without the addition of any fleshy tissue whatsoever. Thus the skeleton of a horse properly mounted will convey the fact that he is galloping, trotting, pacing, pulling a load, rearing, or standing at rest as the case may be. Nevertheless, the correctly drawn silhouette or profile of a living creature is also of immense value in a drawing and must be combined with the skeletal characters to build up the complete impression. For this reason one should observe carefully the very complicated, subtly graded bands of flesh and tissue that bind the animal's framework into a perfect whole, imparting to the wonderfully integrated structure that unequaled poise and coordination of parts so necessary for the difficult work it may be called upon to perform.

It has not been an object in this book to describe in detail the inner layers of muscle fiber or to explain the origin and function of the various muscular units. There are many excellent books on this subject, and they can serve as a help to those who wish to go more profoundly into the matter. Personally, however, I feel that such a course of study though of interest may lead unless wisely applied to an overdetailed drawing, which is not what we are aiming for in our work.

We must remember also that covering the muscular form, as shown in the drawings, large sheets of very thin superficial tissue are spread over the body in various directions, smoothing off many deep grooves between the larger muscles; and that supplementing this layer, the skin envelops the entire animal in one completely comprehensive mass, thus imparting to the living creature those delicately graded surfaces which our life-class instructors always referred to as *planes*. Most animals (owing to their thick skin and hairy covering) display only the more heavily indicated plane formations, but these are evident to a well-trained eye and must be truly represented in any really good drawing. Without insistence on these points, the work will have merely a rounded, rubbery appearance utterly untrue and unpleasant to contemplate. A glance at some of the magnificent drawings by Leonardo da Vinci will explain perfectly what is meant by knowledge of this sort, and we can do no better than try to emulate such great masters.

Although we have already dwelt at some length on the *inner* construction and *outer* skin covering of the animal model, there still remain several other important phases of the problem that deserve our close attention. In some creatures these exterior features are most difficult to understand, the effect of unusual hair disposal and very complicated color patterns making correct observation of the true shape almost impossible. As these traits differ in every species, special peculiarities will require your strict observation. In many instances, nature has so cunningly devised concealing coloration patterns for her favored children that the true form is almost completely masked and obliterated. Such animals as leopards and tigers and many other types of wild creature are so covered by a maze of spots and stripes, areas of strong color contrast, and numerous other means of concealment that a beginner in the art is left completely at sea when he attempts to draw one of these intricately camouflaged beings.

It will be found advisable for the beginner to select a soberly monotinted subject for his early work, a lioness for example, whose heavily muscled frame is very evident in almost any light; here no extraordinary hair development such as covers the neck and shoulders of the male lion hides the shoulder construction completely from view. However, should some intrepid student feel so inclined, he need not be afraid to essay the difficult task of drawing a leopard or a tiger. For if he has read what has just been said about the construction of the animal itself and con-

sulted the accompanying charts, he should be able figuratively to "see right through" these disturbing subterfuges of spots or stripes to the clear, clean lines of the animal's contours. Then, by a careful drawing of the arrangement and shapes of these patterns as they flow over the muscular framework, he will be able to enhance (not destroy) the effect of the animal as a whole.

As in your preliminary drawings, it is well to study the plan of these patterns before putting it down. Leopards, you will notice, have the spots placed in lines crossing the body at an angle of about forty-five degrees, but in different individuals there will be great variety in size and intensity of the spots. The stripes of a tiger are to me particularly difficult to indicate without spoiling the form underneath; while there may be a general plan in their arrangement, it is never very evident. Not only are the patterns very complicated, but color, distribution, and accentuation only add to the general confusion. Difficult as the foregoing problem may appear, persistence, patience, and application will work wonders for you and these aids combined with much practice will gradually enable you to surmount the various obstacles mentioned.

There remains, however, one crucial point to be considered, not a physical but a mental attribute of your model. You should acquaint yourself at least superficially with the psychological traits of the particular type of creature on which you are working. How well, for example, do you understand the reactions of the cat family under emotional stress? Could you say what attitude a tiger might assume if he were angry, pleased, or interested, and how these attitudes would differ from those of a stag under the same emotions?

In all probability you as a beginner could not answer these questions correctly; but until you are able to do so, to a greater or lesser degree your drawing will lack a very important something, the inherently lifelike look so necessary for perfection in your finished work. Constant study of the living creatures will naturally be your only guide to this type of knowledge. There will be (and should be) many days when you will make no attempt to draw your model but will merely absorb the various actions and reactions of the different species—how an antelope looks when alarmed or angry, a snarling wolf or fox, an enraged tiger, or the antics of a group of young lions.

As already noted, it will be of great benefit if you will learn to classify the different types under observation, realizing that all the species of one great race will act in pretty much the same way under similar conditions. By this method you will simplify the problem immeasurably and after a time will automatically recognize certain groups by their characteristic actions. It will be well also to read books on the subject of animals in a wild state, their habits and environment and all other data concerning them. Such reading will stimulate and interest you and give you much insight into animals' special modes of existence,

all of which will be a help when you come to draw them.

If, in the foregoing, we have gone seriously into various details of this most fascinating form of research, let me say that we are merely following precedent and that all great masters of this branch of art have pursued their studies along precisely similar lines. Now that we have discussed what one should know about animal form, color, and reactions, we shall consider the technique of putting all this down. I shall naturally give only my own personal ideas on this point, as there can be no set rules or requirements about a method of procedure.

For drawing, nothing that I have ever used can quite compare with the good old lead pencil for flexibility, convenience, speed, and durability. Pencil also (though modern youth is apt to reject this idea) has the great advantage of being easily removed in case a mistake has been made. Of late years particularly, I have observed among young people a growing tendency to use pen and ink in drawing from the living creature, but to my mind the employment of such a permanent medium suggests too much confidence in one's ability to draw correctly. Don't forget that very able men have not scorned pencil, charcoal, or pastel in making their studies, realizing full well the many difficulties to be encountered. It will profit us to do the same in order to attain something of their perfection.

Loose sheets of paper I have found an abomination; they blow, fall, or shift in a most disconcerting way. Far preferable is any good grade of drawing paper or better yet water-color paper mounted on stiff cardboard. The latter has the double advantage of being a splendid surface for either pencil or water color or a combination of both, an excellent method of treating many animal studies. After all, there are certain animals whose most striking features are their color and pattern, and as a consequence a *tinted* drawing will best explain the impression they create upon the observer. The tiger is a case in point. Though the great brute is undoubtedly wonderful in line and bulk, without his color and stripes he resembles other big cats quite closely. Essentially, we think of him as an orange and black-and-white animal, intricately and protectively colored. Surely, then, a touch or suggestion of the orange color correctly placed can only be an added help to your presentation of the creature and will furthermore be of great use to you in a future painting of the animal. In detailed studies of sections of an animal such as the feet, legs, or body this color addition will not be necessary, but I suggest that every student make several carefully tinted drawings of each species so as thoroughly to acquaint himself with the lifelike appearance of the entire creature. Finished water colors are not necessary; flat tints supplementing the drawing will be all that is required. Your work will thus take on a new significance and at the same time the veritable image of the object will become more firmly fixed in your mind.

Another little trick that I have found very advantageous is to make at some point in your work a small model either in plasti-

lene or in clay, indicating carefully and completely the construction, silhouette, and principal body planes. This is a scheme quite commonly used by animal painters, as it crystallizes the three-dimensional effect. If this model is then placed in the sun, perfectly convincing cast shadows can be secured, shapes very difficult to imagine but that will add greatly to the finished effect of your picture.

Oil technique in the painting of animals, especially in a zoo, may or may not be a heartbreaking experience, depending on the type of creature and its environment; the latter may be so cramped that the setting up of an easel will be impossible. Even pencil drawing is often beset with difficulties, though naturally the smaller space necessary for pencil work has its advantages. Charcoal whenever possible will always be a pleasant change from other techniques, but here again space for a large sheet of paper is not always available. I suggest, however, that whenever it can be arranged the student should try a few studies in this wonderfully responsive medium. A good bold drawing with accent on planes and mass and movement, the whole shaded carefully to accentuate the form, is most suitable to the charcoal method, as the soft transparent shadows can be quickly indicated and shaped according to the varying surfaces beneath. Pastel can also be used at times, and with beautiful results in skillful hands. John Swan, the English painter, has done lovely things in this way, though a certain lack of austerity of line is apt to result in a softness of impression owing to the very nature of the material.

Water color either pure or with white (*gouache*) lends itself readily to many forms of animal painting; I have made many elaborate pictures in this way. Pure water color, *i.e.*, the technique in which white is not used and all high lights are left as white paper, is of course a most effective method of painting. Lovely color effects can be obtained in this way, as well as brilliance and depth. Nevertheless, I prefer a sort of combination *gouache* and clear color technique, not mixing every color with white but using it in small details as in the whiskers of the big cats or where one has very fine light lines running over darker tones. The total result, however, will never be as brilliant as though no white were used, but will very much resemble a flat-toned oil picture somewhat lacking in richness. One can easily work in this way in severely restricted spaces where oil painting would be out of the question.

Without doubt, when it comes to painting large finished pictures of animals against a background, there is no medium that quite compares with oil. The well-known peculiar properties and advantages of this age-old combination of oil and powdered color need no special comment here. But as has been said, unless conditions are just right for working, the animal painter will find himself confronted by the physical difficulties attendant on the use of an easel and a lack of elbow room in general.

This is particularly true in zoos. One most exasperating dif-

ficulty facing the painter of wild animals in captivity is the prevalence of very poorly lighted cages for his models—dark, murky spaces where the animal lurks in a kind of misty gloom, visible but without any interesting light effects. To offset these adverse conditions I have found it most useful to form a collection, more or less complete, of tanned skins taken from wild specimens in prime condition and to take these skins out into the country and place them in a suitable environment of trees, rocks, and bushes. The effect is magical. Now one may see at a glance just how much the local surroundings of sky, leaves, and light and shade influence the color and patterns of the living creature. Our tiger, brilliant as he may appear in a zoo, is quite another thing in a realistic setting, and we are much better able to understand how artfully the great brute is concealed from any but the closest scrutiny. Light patches, dark shadows, reflected green from the foliage, and actual grass and branch obstruction—all blend with the bizarre pattern and glowing tints of the furry hide. It is a most instructive lesson for the animal painter and will very greatly enhance his interest and enthusiasm for the subject. Naturally, when one is fortunate enough to be able to see an animal in its home environment, this plan may be dispensed with, but such opportunities are rare indeed, especially when one is painting difficult and dangerous species of the canine or feline type. A momentary glimpse of a wounded tiger is no doubt a thrilling experience, but it is scarcely the time for artistic contemplation. In my own experience with the animal's tanned hide, it was surprising how dark it appeared, even the white under parts, against a snow-covered background, for example, such as one might imagine for a Siberian or Chinese specimen. We are apt to grow accustomed (quite unconsciously) to the effect of these wonderful creatures against the drab walls of a dimly lighted cage and to miss therefore all the beautiful light-and-shade and color effects of the same animals in their natural setting. From long experience I can heartily recommend the above plan whenever possible and can promise a delightful sense of brilliance and freshness in a canvas done under these conditions.

From a sculptural angle, animals offer some of the very finest opportunities for artistic expression. Their varied forms and actions are a continual delight to the student of living things. Each species has its special traits and proportions, its bulk, grace, peculiarities of movement, psychology, and hair development. The lordly lion with his masses of neck and shoulder hair is a splendid but difficult subject; the great mane must be carefully studied as to its artistic translation into stone or bronze. Their power, grace, and varied emotions of anger, fear, and relaxation will appeal to the sculptor in a survey of all the cats, whereas bulk and an adaptation to unusual structural conditions are very evident in the elephant's physiognomy. In sculpture one must dwell with extreme care upon those subtle planes already mentioned as composing the body of every animal; above all, in a

creature the size of an elephant they are of the utmost importance. Notice the huge but complicated side forms of the great beast, the unique profile, postlike limbs, and curiously short feet. In himself he is a monument, albeit a living, breathing one, and presents great possibilities for sculptural treatment.

As to precise conclusions about the method to be employed in animal painting or sculpture, there can be no rules for the student, a fact that has already been pointed out and that must be reiterated here. You will naturally go your own way in the matter, but the object of this book is to supply you with at least some of the groundwork for a branch of art that has unlimited possibilities in the many phases of its execution. Every requirement of good art applies here with equal force—color values, subject, composition, the old (but ever new) story merely expressed in another phase. The task if you are seriously inclined will be difficult, even nerve-racking at times, but the beauty, grace, and variety of the subjects will be an everlasting source of inspiration and delight. To depict adequately the superb lines and color of the big cats, the grace and agility of a deer, the ponderous power of an elephant, or the exquisite and dainty form of a bird—this is by no means an easy accomplishment. Everything that you possess in the way of artistic perception must be consecrated to that end.

Birds—General Observations

In our little study of the mammals we have been concerned in great measure with the bony and muscular anatomy of the many types under discussion. In the bird family, also a great group of warm-blooded creatures, the shape, size, color, and arrangement of the *feathers* are of prime importance to our correct understanding of them.

Birds without exception walk upon their hinder pair of limbs, the front pair being converted into wings by the addition of long, stiff feathers attached to the digits and also to the bones of the arm. The skull of a bird differs from that of a mammal in the fact that the mouth has no teeth and the face is sheathed in a horny covering known as the "bill," covering the front portion of both the upper and the lower jaw. As a result of this change of structure a bird does not seize and bite its prey as does a mammal but as among the eagles, hawks, and owls may grasp its victim in the powerful, curved talons and holding it firmly down upon some convenient branch or rock tear off pieces of flesh with the sharply hooked beak and swallow them whole by repeated jerks of the head and neck. Other species, like the parrots, quietly grasp the food in one foot and holding it before them slowly break it in pieces by skillful manipulations of the horn-sheathed mandibles, aided by the curiously sensitive, rounded tongue.

As in the mammals there is a vast discrepancy in size between the largest members of the group (in this case the ostrich) and the tiny hummingbirds, which are even smaller than a mouse. Between these extremes, there are species of a multitude of colors, patterns, and feather and bill forms too numerous to mention. But no matter how much these types may vary, they are all covered with feathers, walk, perch, or run on their hinder pair of limbs, and have bills and with few exceptions wings that can be used in flight. Thus as is usual with all the great orders of living creatures, while they may differ in various ways, in the main they have certain fundamental characters that are common to all the group.

As has just been said, the mammals have a rather evident bony and muscular anatomy that must be studied carefully. Just so the birds have a feather arrangement, differing greatly in the various species but equally important as an aid to the proper understanding of their form and character. So subtle are these feather arrangements and proportions, particularly in the wing formation that one grasps their significance only with the utmost difficulty. Nothing in nature, in the author's opinion, is more difficult to draw than the wing of a bird. Stuffed specimens as a rule are not of much help to us in this respect. In the mounted bird, no matter how skillful the work, there is a distinct loss of character and definition, not only in the wing feathers but in those over the entire head and body. One loses those delicate gradations from one feather tract to another that are so beautiful in the living creature.

These feather tracts are situated in certain distinct areas on the bird's body, from which grows the unique covering that differentiates the bird family from all others. In drawing a bird one must analyze these areas very carefully, for different species exhibit extraordinary varieties as to the shape, size, and color of the feathers springing from them. For example, the so-called "tail" of a peacock is not its true tail but a prolongation of the feathers of the back. A pheasant's tail, on the other hand, is anatomically a real tail, for the feathers spring from the tail region itself. Again, what appears to be the tail of some species of the cranes is in reality the extension of the secondary feathers of the wing. We see from these few examples how confusing the subject may be unless clarified in the observer's mind by a knowledge of what to look for in each instance. The disposition and function of these feathered areas will be better understood by reference to the diagrams.

The diagrams also demonstrate that at will many species of birds can erect or otherwise change in form certain individual feathers or groups of feathers. Mammals have very little power over the movement of the tracts of hair on their bodies with the exception of a certain ridge, or crest, along the middle line of the back and neck, easily seen when a wolf or dog is either frightened or angry. All birds, on the contrary, seem to possess more or less of this power to erect sections of the body covering, exhibited principally in the breeding season or in preening and arranging their feathers. Who has not seen and wondered at the extraordinary and bizarre displays of our common turkey, as well as the superb exhibition under sexual excitement of the male peacock? Each species of bird has its own peculiar method of "showing off" before the female, and some of them, for example the birds of paradise, perform most amazing contortions. At such times the male appears temporarily hypnotized and oblivious to its surroundings and hops about in a frenzy of excitement that may last for several minutes. The futility of attempting to draw a bird in any of these positions without a knowledge of the feather tracts involved is very evident to anyone essaying the task.

It goes without saying that birds as a class present many difficulties for the artist. But they are so varied and beautiful in form and color, so wonderful in action and withal so delightfully decorative that one quite forgets the many problems to be solved in connection with their use in art.

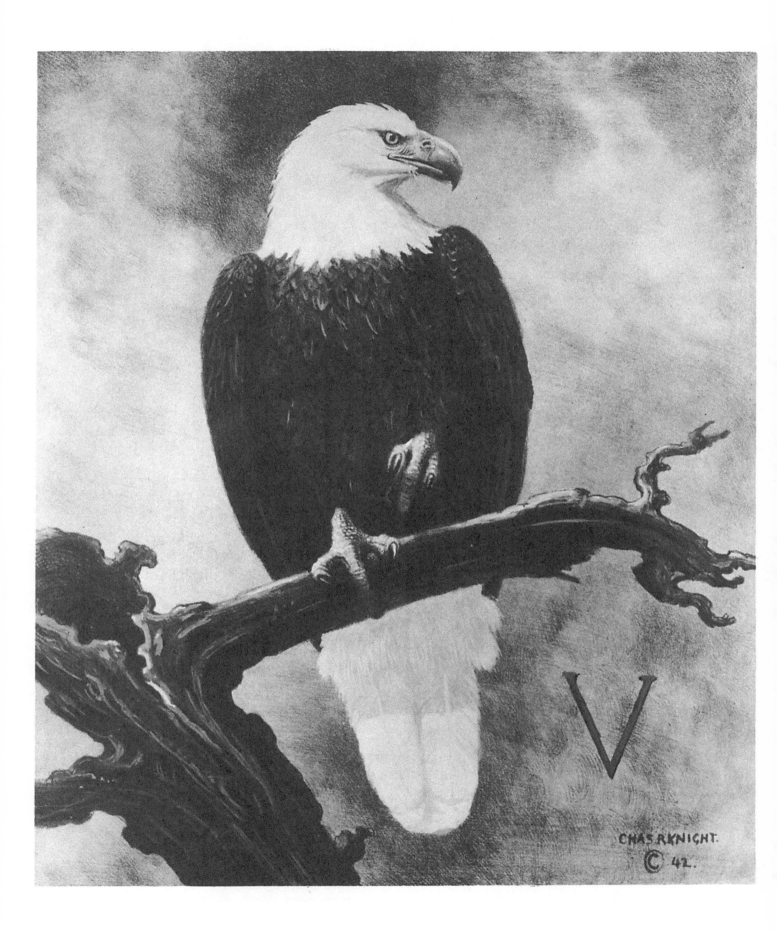

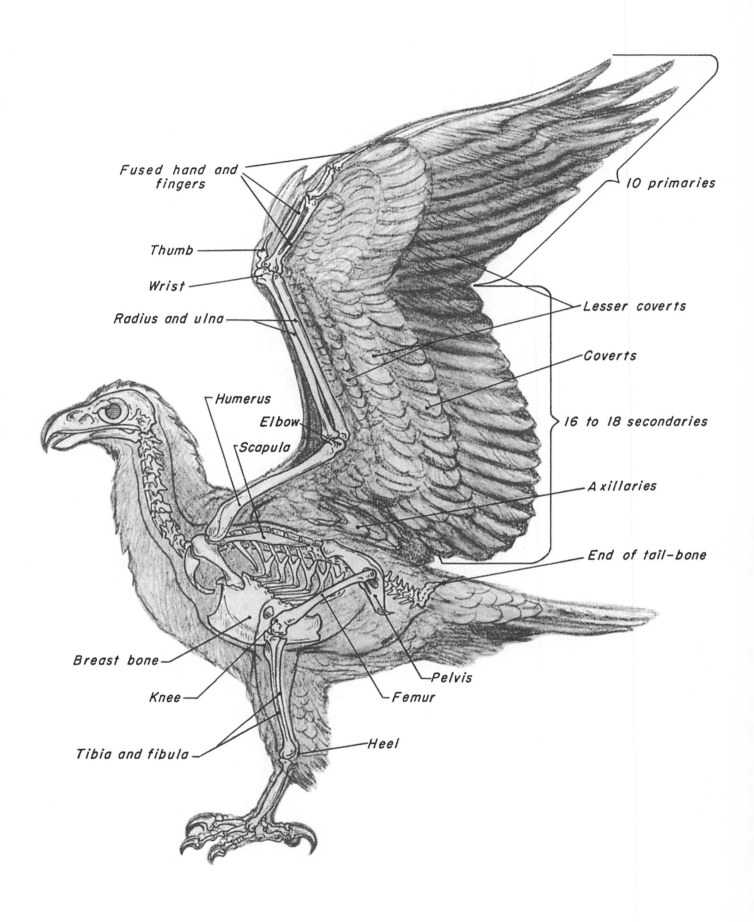

Fused hand and
fingers

Thumb

Wrist

Radius and ulna

Humerus

Elbow

Scapula

Breast bone

Knee

Tibia and fibula

Heel

Femur

Pelvis

10 primaries

Lesser coverts

Coverts

16 to 18 secondaries

Axillaries

End of tail-bone

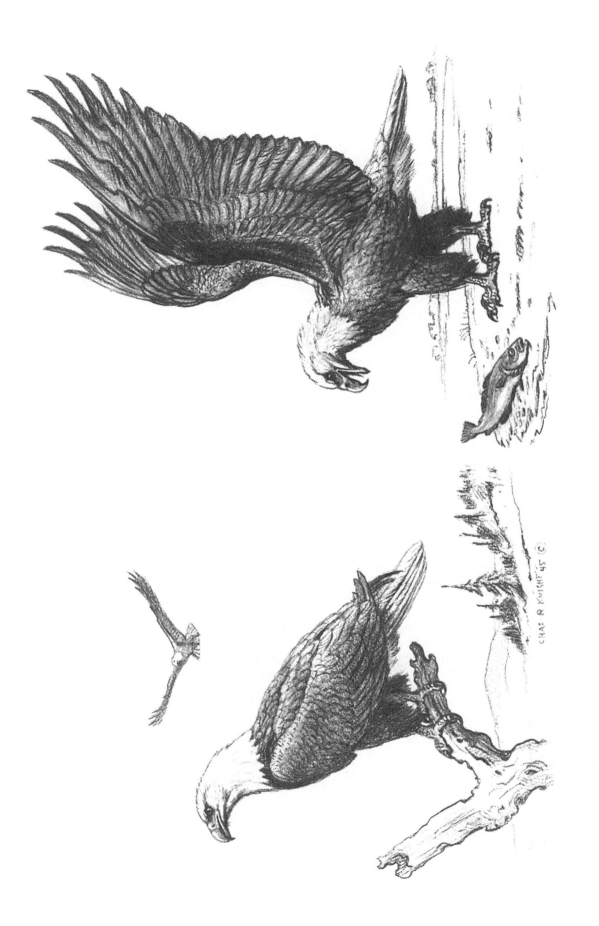

AMERICAN BALD EAGLE

Wings

The wings of a bird form the most striking, specialized, and complicated features of its external anatomy, and a study of their varying proportions and general construction is of the utmost significance to the artist. A bird at rest upon a branch or walking about upon the ground is a lovely and interesting object, but a bird in flight arrests our immediate attention by reason of the novelty and extraordinary adaptation and variety of its gyrations in the lighter medium. While with swift and powerful wingbeats or slow sailing motions on fixed pinions it cleaves the air with perfect ease and grace, it is a thing of beauty and at the same time a revelation in precision and adaptability.

Everything about a bird, both its physical and mental make-up, is naturally modified and controlled by this function of flying, and the wing is far and away the most important aid to the accomplishment of that end. In fact, whenever for any reason the wings of a given species become too greatly reduced in size, the phenomenon of flight becomes impossible for that particular branch of the family. There are, to be sure, a number of ground-living forms such as ostriches, penguins, and apteryxes whose wings are either so small or so specifically modified that they cannot be used as flying organs. Ostriches running at full speed spread their plumed but abbreviated appendages, which act as balancing supports for the heavy and powerful body. Penguins literally fly under the water, the paddlelike wings propelling them with ease and prodigious energy through the Antarctic seas. The New Zealand apteryx bears no visible wings, depending on its short, stout limbs and heavy feet as a means of progression during its nightly journeys in search of food.

In the soaring birds such as gulls and albatrosses, which have long, narrow pinions, the flight feathers are held tightly together except in rising or descending swiftly. Eagles, hawks, and vultures, which soar to great heights, spread the flight feathers at the tips, even though there may be no flapping of the wings. The rapidity of the wingbeats also varies greatly in different species. Herons, gulls, and vultures move their pinions deliberately except under unusual circumstances, while pheasants, ducks, pigeons, and many small birds dart swiftly from place to place in a whirl of fast-moving wing motions. The diminutive hummingbird, poised before his favorite flower, maintains his position by a series of such lightninglike pulsations that only a very fast lens can record the fact on a sensitive photographic film. However, all these tremendous expressions of energy have just one objective, and that is to keep the comparatively heavy creature suspended in the air, from which vantage point so many phases of its life history are made possible.

To us who are tied to the earth unless assisted by mechanical means, a flying bird is always a source of wonder and delight. The majestic eagle soaring on widespread pinions against a sunset sky, white gulls along a yellow beach or over the deep blue ocean, a V-shaped flight of honking wild geese, or lines of pelicans gliding over the glittering Florida surf—all are thrilling sights to bird lovers, but they exemplify only the merest fraction of the splendid possibilities for artistic expression inherent in these fascinating examples of animal creation.

As the wing is of such paramount importance in the bird's economy, it behooves us as artists to study at some length not only the bones, muscles, and feathers of which it is composed but also something of its various positions and motions in flight and at rest. Broadly speaking, the wing is of course simply the forelimb, or -arm, region, with the usual bones, scapula, humerus, radius, and ulna, together with the wrist joint and a modified hand, thumb, and fingers. The latter are fused together, as they do not function as digits. There is comparatively little motion to the long, narrow, and almost horizontally set shoulder blade, or scapula, bound as it is quite firmly against the fore part of the body over the rib section. But the joint of this bone with the humerus, or upper armbone, is very important, for the whole wing rotates directly from this connection. Huge breast, or pectoral, muscles lie on either side of the very deeply keeled breastbone and control in part the powerful strokes of the wing executed by a complicated sculling motion of the whole mechanism. Certain birds after a few preliminary flappings fix the outspread members in such a way that the air currents serve to buoy up the heavy body as it advances through the ether in long, swinging curves or, as with many gulls, in a comparatively straight line. Indeed, who has not observed this extraordinary feat (now being emulated by our glider pilots) and marveled at the inspiring effect of a soaring buzzard or red-tailed hawk as it wheels and rises and falls in a series of ever-widening or diminishing circles?

The intricate feather developments that cover and project from the various sections of this beautiful flying contrivance are evidently an absolute essential to its successful functioning. They are arranged in the most exquisite and complicated manner to ensure the bird its ability to mount into the air and there remain either in rapid motion or floating gracefully about until it wishes to descend once more to terra firma. Quite apart however from the mere aesthetic value of this extraordinary accomplishment is the practical mechanism that makes it possible. A glance at the accompanying drawings will acquaint the student with the more prominent and important feather tracts, or areas, from which spring the various feathers of the wing both on the upper and the lower side, and also the astonishing transforma-

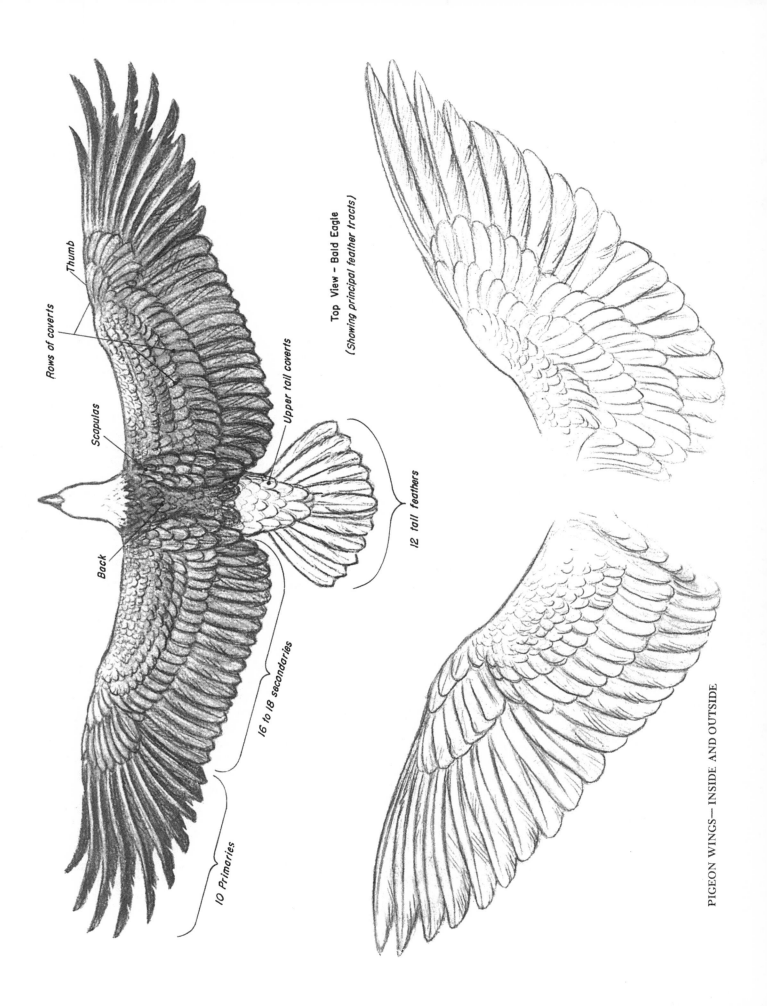

Thumb

Rows of coverts

Scapulas

Back

Upper tail coverts

Top View – Bald Eagle
(Showing principal feather tracts)

12 tail feathers

16 to 18 secondaries

10 Primaries

PIGEON WINGS—INSIDE AND OUTSIDE

tion in form and position of the various parts of the wing in the open and closed attitudes. Regarded purely as a piece of mechanical ingenuity, no man-made object can compete in compactness, strength, and fitness for its particular work with this truly amazing combination of feathers, bone, and muscles, quite apart from the grace, beauty, and subtlety of line and form that make the wing of a bird so outstanding in a world of lovely things.

To understand just how a bird's wing works is a difficult task, made more so by the very perfection of its parts and the unusual and tremendous stresses that it is called upon to bear. I again suggest that a living or freshly killed specimen should be studied on every possible occasion. By careful drawings of the various feather tracts as they fold one upon the other a clear idea can be obtained of the principal feather masses, their size, shapes, and direction, and how and where they are inserted into the heavy tissue of the muscle, skin, and bony structure of the wing as a whole. The drawings accompanying this chapter will explain better than any verbal description the difficult and little-understood problems with which we as artists are confronted whenever the drawing of a bird's wing is in question.

The proper rendering of feather forms is an art in itself. Nowhere over the bird's body are they more characteristic than on the wing. The flight feathers are naturally the most important of this group, those long, stiff plumes which originate on the fused finger section of the bird's hand and wrist. They are as a rule somewhat rigid, subtly curved objects marvelously designed for their special purpose and at the same time one of the most delicately fashioned bits of nature's handiwork. They have the property of turning upward and spreading apart at the tips or curving downward as the case may be when opposed to swiftly changing pressures and air currents. In substance they are flexible, strong, very light, replaceable if injured or molted, and indispensable to the bird's very existence. In order to enhance their value as powerful lifting and propelling agents the bases of these feathers are covered for some part of their length by several rows, or tiers, of smaller scalelike feathers known as "wing coverts." These shorter and more rounded adjuncts to the general wing expanse not only grow upon the upper side of the wing but also sheathe the underside in glistening, scale-like forms of most lovely texture. At the same time they act as stopgaps to prevent passage of air through the sail-like wing, a device calculated greatly to enhance its sustaining power. As in an airplane, the forward edge of the wing receives the brunt of the passing air currents and not only is thickly covered by a mass of small dense feathers but also has a rounded contour to lessen the intense friction as the moving creature breasts the wind at a high rate of speed. Reinforcing this resistant form of construction, a long elastic tendon incased within a toughened triangular tissue extends beneath the feathered shield from the wrist joint to the body insertion of the wing. This enclosing piece of skin fills the long gap between the wrist, elbow, and shoulder in a most perfect and highly efficient way, stretching widely when the wing is fully extended and contracting when the wing is either partly or entirely folded. However, for the art student this peculiar arrangement proves to be somewhat of a puzzle, as he often fails to notice the relative position of the wrist joint, elbow, upper arm, and shoulder blade, masked as they are by many small feathers. The elbow joint is not clearly indicated in many small birds, but in the eagles and vultures particularly it is distinctly visible as a raised point upon the upper surface of the wing. These great birds when walking or resting often elevate the elbow region well above the back line, imparting a curious crouching appearance.

Now that we have discussed briefly the so-called *primary*, or flight, feathers growing from the hand and finger portion of the wing, the next great tract, the *secondaries*, which occupy the space between the wrist and the elbow, must be considered. These bladelike shafts while neither so long nor so stiff as the flight feathers are of almost equal importance as sustaining structures and fold in a most beautiful way *over* the flight feathers when the wing is closed, in many species, such as pheasants and partridges, practically concealing the latter appendages. In fast-flying types, however, the long primaries will extend beyond the secondaries in the folded wing position, the tips crossing each other over the base of the tail. As with the primaries, the bases and insertion of the feather shafts of the secondaries are sheathed in closely aligned coverts, a section over and under each great tract, all working in beautiful rhythm within their restricted spheres of action.

Though we have spoken only casually of the folding and unfolding of a bird's wing, a book might be written upon the subject, so intricate are the various motions involved in what is apparently a very simple action. Let us glance, for example, at a pigeon walking about or resting in some quiet spot. The beautiful compact form of the bird is as a whole clearly evident, but just how the creature has contrived to fold away its long and powerful wings is a mystery not so easily understood. A subtle broadening of the shoulders, smooth contours, and delicate gradations of planes meet one's admiring gaze, but on closer analysis other features become evident. Over the shoulder region, for example, two long oval mounds, one at each side, lie close together near the middle line of the back. These are the scapulars, or shoulder tracts, resting *above* the junction of the wings with the body, while further toward the tail still another tract is visible lying *between* the wings and extending over the base of the tail feathers. This section comprises the true back feathers and the upper tail coverts. In a resting pose the tail itself is usually folded together, but the instant the bird leaps into the air it is widely spread and is used as a sort of balancing rudder. We may not have noticed the tips of the long primaries crossing over the base of the tail, for they are so folded underneath the

secondaries that they have eluded for a moment our careful observation. See now the beautifully iridescent neck of the male bird as he trots jerkily ahead of us, and the bright-pink feet and short, stout legs that serve him so well upon the ground or in perching on a tree. Until this moment he is to all intents a creature of the earth; but something startles him, and like a flash he is transformed. Outspread are the once-folded wings, the long quills beating the air with powerful downstrokes, the tail expanded, the neck and head stretched tautly forward, and the feet pressed closely against the underside of the tail. For this is a bird in flight, when in an instant every part of his being responds to the physical effects of a medium lighter than his own body, when perfect balance and correct judgment of distances are of paramount importance and the brilliant eyes must focus accurately or he may meet disaster as he nears the upright wall of a great building or merely decides to drop lightly again to the ground. So frequent is this phenomenon and accomplished with such perfect ease that we are apt to lose sight of the extraordinary transformation involved in what we have just witnessed, while to the bird itself the entire movement is merely a commonplace of everyday existence.

As has already been said, birds possess certain definite areas of feather growth upon various parts of the body, a feature called *pterylosis*. The extent and origin of these different tracts are not clearly apparent to the untrained observer. Yet knowledge on this point constitutes a very necessary part of the bird painter's equipment, for without it he will not be able correctly to analyze the shape and significance of the complicated feather arrangements that he may be called upon to portray. One is much surprised, for example, to observe how widely separated from one another these tracts may be and how scalelike the placing of the feathers, so that they overlap as did the scales of their reptilian forebears. To be sure, the intervening spaces between the tracts are covered to a greater or lesser extent by soft, downy feathers, but they as a rule are not evident except in immature birds.

It is a fact that birds more than any other class of living creatures can easily alter at will and to a very great degree the silhouette, or contour, of the body. This they accomplish by simply raising or spreading certain sections of the feather anatomy, thus completely changing their entire appearance for the time being. Neither the skeleton nor the muscular form of a bird except in respect to proportion and the character of the bill and feet will give a very distinct impression of the creature in life. For that we must look at the feather pattern and development and so train our eye that we can discern at a glance the various tracts already referred to, even though their size, shape, and coloration differ so widely in the various species.

For example, birds of paradise possess a remarkable development of all these parts and under the stress of sexual excitement exhibit many strange and bizarre poses. While these exotic types are spectacular, there are many other families with whose extraordinary attitudes we are much more familiar.

Among these is our common peacock, in reality a native of India, properly regarded as the prince of the feathered tribe, whose glittering, jewel-like train we have all admired and wondered at on every occasion of its display. Perhaps no other bird, large or small, so clearly exhibits the wonderful feather divisions of which we have been speaking, a fact that makes the peacock particularly valuable to us in our work. If we look closely as the magnificent creature moves slowly about, certain aspects of its feather forms at once become evident. First, as has been said, what we have always thought of as the tail is in reality not the true tail but the tremendously long and widely spread feathers of the lower back. From the rear view the actual tail feathers shaped like an upright pointed spoon are now shown erected and pressed closely against the back of the long, vibrating plumes, assisting materially in holding them erect in the display attitude. The wings as well are clearly visible in their striking pose. The seldom-seen reddish-brown primaries hang below the contour of the body. The stiffly carried neck, of an ineffably brilliant greenish blue, the curiously bent down head with its fanlike crest of glittering azure, and the conventionally flattened, dark breast feathers are but a part of this creation of loveliness. Yet without doubt it is the extraordinary shape, size, pattern, and color of the magnificent train that focus our rapt attention as the bird, apparently conscious of the impression it is creating, revolves slowly with dignified steps in a curious dancing motion. Above and about the bird's head and body sways the great semicircle of the wonderful plumes, graded in length with mathematical accuracy, each having at its tip the celebrated eye, a more or less circular piece of superbly varying colors, turning purple, blue, gold, and crimson as the light shifts and changes upon the pulsating feathers. If we study these "eyes," we see that they are set in ever-widening curves as they reach the outer rim of the train. Growing in the usual scalelike manner but tremendously lengthened, very numerous, and exquisitely shaped and tinted, these most lovely ornaments are among the finest examples of sexual and aesthetic adornment in all bird life.

Though such an analysis may sound prosaic in the presence of so much beauty, it must be part of every bird painter's procedure; for without a correct understanding of the various feather tracts of each species, both in a tensed and in a relaxed condition, a truly excellent representation will not be possible. Other birds in other poses will reveal their own special attributes as to actions, shape, size, and prominence of certain feather areas, as well as their color, pattern, and general contour. Also and of equal importance will be a grasp of the true psychology of the various species, whether carnivorous or otherwise, their methods of life, environment, etc.—truly a formidable list of requisites but to the bird enthusiast merely an incentive to

more intensive research.

From the purely artistic standpoint, bird feathers in themselves are difficult to draw, as they sheathe the lovely creature in a covering of extremely diversified colors and patterns. Never lose sight of the scalelike form and placing of the feathers in most species of birds, though in many they may be difficult to see. Correct contours, as in any drawing, painting, or model, are of the greatest importance. These you will study from life whenever possible, for they are in substance the expression of the life itself. Freshly shot wild birds are of course invaluable for details of bill, eye, and leg coloration, as these tintings are never at their best in captive specimens, and they fade and change very quickly after death. Feather patterns and their disposition as well as general construction are also beautifully shown in a dead bird; but the pose of the living creature is no longer evident, nor will it be easy or even possible to place the relaxed body in its characteristic life attitude. Even the great Audubon was not a master of silhouette, though he made many careful studies of freshly killed specimens. Undoubtedly, however, his drawings do have a certain lifelike virility as a result of his intense application and love of his work. We today are fortunate in possessing beautiful photographs of living birds in which the complicated and exquisite forms of these fairylike beings are presented, many of them in full color. These should all be thoroughly absorbed, not copied, by the student, but regarded merely as valuable data and as a tremendous help in fixing the image of the creature firmly in mind. This same kind of data and the method of utilizing it apply equally well to all phases of animal life, especially where fast-moving objects are concerned. The bird's swift wing stroke, the leg positions of a running horse, and many other difficult actions are now frozen for us by the miracle of the improved photographic lens in a manner that could not possibly be duplicated by the human eye.

In the matter of color and texture birds as a class are almost unique among living things for variety and brilliance and for the difficulties they present to the artist. Extraordinary effects, extremely bright local color areas, velvety or satiny sheens, and an endless variety of soft grays, greens, and browns present such a mass of kaleidoscopic impressions that the beginner will often experience bewilderment in the presence of so much loveliness. As already suggested, these problems must be approached in a calm and methodical way by analyzing the various factors presented. Their practical solution must rest with you as an artist, but to achieve this solution you must keep up your interest, study from life, and read carefully on the various points of special importance. You will never cease to marvel at the variety and beauty of these highly specialized feathered beings, so fraught with artistic and aesthetic possibilities for nature lovers in all parts of the world.

Beaks, Tails, and Feet and Legs

Even a cursory discussion of the beaks of birds, their form, size, and adaptation to certain foods and methods of feeding would fill a large volume, but we may note just a few of the most striking types and to what use they are put. The herons have straight, sharp-pointed, daggerlike beaks with which they strike and sometimes transfix their finny prey. Cranes, on the other hand, employ their bills as digging implements, boring great hollows in soft, muddy ground around water holes or boggy places in open prairie country. Ducks, whose bills are more or less soft and pliable, dabble about on the bottom of bodies of either fresh- or salt-water areas in search of living things, fish, worms, or frogs, or swim along the shore where the vegetation is soft and succulent. Geese literally graze at times like cattle, pulling off pieces of grass and weeds, which they swallow whole. The large family of the scratching birds to which belong our domestic chickens and their wild relatives, as well as the pheasants and peacocks, all busily employ their powerful feet and blunt claws in an effort to uncover some coveted worm or other tidbit. When found, however, this food is not grasped by the feet but is seized by the hard, slightly curved bill and quickly jerked backward into the throat. The grotesque hornbills and toucans, both fruit eaters, exhibit enormously developed bills seemingly too heavy to carry but in reality quite light and spongy in texture beneath the hard outer surface. Woodpeckers probe and chisel into trees for grubs, beetles, and other concealed dainties. So we might continue indefinitely, but enough has been said to demonstrate how many and how diverse are the ways in which birds obtain the necessary nourishment to maintain their swiftly moving bodies.

Tails in their widely differing forms are also of prime interest in bird study. They are used as rudders and balancers and also contribute to the wind-surface area of a bird in flight. On the ground they may be raised, lowered, or spread in the breeding displays and are subject to enormous variations in size and shape, particularly in birds of the pheasant variety. In the skeleton, the tail of a bird is a curious little triangular piece of bone terminating the vertebral column. From it may extend feathers as much as six or eight feet in length, as in Reeves's and argus pheasants. Macaws, too, have long and brilliantly colored tails; in other species short, broad, or pointed tails are found.

There seem to be as many variations in feet and legs as in other parts of the bird's anatomy. The true birds of prey as has been said have powerful, seizing feet, armed with sharp and cruel talons. Vultures, usually carrion feeders, also have heavy, strong feet, but the claws are blunt and used only in holding down the food. Ducks, geese, swans, pelicans, cormorants, and gulls have large webbed feet and short legs as an aid in swimming, while the herons and other waders have long, delicate toes and exceedingly thin and fragile legs to support them on soft mud or even on floating vegetation. The perching birds, usually of smaller size than those already mentioned, have delicate feet with long claws with which to grasp the branches of trees. In the goatsuckers and swallows, the feet are so small as to be almost invisible to a casual observer. In the swiftly running ostrich, a giant among birds, the legs are very long and powerful, and the toes have been reduced in number to two on each foot; they are of enormous size and terminate in powerful, blunt claws.

Though it may seem a little out of the ordinary thus to separate the external bird as it were into its principal component parts, yet so important and so varied are these sectional divisions of the anatomy that they really repay individual study and will be found of great assistance in analyzing just what one is looking at in any given member of the bird family.

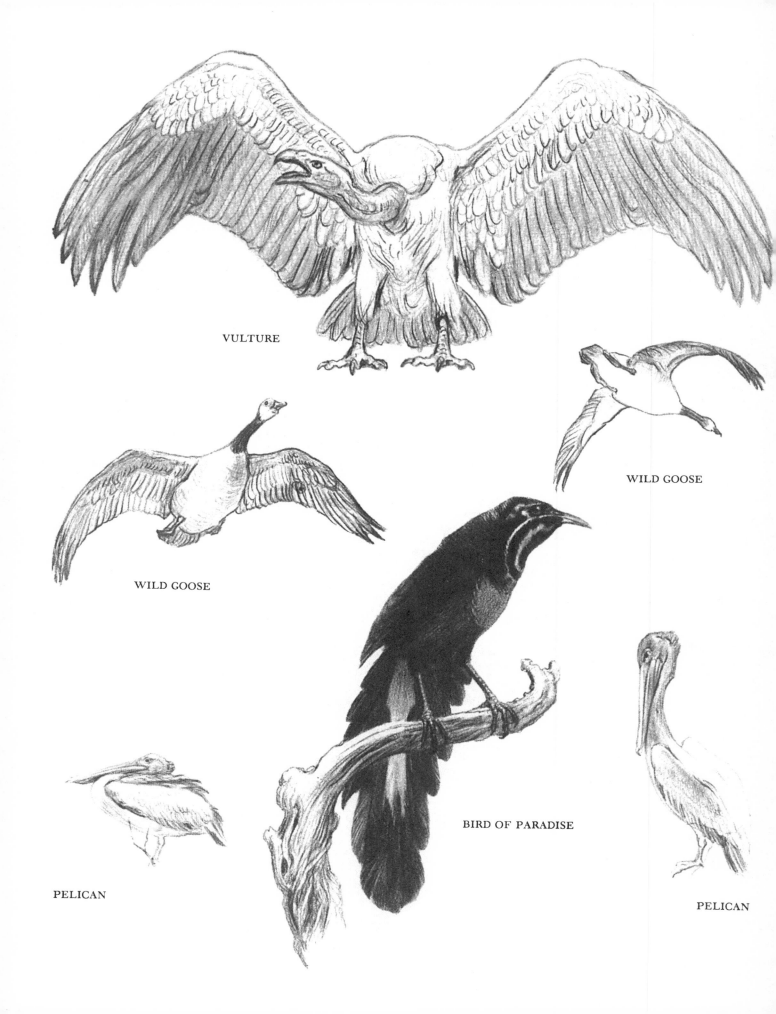

VULTURE

WILD GOOSE

WILD GOOSE

BIRD OF PARADISE

PELICAN

PELICAN

Expression in Birds' Eyes

The eyes of various species of birds like those of mammals differ considerably in position and expression. Most birds have eyes placed well at either side of the head, so that they have a more or less one-eyed vision, while others such as eagles and, particularly, owls look directly ahead, concentrating their gaze as does a human being. Naturally, these various positions of the eye have much to do with the expression of the bird, and a knowledge of them is necessary if one is to draw with character. Ducks and geese, for example, have small, beady eyes set at the side of and very close to the top of the head, while woodcocks have large, dark eyes in a similar position. In general, all small birds and many larger ones have a distinctly sideways vision.

Chickens, pheasants, guinea hens, turkeys, and many herons and gulls have quite reptilian or lizardlike expressions. Peacocks possess dark, shoe-button-colored eyes. It is in the hawks, eagles, and owls that the eyes seem to attain their most striking effects, but even among those fierce marauders there is much variation between the different species.

Eagles in general, especially the larger types like our own bald eagle, the golden eagle, and the European sea eagle, have sharply indicated bony ridges over the eye sockets, a feature that as it casts a downward shadow imparts a peculiarly lowering and defiant look. This combined with the diagonally set eyes imparts also that highly concentrated gaze so characteristic of the eagle family. The bald eagle shows a light-yellow iris sharply contrasting with the black pupil. The eye of the golden eagle is a dark, lustrous brown, not at all fierce in expression, and certainly not a true indication of character.

Among the hawks, the large gyrfalcon and the duck hawk or peregrine falcon turn soft, dark-brown eyes upon an intruder. The wildly fierce gaze of the goshawk is caused by the contrast between a very light yellow iris and a dark pupil.

All species of owls stare directly forward through their great, lustrous orbs. In most types, especially the big eagle owls of Europe and our own great horned owl, the huge orange or bright-yellow iris surrounds a seemingly bottomless pupil of intense black, the whole encircled by heavily feathered lids, which either half open or widely distended give a most extraordinary character to the terrifying gaze of these fierce nocturnal killers.

Large facial feather disks, surrounding the eye itself, and the sharply raised so-called "ears," or "horns," which are merely elongated feather tufts, also produce a series of diabolical expressions in what is already a unique countenance among the members of the feathered tribe.

As most owls feed at night, the pupils of the eyes are very large when expanded in order to absorb every ray of light; they contract greatly in the sun's rays, or the eyes may be closed altogether as a screen against the confusing glare. Certain species, however, chiefly the great Arctic white owl, must be able to see well in daylight, for its home environment during the short Arctic summer is almost continuously illuminated.

Birds also have a well-developed third eyelid, which can be drawn across the eyeball in such a way as to reduce greatly the amount of light entering the pupil. Thus protected, an eagle may gaze directly at the sun in what seems to us a most nonchalant manner. Both ostriches and hornbills possess what at a first glance seem to be true eyelashes; these, though they certainly function as such, are fashioned of a feathery substance, not a hairy one as in the case of all mammals. Night-feeding types such as the owls already mentioned and the whippoorwills and night herons exhibit large and lustrous eyes. The kiwi or apteryx of New Zealand, a highly specialized wingless species, also nocturnal, has a long, sensitive bill, with nostrils near the tip, and small eyes surrounded by long bristlelike feathers, or feelers; it procures the worms upon which it feeds by probing for them in the soft earth.

The faces of birds insofar as muscular changes are concerned are practically immobile and set in character. The bill, or beak, unlike the mobile, fleshy lips of a mammal, is a hard horny substance sheathing the nostrils and covering entirely the fore part of the upper and lower jaws. But the eyes and the variously shaped and movable crests combined in certain species with strangely shaped and brilliantly colored wattles and bills, can create a series of most diverse and often bizarre effects found only among the feathered tribes. In general it may be affirmed that the eyes of birds are extremely limited in expression. The softer and more complicated glances so often seen in the eyes of a mammal are quite beyond their achievement.

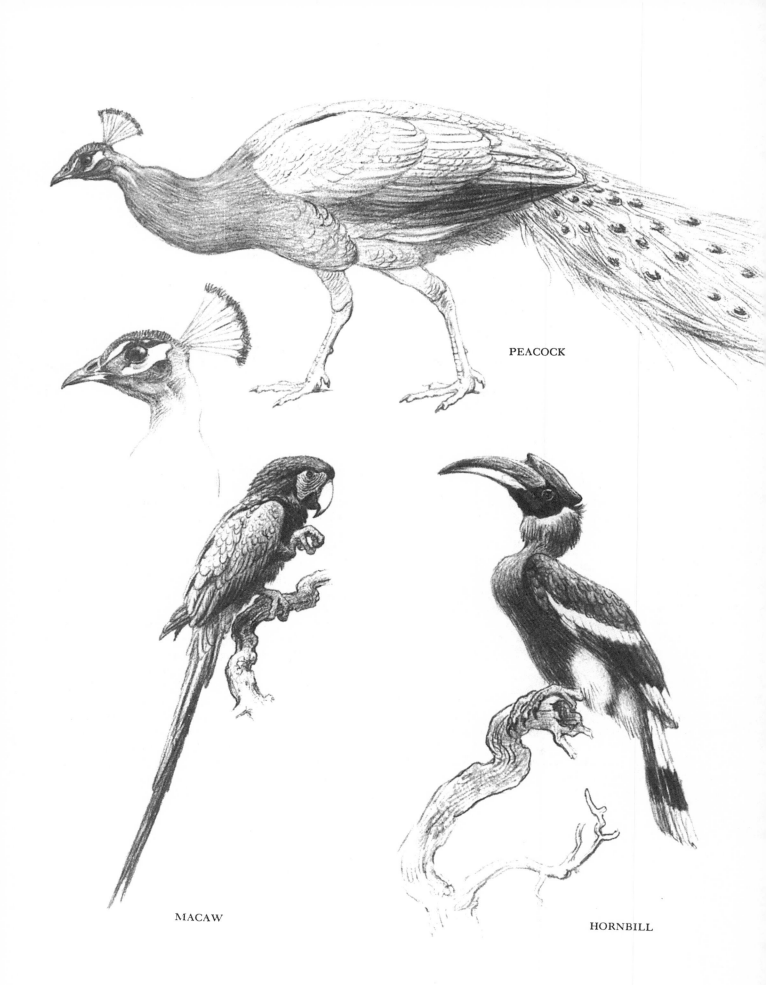

PEACOCK

MACAW

HORNBILL

Reptiles: Crocodiles, Lizards, Snakes, Turtles

Reptiles are all cold-blooded creatures and with the exception of the snakes walk on four rather short and curiously shaped legs with the belly almost touching the ground. Today most reptiles with the exception of crocodiles and alligators are small in size, seldom attaining a length of more than six feet. The crocodiles and pythons may run up to thirty feet, but these measurements are well above the average. There was a time, however, many millions of years ago, when the reptiles grew to enormous proportions, some dinosaurs, brontosaurus for example, attaining a length of perhaps seventy-five feet and a standing height, on all fours, of fifteen feet at the middle of the back. To be sure, most of this vast length was comprised of neck and tail, and the creature spent most of its time in the water. Nevertheless, no modern reptile can be mentioned in the same breath as far as mere bulk is concerned. Other species of dinosaurs, particularly the carnivorous forms, stood upright in walking and with their huge heads and formidable jaws filled with long, sharp teeth must have presented a truly terrifying appearance. Fortunately for our peace of mind these sinister beings departed this earth ages before man made his initial appearance, so that their anatomy concerns only specialists along these lines. They are mentioned merely to show the extraordinary diversity in size and form that has characterized the reptiles as a class.

Our modern lizards belong to a type that existed even before the dinosaurs and that has continued with certain deep-seated anatomical similarities to the present day. The mythical creatures that we know as "dragons" may have been inspired by the sight of certain species of lizards; as represented, they usually bear more or less resemblance to these scaly, crawling reptiles. Chinese and Japanese artists in particular have made constant use of dragons in their wonderful productions. Indeed, no piece of Chinese decoration seems quite complete without one or more of these sinuous and fantastic creatures appearing at intervals in the design. The Hindus regarded the hooded cobra and the tortoise as important deities in their complicated mythology. It is evident therefore that reptiles, in spite of the repugnance with which some people regard them, have played no small part in the art as well as in the religions of the past. For this, if for no other reason, their peculiarities of form and posture should be carefully studied.

Many varieties of snakes are most beautiful in color and pattern, and certain lizards glow like jeweled bronze under anger or sexual excitement. As to pose, the lizards, when at rest, carry the upper sections of both fore- and hind legs projecting almost at right angles to the body. When running, certain species stand on the hinder pair of limbs, but they hold this pose for an instant only. In drawing the creatures, it is important to observe the main horizontal curve of the backbone from head to tail, a point that gives grace and power to the form, the legs being somewhat secondary as to their position. Most lizards have very small scales, except about the head and the center line of the back. The correct drawing of these scales will give definite character to your studies; they must be closely observed. The proportions of the clawed toes are different from those in a mammal, and the curious skin folds give an unusual appearance to some types and are unlike those in warm-blooded animals. The expression is somewhat birdlike. Snakes from the fact that they do not possess eyelids have a fixed stare. Lizards, crocodiles, and turtles all have the lids well developed.

One must look carefully to see just what constitutes the unique impression conveyed by these lowly animals with their glittering, scaly skins and hard, bright eyes.

The great family of reptiles will furnish endless suggestions for decorative color schemes and for grotesques in bronze or stone.

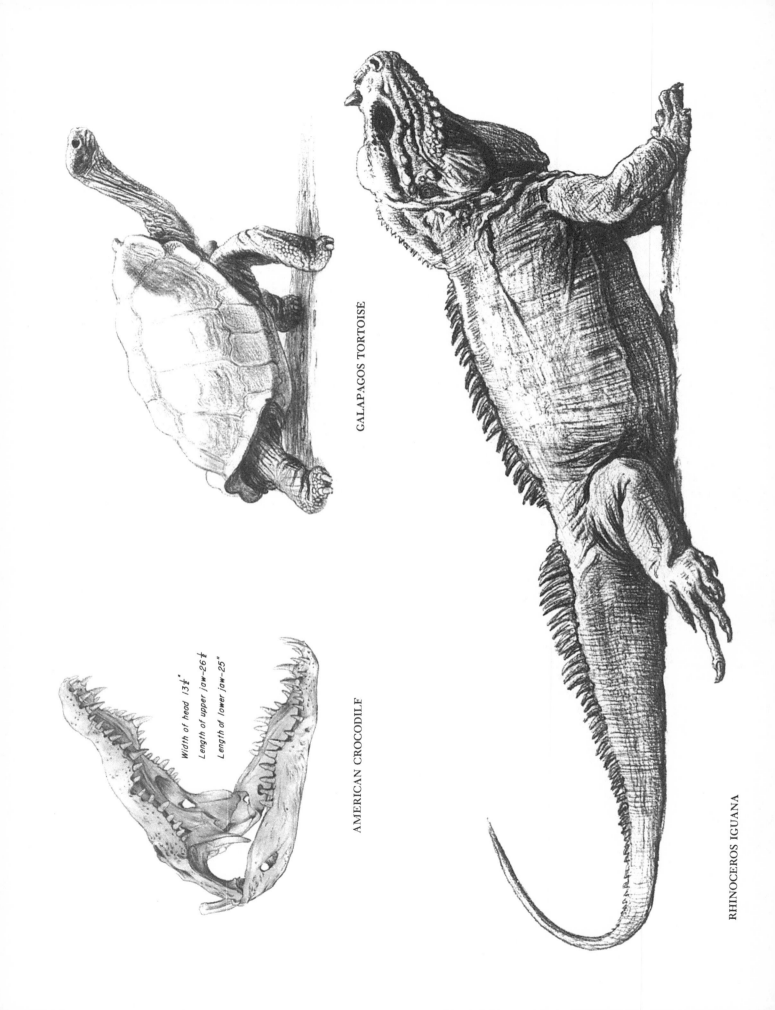

GALAPAGOS TORTOISE

AMERICAN CROCODILE

Width of head 13¼"
Length of upper jaw—26¼"
Length of lower jaw—25"

RHINOCEROS IGUANA

Fishes

Of all the lower forms of animal life, possibly no group shows more diversity in type than the fishes. In size they may vary from the great whale sharks some forty feet or more in length to species so small that we can hardly distinguish them in an aquarium. Some forms glow with iridescence or local color; others again are dull and somber in hue. Fins and tails may be large or small, elongated into attenuated streamers or clipped off close to the body. Spots and stripes in bizarre patterns are evident in many species, serving to break up the apparent form and rendering the creature almost invisible. In spite of these great variations in the different types, they all have one property in common, viz., their ability to exist in—to float in and propel themselves through—the water by means of fin and tail motions and undulations of the body. Artistically they are most inspiring, as they glide gracefully through the heavy liquid medium, perhaps poised like a bird for an instant on some weed-covered ledge or dashing swiftly after their prey.

The numerous species of sharks are particularly graceful in form and undulate through the water by a sculling motion of the long and powerful tail. The gorgeous reef fishes spend most of their time browsing on the coral polyps or hiding in dark crevices to escape their enemies. Again we have the fresh-water game fishes, the salmon, trout, black bass, and many other splendid, active creatures, as well as the great sea fighters, the sharks, tuna, sailfish, tarpon, and swordfish. These latter are all tremendously powerful species and when hooked are worthy antagonists for the most skillful anglers.

These varying types are mentioned to show the possibilities for the artist who is interested in such subjects, but much study will be necessary before he develops the ability to visualize the different forms properly. Primarily, of course, they all follow a general plan. A typical fish is shown in the plate; but there is variation in the position and number of fins, and one must strive to understand the particular developments of these parts in any given species.

We should realize in drawing a fish that practically all species possess two pairs of special fins, the pectorals and the ventrals. In a way these fins compare with the four limbs of a mammal or reptile. The pectoral pair project as a rule from points just behind the gills, or breathing organs; the ventrals lie farther along toward the tail, one at either side of the belly. Besides these so-called "paired fins," there are the dorsals, situated along the middle line of the back, one, two, and sometimes three in number. The caudal, or tail, fin is a most important part of the fish anatomy and is used in propelling the creature through the water. It varies enormously in shape and size in the different species. Still another fin, the anal, is placed near the tail on the median line of the belly.

Infinitely varied as the fishes are in form, size, and feeding habits, their wonderfully varied color schemes, concealing patterns, and exquisite textures appeal especially to the artist wishing to portray them. Rivaling even the bird world in these aesthetic characteristics, they will well repay a close and concentrated study as most beautiful subjects for painting. In Bermuda, for example, and all other coral-reef localities of the world, the clear, intensely blue water bathes its lovely inhabitants in every shade of cerulean and azure tints, and wonderfully shaped and colored sponges, sea fans, and corals blend with these gemlike creatures as they flash and glide through shadow and sunlight in great schools of glittering, iridescent units. Meanwhile, the larger species of submarine beauties pass slowly in a dazzling procession. This rhapsody may sound a little "fishy" to one who has never witnessed such a scene, but I can assure the reader that it is really far from being an exaggeration in its aesthetic impression upon the sensitive observer.

The opportunities for decorative rendering of fishes are practically unlimited. The subject is a new and fascinating one, which merits greater attention than is usually bestowed upon it.

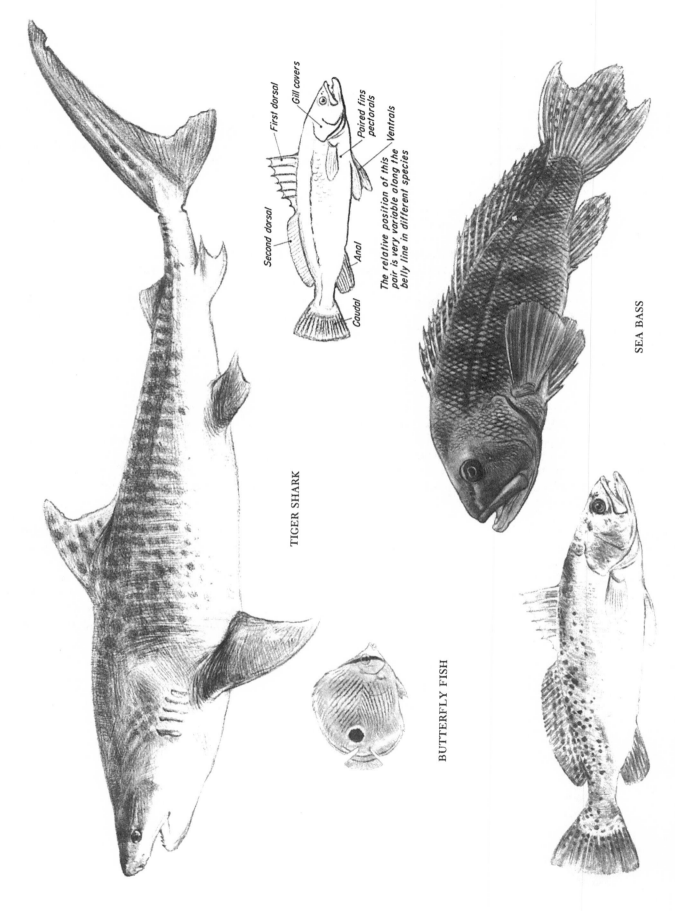

TIGER SHARK

First dorsal

Gill covers

Second dorsal

Paired fins
pectorals

Ventrals

Anal

Caudal

The relative position of this
pair is very variable along the
belly line in different species

SEA BASS

BUTTERFLY FISH

SEA TROUT OR SOUTHERN WEAKFISH

Invertebrates

In dealing with the possibilities of these lovely creatures as material for artistic production, we are confronted by so vast an assemblage of varying forms that we hardly know what special types to select for our purpose. Naturally, they fall into many classes or groups. We can perhaps do no better than discuss a very few of those which, in the author's opinion, offer suggestions for decorative themes.

All of us, no doubt, appreciate the value of the lobster and the crab as luxurious additions to our usual prosaic diet. But perhaps we do not at the same time realize the inherent beauty and artistic possibilities of these complicated crustaceans. It will prove a shock to us with our hard-acquired knowledge of anatomy when we finally scrutinize closely the unique construction of the delectable animals, for they just aren't built along the mammalian lines. For example, they have no feet or hands or fingers or toes, no shoulder blades, ribs, or pelvis, and no elbows, heels, or wrist joints. They do have legs, to be sure, many of them terminating in claws, which they use in walking, fighting, and procuring their food; but the joints are all oddly shaped, they bend in strange directions, and they don't seem to work like those of a warm-blooded animal. For this reason, we shall have to begin afresh on our studies and try to understand this new problem to the best of our ability.

The lobster exists for most of us in two very definite states. When the lobster is alive, its shining surfaces aglow with all manner of Persian-rug hues and colors, reds and greens, cerulean blues, and shades of orange are exquisitely blended in a maze of concealing shadings. When it is boiled and set out upon a platter, the total effect is entirely different and the contrast is quite extraordinary. For now the once multicolored shell is one bright mass of flaming vermilion, with every joint and claw showing clearly the devious lines of its unusual construction. At this stage, the food appeal is no doubt very urgent for most of us. But to one of artistic leanings the possibilities for a wonderful still-life study of the highly colored creature are also most apparent, particularly when it is combined with various accessories in the shape of oysters, celery, and even a cold bottle by way of (artistic) contrast. Seriously, however, the whole beautiful arrangement has appealed many times to artists in the past, the great Dutch masters being especially fond of this type of picture. Crabs in all their varying colors and markings also afford excellent suggestions for decorative designs in any medium. They, too, are hard to draw so that their peculiar characters are correctly suggested.

In the insects, our interest is naturally captivated by the well-known types of moths and butterflies. No creature quite approaches the butterfly in certain aesthetic attributes. The four exquisite wings are shaded with some of nature's most delicate and intricate color tints and patterns which flash and gleam in the bright sunlight.

To many persons the collecting of shells is an engrossing pursuit; but few collectors, except, of course, the scientific type, are more than mildly interested by the forms and life histories of the creatures that make these delightfully shaped and tinted little dwellings. Indeed, the average shell enthusiast and certainly the layman neither know nor care anything about the living inhabitants of these fairy castles.

Even prehistoric man was in his primitive fashion a shell collector. We often find specimens, principally of food varieties, that have been drilled and made into necklaces or other articles of personal adornment. The much later Greeks and Romans, together with the masters of the Renaissance, also employed shell forms in their architectural designs as well as in jewelry and household utensils. The scallop, the beautifully curved nautilus, and the triton, a large spiral species (the type used by the sea-god Neptune when summoning his water-living hosts) were all prime favorites. Aphrodite, the Greek goddess of love, known to the Romans as Venus, is depicted rising from the depths, supported upon a pearly shell.

Fascinating legends these, attesting the great interest displayed by all Mediterranean peoples in the sea and all the various forms of life contained therein. In this vast assemblage the shells, with their infinite variety of shapes, colors, and textures, occupy a most prominent position. We must study carefully these superbly fashioned objects, for they will give us rare insight into the possibilities of pure form combined with exquisite surfaces.

It seems difficult to realize that so much beauty can be produced by such lowly animals. A shell is produced by the mantle, a portion of the fleshy anatomy. As it grows, it builds its own extraordinary dwelling, beginning as a minute organism. Successive layers of the shell substances are added to the tiny domicile, each species after its own fashion, until the maximum development for a particular type has been attained. If we but knew the principle that controls this singular power, all life secrets would be as an open book.

When we realize how vast in number and variety are the living things that the oceans harbor in their depths, the possibilities for artistic translation of these fairy beings become ever more apparent. For example, we may, if we like, go on to study the still lowlier types such as the flowerlike sea anemones, whose widely spread, delicately tinted tentacles prosaically seize the

AMERICAN LOBSTER

SCALLOP

PEARLY NAUTILUS

TRITON

BLUE CRAB

CONCH

LOBSTER WALKING IN WATER

tiny particles of food carried by the ocean currents. Combined with these are all the wonderful and fantastic edifices built by the coral polyps, small creatures not unlike a diminutive sea anemone but whose vast numbers through long ages have built the formidable barrier reefs surrounding many islands of the South Seas. Against this mysterious and highly suggestive background, replete with all manner of intriguing light and shade effects, a whole new world with everything to please and stimulate the artistic imagination awaits the student who will delve into this little-known and undeveloped field of art expression.

Protective Coloring

Because so many birds, mammals, reptiles, and fishes as well as the invertebrates, insects, crustaceans, and mollusks, are more or less protectively colored, the subject offers many interesting research problems to the animal artist. The student of the human form is spared this difficult phase of art simply because man's skin coloration is practically a monotone. There are, to be sure, delicate tints of color, yellow, green, white, or red as the case may be, but no intricate lines of spots or stripes, no colors shading from dark to light, and vice versa, and no question of how to treat fur, feathers, or scales upon the body surface. Yet to the true animal painter or sculptor these minor puzzles are merely something to be taken for granted in the general plan of his work, difficulties that when studied and successfully surmounted will prove a never-ending source of interest and satisfaction.

We have casually mentioned coloration problems in various parts of our discussion, and it may be well at this point to elaborate somewhat upon this phase of nature's attempts at protection for many forms of animal life. Our tiger model, for instance, is a splendid example of how successfully the intricate maze of dark stripes combined with a white and orange ground will serve to conceal so large an animal in its natural environment. The much-discussed question as to whether the tiger had a hand in fitting itself into its background or whether natural surroundings influenced the coloring is a proposition into which we need not enter here. In any case, the resulting effect has given us as artists something interesting to think about and be very much aware of as a distinctly difficult part of our animal study. For with incredible ingenuity this seemingly innocuous pattern is so disposed that it effectually nullifies the muscular form at every point possible, and combined with the subtle shading of the animal from dark orange above to white below it successfully reduces the great carnivore to a flat, confusingly marked feline with length and breath but no apparent thickness.

For many years under the influence of men like the great English naturalist, Charles Darwin, we assumed that the reason a tiger was more or less invisible against his background lay in the fact that it was the same *color* as its background. It remained, however, for our distinguished painter Abbott H. Thayer, himself a naturalist of parts, to clarify and amplify this statement by declaring that the big cat was made invisible because its maze of stripes and color so broke up the concrete body form that it assumed the *effect of the light and shade* upon that background, a very different point, but one that we now recognize to be well taken.

However this may be, for those of us who for pleasure or profit are constrained to draw or paint the big cat, this bizarre coloring is certainly a most baffling phase in our artistic efforts to visualize his physical appearance. It has seemed to me desirable whenever faced with this difficulty to ignore these stripes as much as possible at first, concentrating on the silhouette, correct pose, muscles, and character generally and by half closing the eye to merge the creature into a more or less monotone type of coloration. Your previous anatomical studies will be of the greatest value here, because you will be able to understand and discern the form in spite of the all-pervading striped effect of the animal.

As a matter of fact, many species of the cat family are thus effectually screened from observation, not only by striped effects, but by elaborate patterns of spots as well. Leopards, jaguars, ocelots, and numerous others are so protected. One is amazed at the variety of ingenious designs thus employed. Certainly the rich, gleaming coat of a leopard or a jaguar is one of nature's most beautiful skin decorations, tremendously elaborate, the shape and size of the spots varying at many points and forming a pattern that is a most potent factor in concealing the fierce creature to an extraordinary degree. In looking at these animals in a zoo, one is tempted at times to doubt the last statement; but we have the word of many sportsmen that this is undoubtedly the fact, so much so that in many instances, even though the crouching brute is pointed out by a native guide, it will yet remain invisible to the untrained eye.

Besides the numerous instances of concealing pattern among all classes of animals, there is also the device of canceling the light and shade by darker or lighter body tones, though the actual color remains practically the same over the entire animal. Lions and pumas are good examples of this type of concealment, the darkest shades being found along the back of the animals, with lighter tones on the side and still lighter on the belly. The result of this scheme is obvious, the darker color being offset by the brighter light on the back, the belly in shadow relieved by the lighter tone of the fur. Indeed, this type of shading exists even when the skin is covered with spots or bands. It is a wonderfully successful method of reducing the animal to a flattened plane with no light and shade visible.

Although the body of a bird is often thus concealed, quite frequently the plan is apparently abandoned for some other form of confusing effect by means of bands, spots, and infinitely delicate markings, splashes of brilliant color, or bizarre patterns in great variety. White is a fairly common color among birds; black or the effect of black occurs quite frequently; red, yellow, blue, and green in every shade and design exist among these

lovely feathered creatures. But there are some birds whose camouflaged effect is extremely elaborated. Woodcocks, partridges, female pheasants, whippoorwills, and many others are exquisitely designed for concealment.

In the reptiles we see again in many species most beautifully worked out schemes of color, spots, and bands. Rattlesnakes, copperheads, pythons, boa constrictors are all thus subtly decorated, their coiled forms thus becoming essentially a part of their environment.

Fishes as well offer delightful and amazing examples of nature's concealment plan. This is accomplished in a number of ways, by color, bands, stripes, and spots, iridescence, actual skin projections, and the simulation of bits of sea weed and other objects. In many species this is combined with the unusual power of actually changing their normal skin appearance by bringing forth or retiring brilliantly contrasting shades; the general effect of the marvelously constructed creature is thus entirely altered. The sargassum fishes, living in the weed of the same name, are unbelievably like their surroundings in color, pattern, and even form, their grotesque body and fin construction greatly adding to the general effect. Reef fishes are tinted in all manner of glowing colors applied in oddly decorative shapes. They also may assume fearful and wonderful body and fin filaments, excrescences, knobs, and a host of other interesting characters, making them very difficult to distinguish against their submarine backgrounds of coral rock and seaweed.

So down the long pathway of life we may wander with ever increasing interest and delight as we survey the many manifestations of beauty, practical utility, and versatility along the lines that we have chosen for our study.

We have briefly discussed some of the possibilities and the difficulties in the proper representation of animal forms when masked, concealed, and even apparently distorted. After a serious preliminary study of their bony structure, muscular development, and action, you will be able to discount the baffling effects of the color patterns upon the creature as a whole. Correct values are of the utmost importance. For example, don't paint a black bird black all over. Light and shade must be duly considered. Also, see if you can realize the exquisite livery of a more or less simply colored bird, a mocking-bird for example, darker on the back, lighter on the belly, yet influenced always by the light and shade upon the solid form. Accurate rendering of the color scheme and values of any animal is an artistic triumph, but its successful accomplishment will tax your observational power to the utmost. Study, then, the fairylike forms of birds, so exquisitely light and graceful, encased in softest-tinted feathers or splashed with brilliant hues, the iridescence of fishes floating in their chosen element, or the full glory of the fur of a great, spotted cat, black upon a golden ground. All these will stimulate your creative sensibilities, urge you to greater efforts, and supply you with inspiration. As devotees, then, of the great field of animal representation we must be prepared to recognize and face a constant series of seriously involved problems connected with our chosen work but may congratulate ourselves upon having hit upon one of the most enjoyable branches of the painter's and sculptor's art. One feels convinced that perhaps the greatest assistance to an aspiring art student is to call his attention to as many points of vital interest and value as the subject requires. To see is to know, and to enable him to see accurately is to put into the mind and hand of any artist the greatest power of expression of which he is intellectually capable.

Summary

It goes without saying that during my years of drawing in various zoos both here and abroad I have met some very curious and interesting human types all keenly desirous of watching me at work. Under these sometimes trying conditions one must be reconciled to the fact that anyone drawing in a public place is an absolute lodestone. Most persons are attracted to such a one-man exhibition in a most surprising degree. Almost all of these, you will find, are merely curious and politely interested, but others take advantage of one's helplessness to impress one with the fact that a certain mythical cousin, who "never took a lesson in her life," can "sit right down and draw a perfect portrait of anyone in five minutes." I've always wanted to meet that gifted relative, but without seeing her work I rather imagine I can guess just how much it is worth. It's a dreadful bore, of course, but you must learn to ignore all these little interruptions and try to concentrate on the business at hand, which is, Heaven knows, difficult enough under the best conditions.

Another important thing is to make friends with the keepers. These men can and will do you many little favors, thereby saving you a lot of trouble and time. Don't, however, make the mistake of presuming too much upon their kindness by becoming unduly free with your models, particularly the big cats, or you may be minus a hand or arm before you realize that your feline friend is just another fierce and more or less treacherous bit of animal creation. Beware also of the mild-eyed deer and the docile antelope, for they can deliver a very quick and powerful blow with their horned heads, mashing your fingers against the bars or otherwise hurting you badly. In other words, be careful and you'll stand a much better chance of continuing your art studies unscathed.

You will learn by experience that in no one zoo will all the animals be of outstanding excellence; on the contrary, some little catchpenny show may possess just one superb black leopard or a wonderful eagle, while the rest of the stock will be of the poorest description. This brings me to a very important point which you must always consider in your work—the necessity of cultivating your critical sense of what constitutes a really fine specimen of any given creature. Too often one sees exhibited crippled, weak, aged, and poorly developed animals simply because no other specimens are available. Especially common among the big cats are these deformed individuals, very apparent to the trained eye, really poor, miserable brutes with ridged backs, bent legs, permanently curled tails, and a general air of misery and decrepitude. I have always been astonished at the comparative lack of awareness of these very evident defects even among members of the artistic profession. The worst part of it is that a model so deformed is just as difficult to study as a perfect individual of the species. Such inferior creatures would naturally not survive in a wild state, but in a zoo, where food, water, and shelter are provided, the poor beasts may and often do live for many years in comparative comfort.

Be particularly critical of all such inferior stock, and try always to work from the very finest examples possible. Watch closely for coordinated rhythm (no wobbly or uncertain gaits will do), fine, large, well-developed, shapely muscles, beautiful lines, and a general air of alertness and well-being. In time and with practice you will learn to sense these points at a glance and choose your models accordingly.

Today with the excellent lenses of the modern camera, splendid snapshots of wild animals are easily obtained. Consult but do not copy from these often superb examples of photographic art. They will serve to fix in your mind the veritable life appearance of many magnificent types. Always you will notice in these untrammeled creatures the very points of beauty upon which I have been insisting, the perfect bodies, strong limbs, and general carriage necessary in a struggle for existence.

So difficult is the subject before us that I do not hesitate thus to suggest all legitimate means for the acquisition of as much knowledge as possible as an aid in fixing the image of an animal in the mind of the observer. By the constant study of skeletons, muscular forms, actions, psychology, by drawing, modeling, and painting from the living creatures, and by dissecting dead specimens, we may so train our powers of observation that what was at one time a most confusing and baffling problem will resolve itself into an all-absorbing and delightful study, filled with the thrills of new accomplishments along artistic lines and an immense satisfaction in the knowledge that at least we have perused and learned much from one volume in nature's vast library of living things.

Remember too that above all it is *art* we are seeking to experience while we turn these pages, that our own individualities are being consulted at all times, and that the better artists we strive to become the finer will be our productions in the field of art expression. Indeed, all the things that I have told you in this book are merely guides along the path that you have elected to follow.